BETWEEN YOU AND ME

{ BETWEEN YOU AND ME }

QUEER DISCLOSURES

IN THE NEW YORK ART WORLD,

1948–1963

GAVIN BUTT

DUKE UNIVERSITY PRESS

DURHAM AND LONDON

2005

© 2005 DUKE UNIVERSITY PRESS

ALL RIGHTS RESERVED

PRINTED IN THE UNITED STATES

OF AMERICA ON ACID-FREE PAPER ∞

DESIGNED BY AMY RUTH BUCHANAN

TYPESET IN MINION AND FUTURA BY

TSENG INFORMATION SYSTEMS, INC.

LIBRARY OF CONGRESS CATALOGING-IN-

PUBLICATION DATA APPEAR ON THE LAST

PRINTED PAGE OF THIS BOOK.

THE DISTRIBUTION OF THIS BOOK IS

SUPPORTED BY A GENEROUS GRANT FROM

THE GILL FOUNDATION.

FOR MAM AND DAD

{ CONTENTS }

{ LIST OF ILLUSTRATIONS }

{ ACKNOWLEDGMENTS }

There are a number of people I would like to thank for helping me carry this book along the sometimes seemingly endless road to completion.

First of all, Adrian Rifkin, who, as supervisor of this project's early life as a dissertation at the University of Leeds, gave me permission to think in an unorthodox manner. Without his encouragement of counterintuitive thinking and researching, this project would simply never have materialized. I am also indebted to Andrew Stephenson and Griselda Pollock for their careful and probing comments as examiners of my dissertation.

Researching my curiosities has been immensely enjoyable, and has been made all the more so by staff at the following institutions: the Andy Warhol Museum and Archives, Pittsburgh (especially Matt Wrbican); the Archives of American Art, New York; the British Library; the library at Central Saint Martins College of Art and Design, London; Gay's the Word bookshop, London; Hall Carpenter Archives, London; Leo Castelli Gallery, New York; Lesbian, Gay, and Bisexual Archives, Toronto (particularly Alan Miller); New York Public Library; One Institute and Archives, Los Angeles; Robert Mapplethorpe Foundation, New York (especially Anise Richey); Susan Sheehan Gallery, New York; Tibor de Nagy Gallery, New York (especially Eric Brown); and the University of London Library. I'd also like to thank those people who took time to talk to me (Billy Name, John Gruen, Nat Finkelstein) and respond to my mail (Rachel Rosenthal, Joe LeSueur, David White).

My colleagues in the Department of Visual Cultures at Goldsmiths College have been instrumental in shaping the book's intellectual ambitions

without perhaps being aware of it — particularly Irit Rogoff whose own perspectives on gossip made this book possible. Other friends and colleagues have generously offered advice and ideas, and occasionally juicy snippets of information when I needed them most. Jon Cairns has carefully and scrupulously read the whole of the manuscript, possibly more times than he should, and also came up with the idea for the book's current title. I am also extremely grateful for the intellectually savvy comments of Carol Mavor and José Esteban Muñoz, and particularly to Carol for suggesting I might flirt with the idea of flirtation. Jennifer Doyle, Ben Highmore, Jonathan Katz, and Amelia Jones have read parts of the manuscript and have been astute and helpful with their words. My editor, Ken Wissoker, has been understanding and supportive throughout the production of this book. Others, including Kate Love, John Seth, Nigel Shardlow, Joshua Sofaer, Andre Dombrowski, Rachel Withers, Alec Kennedy, and Terry Myers, have helped in different ways again. Francis Lee provided love and support in great measure during the research phase of this project. More recently Andrew Walby has provided me with more than enough love to distract me from getting altogether too serious about "the book."

Earlier versions of the arguments contained here have been aired at the following conferences and conference sessions: "Queering the Gaze" at the Association of Art Historians (AAH), London, 1995; "Who's Deconstructing the Closet?" at the College Art Association, Boston, 1996; "Performance and Performativity" at the AAH, London, 1997; the "Body Currency" event at the Vienna Festival, 1998; the Andy Warhol Study day at Nottingham University in 2002; "Queer Visualities," New York, 2002; "The Independence of American Art" at the Louvre Museum, Paris, 2003; and the "Sexuality after Foucault" conference at the University of Manchester, 2003. I have also been lucky enough to speak to staff and students in the Departments of Art History and English, at the University of California, Riverside; the Department of Art History and Theory at Essex University; and the Department of Art History, University College, London. Thanks to all those who invited me to these occasions.

My students at both Central Saint Martins from 1992 to 1997 and since then at Goldsmiths have been exposed to various formulations of the book's problematic, and have helped in bringing it to its final form in these pages. I would also like to mention the importance of student contributions to my short course on Warhol at Tate Modern in 2002.

The book owes a great deal to pioneering queer scholars in history and art history without whom this project would be unthinkable: in particular to

George Chauncey, Jennifer Doyle, Jonathan Katz, Richard Meyer, José Esteban Muñoz, Kenneth Silver, James Saslow, and Jonathan Weinberg. However, it was also formed intellectually in the crucible of the 1990s queer theory and performance studies explosion, and it is particularly indebted to the work of Judith Butler and Peggy Phelan. Equally, moreover, the book represents to me a more lengthy, and perhaps twisted, engagement with the social history of art. Gratitude is therefore in order to T. J. Clark for his work in the field but also, perhaps above all, to Fred Orton, whose enthusiastic teaching I benefited from immensely at the University of Leeds in the late 1980s and early 1990s. His influence, I feel, is still evident in these pages, even though it may not appear so to some.

The writing and publication of this book were made possible with support twice-over from the Arts and Humanities Research Board of Great Britain. I was a grateful recipient of an AHRB sabbatical during the 2000–2001 academic year, during which time the framing of the book's problematic was finally wrought and much of the writing done. I also gratefully acknowledge receipt of an AHRB Small Grant in the Creative and Performing Arts to cover the book's illustrations costs. The book also benefited from an earlier sabbatical from Central Saint Martins in autumn 1996.

Finally, I owe a debt of gratitude far greater than I can express here to my parents — not just for their expressed support for this book and my ambitions, but for their unconditional love which has sustained me throughout. The book is dedicated to them.

{ INTRODUCTION }

GOSSIP:

THE HARDCORE OF

ART HISTORY?

In a 1974 interview for *Gay Sunshine* magazine, the poet John Giorno draws attention to the currency of gossip about artists' sex lives in the 1960s New York art world.[1] Such talk, he contends, is an inescapable feature of metropolitan artistic life, as "everyone is always gossiping about what everyone else is doing, like who's making it with whom, who has done what to whom, and all the weirdnesses" (G 159). Such is the humdrum discursive actuality of bohemian life, and one that might be generalizable to countless other fields of professional endeavor both before and since. But Giorno turns out to show more than a usual investment in the value and significance of this everyday talk. "Ordinarily it just seems like boring gossip," he says, "but it actually is the dynamic relationships between artists, between artists and poets." Rather than dismissing such talk in more customary fashion as discursive flotsam, then, Giorno sees it as a key form through which artists and poets go about conducting their creative business. For him, gossiping is a form of social activity which produces and maintains the filiations of artistic community. But even more than this, he ventures, upping the critical ante somewhat, such gossiping might be approached as "the hardcore of art history" (G 159). This is an interesting expression which signals Giorno's appreciation of gossip's central importance for understanding art history which resides, he suggests, in its capabilities for revealing the art community's sexual secrets. Like pornography's "explicit" representations, gossip's narratives are capable of speaking in a relatively untrammeled manner about the place of sexual intrigue in the American art world. As such, he argues,

they offer an invaluable resource for discovering sexual meanings which might otherwise be passed over in silence by the discursive proprieties of art history.

In order to capitalize on gossip's informative power (and not forgetting, of course, it's equally important pleasures), Giorno had already, in 1969, set up his own gossip column called "Vitamin G," which appeared in the journal *Culture Hero*. The title, in suggesting gossip's generally healthy and energizing effects, implies a revalorization of what is often taken to be a harmful and malicious form of communicative activity. Here he was able to disseminate "the really sordid details which came to me at the time. It was what people said to each other, like in the back room at Max's. The things people scream at each other in laughter or telephone each other and say, 'Listen to this!' . . . Like the size of their cocks hard: Bob Rauschenberg, Jasper Johns, Andy Warhol and Brion Gysin. Then what they like to do" (*G* 159). For Giorno, this is "*really* art history" (my italics). Unlike art criticism, which he accuses of being ultimately an instrumental discourse serving the interests of the art market, he takes art-world gossip as witnessing the real things which affect artists' lives and the making of their art: "I think who's fucking who is where it's at . . . And all the neurotic pain between people, which has some effect on their work" (*G* 160). One issue from January 1970 provides a plethora of such information, including a story about Andy Warhol's desire to make a work of art out of playing with Jasper Johns's penis, and a report on three "boys" sighted at painter John Button's apartment ("there was a tube of vasoline on the breakfast table").[2] Alongside such "scurrilous" sexual reports, Giorno provides short and enticing accounts of other subjects, which include Philip Johnson's cosmetic surgery; Charles Olson's recent hospital visit; and the theft of part of Henry Geldzahler's art collection by Paul America, star of Warhol's underground film classic *My Hustler*.

Although, as it will become plain, I have little investment in simply asserting gossip's epistemological priority for sexual truth telling, I am nevertheless very interested in following up Giorno's lead here in reevaluating the potentiality of gossip's knowledges for art history. Certainly, since 1969, Giorno has been joined by a host of others writing within the academic discourses of the social sciences, literary studies, and cultural studies who have been at pains to rescue gossip from the moral opprobrium customarily heaped upon it.[3] But unlike most of these authors, who have argued for the generally positive social roles played by the activity of gossiping — from the building and sustaining of particular communities to its function

as entertainment — "Vitamin G" goes a little further in suggesting its value and significance *as a discourse of history* and, moreover, as a discourse of *art* history.

This proposition may strike us as art historical business as usual, especially if we think of how Western art history in its widest sense — ever since Giorgio Vasari's writings on Renaissance art — has been founded in the recounting of tales about artists' personal lives. Often such stories, even if highly embroidered or exaggerated, have found their way into the historical record and have been accorded significant value in attesting to the unruly and mythological power of artistic "genius," whether it be through accounts of Picasso's now legendary sexual drive or of Jackson Pollock's almost equally (in)famous brawling at the Cedar Tavern. Equally, however, Giorno's discursive gambit might strike us as simply too much of a perverse suggestion to be taken seriously, representing perhaps something like a woeful falling away from the archivally sanctioned practice of history "proper." This might appear so, especially in the light of sociohistorical approaches to art history, which, in the past few decades, have shifted disciplinary attention away from the dissemination of mythology to the production of less sensationalized, and rather more sober — which is to say, socially and historically justifiable — accounts of art's production and reception.

Indeed it *is* difficult to imagine Giorno's project as being articulated without, at the least, *some* degree of camp or irony, especially given its historical rootedness in the queer underground world of New York at the end of the 1960s and beginning of the 1970s. We might be wise, therefore, to see him as parodying art history's interest in sexual tittle-tattle rather than take his comments as an earnest and "serious" contribution to historiographical debate. Nevertheless, I want to insist here on taking up what I see as the thought-provoking point of all this camping: namely, that in the two decades in American art which preceded the Stonewall riots, discussions of sexuality, *and particularly of homosexuality*, were habitually bracketed off into "lesser," quotidian modes of communicative activity, positioned as outside the circuits of art critical meaning and exchange.[4] Since these two decades roughly comprise the historical moment which I focus on in this book, I shall therefore be keen to explore the consequences of these discursive practices — which, as we shall see, are not strictly speaking limited to gossip — for reconsidering questions of sexuality, and particularly, of homosexuality, within the history of art of this time. For even if art history *has* been customarily interested in tales of artists' intimate lives, it has been largely afflicted

by a heterosexism which has admitted only stories about normative masculinity as legitimate artistic narratives. "Vitamin G," on the other hand, insofar as it gives over much space to scandalous tales about male homosexuality, not only demonstrates the historical importance of gossip in disseminating "knowledge" about same-sex sexuality in the art world of the fifties and sixties, but it also suggests how we might usefully attend to the informal traditions of everyday talk in writing historically of the art that came out of it.

Therefore what I do in this book is explore the consequences of approaching gossip—both as object of study and as form of knowledge—for producing queer understandings of the art and artists of this period. Inevitably, as I cast my attention to such a widely derogated form of communication, I flirt with the dangers of not being taken seriously by the guardians of those who would claim to know the value of "proper" historical work. But this risk is the lot of almost anyone who writes historically of homosexuality, regardless of the methodology employed. Indeed to speak or write of homosexuality *at all* is to run the risk of being taken as a gossip. Given that historical events have conspired to make homosexuality a subject of scandal, then gossip, as that "low" discursive practice drawn to scandalous subjects, has come to enjoy a peculiar affinity with homosexuality. Certainly, as I will argue in what follows, in the contexts of U.S. culture in the 1950s and 1960s, to speak of an artist's homosexuality was to be seen as engaging in a slanderous mode of address which was inconsistent with the job of art critical evaluation. This is borne out by Giorno's recollection that "what I did [in "Vitamin G"] freaked everyone out . . . They said I was ruthless and malicious . . . Actually people started hating me" (G 159). This attribution of harmful or mischievous intent to the speaking of homosexuality in the late sixties is also echoed in more recent times. As I write, in the United States, referring to someone as gay might still be considered as a defamatory, prosecutable activity—despite a recent ruling to the contrary—and art historical inquiries into homosexual meaning viewed as inappropriate invasions of the artist's privacy.[5] Thus simply engaging in a historical study of homosexuality is to risk being seen as motivated by a malicious, or political intent (the two are not necessarily inseparable), rather than working in the disinterested pursuit of historical truth. This means that any academic inquiry into matters queer is in danger of being considered a questionable form of scholarship, tainted by the presumed tendentiousness of those who speak and write about it.[6]

As a response to this, lesbian and gay scholars writing on American art of the 1950s and 1960s have worked hard to counter such assumptions by making readings of homosexuality in art which have marshaled all the apparatus of positivist historical interpretation. This is in order to *prove* that homosexual meaning in art history amounts to something more than the willful projection of gay activists or the malicious fictions of inveterate scandal-mongers. Scholars including Jonathan Katz, Richard Meyer, Kenneth Silver, Jonathan Weinberg, and others have produced important and scholarly work which has researched the historically specific contexts in which gay artists have operated, and have utilized such research in making careful and nuanced readings of gay identity in art.[7] Such accounts tend to deploy a mixture of biographical and iconographical analysis in making such gay subjects belatedly present, both to the contemporary viewer of the works of art in question, as well as within the disciplinary narratives of the art historical record.

In most of these studies, the gay artist is appealed to as the "truth" of the work's meaning, the paintings themselves cast as confessional texts which speak of their maker's gay subjectivity in hidden or coded language. For Silver, author of a pioneering essay on gay identity and Pop art, "disclosure" is the preferred metaphor here, implying that the hermeneutic job at hand is one of unearthing, of making visible what is hidden, of making the silenced gay self "speak." According to Silver, "only an intense voyage inward, along a rather tortuous path" will reveal the gay significance of the gay artist's work. "In a sense, this movement inward rehearses the dynamics of closeted behavior, the result being that traditional art historical exegesis—the investigator's journey into the work's meaning, the revealing of 'hidden' or buried signification—bears an unfortunate but necessary relationship to 'outing'" (183).

Although I am in sympathy with such interpretive maneuvers, especially insofar as they redress the heterosexist exclusions of much historical work on these artists, I want to shift my attention slightly and foreground that which has remained as unexamined background to work of this kind: namely, the role played by gossip in keeping the (presumed) homosexual identity of artists from this period *in discursive play*. I am interested in how gossip, and other informal modes of talk, perpetuate narratives of artists' sexual lives which fail to be resolved as truth or falsity. Gay art history has more commonly been concerned with the actual "facts" of who was or wasn't gay, and

how homosexuality has entered the artist's work in overt or covert forms. As such it has, like much work on the history of homosexuality, been dogged by the relative paucity of sexual evidence. This may be due to the lack of available testimony from (still) closeted artists and critics and/or the absence of recognizable markers of homosexuality in works of art made at a time of acute homophobia and historical repression. What I want to propose, however, is that rather than lamenting this lack of hard evidence as something which undermines the securing of iconographic meaning in works of art, we might explore the sexual uncertainties which proliferate around such scenes of sexual interpretation *as discursive phenomena in their own right.* That is, insofar as the homosexuality of this era comes to be the subject of rumor and suspicion both for the art-world gossips in New York *then*, and for contemporary historians *now*, I take the practices of gossip and rumor-mongering *as fundamental to its very representational construction.*

What I ask in this book, then, is: How do "revelations" about homosexuality in the postwar New York art world, when passed around as gossip and rumor, come to affect the public visibility of artists' bodies and the meanings that we might attach to their works? Moreover, and getting to the epistemological heart of my project, how might the circulation of gossipy fictions perpetuate a *queer* knowledge of (homo)sexuality, one that, as Heidegger would say, "perverts" the very act of disclosing itself.[8]

In addressing these epistemological questions, I explore what Ralph Rosnow and Gary Alan Fine in a useful social scientific study from 1976 call the "suspect evidence" provided by gossip and rumor.[9] Although writing largely about rumor, they suggest that what such forms of hearsay provide is, by most standards of academic or authoritative discourse, "nonnormative" or "deviant" forms of evidence — that is to say, evidence which remains unverified by some authorized body or mode of validation. Rosnow's and Fine's turns of phrase are suggestive of what I take to be gossip's and rumor's decidedly *queer* epistemic status. This might be seen to reside in the peculiar condition of the knowledge they provide as it refuses to abide by the conventional rules of truth or falsity by which we normally assess the value of information. Rosnow and Fine go on to make some distinctions between gossip and rumor on this issue, namely, that the content of the former *may or may not* be a known fact, whereas the basis of rumor is *always* unsubstantiated. This is because the definition of a rumor resides in its status as an unverified story. Rumors which later turn out to be "true" *cease* to be rumors once their informational content becomes recognized as official truth. Gossip, on the other hand, as a form of witnessed knowledge, is often taken by aca-

demics as being only as unreliable as the person conveying the information, and, by definition, it is not *necessarily* unsubstantiated. Further it is hard to dismiss gossip as mere whim or simple untruth because it's "unwritten law," to quote David Ehrenstein, is that "where there's smoke, there's fire," suggesting that even if gossip gets some things slightly skewed, it nevertheless contains some kernel of truth.[10]

And it is this idea of gossip as failing to abide by true/false binaries which concerns me here. Following S. I. Salamensky's recent writings on talk, I am interested in how gossip, even though "unreliable," can nevertheless be seen to *bear witness*, to act as *trace* of some historical real—or some event, act, or identity.[11] To this degree I am also indebted to the work of Irit Rogoff, who has argued for a recognition of gossip as a form of "postmodern testimony." In a still highly suggestive essay, Rogoff suggests that gossip's postmodernism resides in its express acknowledgment of its author's and audience's curiosities in fashioning and sustaining its sensational stories.[12] It is a form of discourse, therefore, which departs from the protocols of historical realism since it foregrounds that which is "evidenced" as phantasmatic projection of the particular communities which entertain it.[13] I therefore want to follow on from these authors in holding onto the idea of gossip as trace and evidence in order to *queer the very ways in which we might think of the evidential.* Thus I am concerned with gossip's testimonial power to make evident that which could not been seen, which was not clear, and which was not disclosable—to consider the evidence of gossip's conventionally *non*evidential meanings.

This leads me into murky epistemological waters indeed. By adding in gossip to the category of evidence, by allowing it to supplement the "hard facts" of history, I offer a rethinking of the evidential which deconstructs the bases of authoritative constructs of truth. This I do by allowing the *dangerously* supplemental nature of gossip to displace so-called verifiable truths from their more positivistic frames of reference and to render them instead, like gossip's narratives, as projections of interpretive desire and curiosity.[14] In this way I bring the sometimes luminous and racy narratives of gossip's "hard core" into play with the realm of "hard" facts in a bid to pay heed to (homo)sexuality's disruptive effects on evidential discourse.

And I do so in relation to both gossip *and* rumor about homosexuality, since I am not overly concerned with establishing differences between them. Gossip is often distinguished from rumor by its focus on supposedly trivial personal occurrences, and it is particularly associated with sexual intrigue, whereas rumor is usually associated with important public events.[15] In this

book, however, I will focus on the ways in which the subject of homosexuality was taken to be *both* a subject of national importance *and* one of personal, intimate discourse about friends and social familiars. In this way I will court the abiding tendency of rumor and gossip to blur and overlap and, since I am not in the business of making a social-science study, I shall not worry overmuch about policing the boundaries between them. Indeed, their ready confusion might signal another queer dimension of these modes of everyday information exchange as they resist the taxonomic attentions of academic study. Rosnow and Fine call information which is neither easily classifiable as gossip or rumor, but seems more a mixture of the two, to be "androgynous hearsay." Thus I will underline the degree to which gossip and rumor can often be seen as synonymous and, as practices of information or disinformation, can be seen as almost interchangeable in the degree to which they are frequently looked down upon as being of little positive social or epistemological value.

Further, I should also say that my interest is not strictly limited to forms of *actual* hearsay, to things *voiced* in everyday talk. My focus on the phantasmatic dimensions of gossip also leads me to consider those identifications and suspicions *not* spoken of, ones which might have remained as unarticulated thought but which nevertheless can be credited with animating the sexual meanings of art and artists in the period under review. In short, this book adopts gossip as its overarching metaphor for the various forms of unofficial meaning, and the identificatory practices which sustain them, which I explore in relation to the public visibilities of the New York art world.

Insofar as I am hoping to reappraise such degraded forms of meaning here, I hope to bring about a *queer* turn in the writing of art history. Queer in the sense that what I am interested in here is no simple revalorizing of gossip as good but rather—as with the resignification of the term *queer* by 1990s queer activism—an intentioned embrace of some of the things that are customarily taken to be bad about it: namely, its unreliability as a source of knowledge and truth. In approaching the uncertainties of gossip and rumor as testament to those meanings unspoken within the circuits of so-called official criticism, I do so not in order to simply invoke it as additional, or one could say alternative, archival material. Indeed I hope instead to experiment with writing a history which works against the very logic of conventional, archivally sanctioned historical practice. Giorno's column is important in reminding us of the ways in which sexual meanings, as they circulate within the unconfirmed reports of everyday talk, consistently appear in discourses which have less rigorous standards of corroboration than those we

normally associate with academic inquiry. In exploring the challenges that gossip presents to "evidentiary" understandings of sexuality then, I will address head-on the vexing problem of the limits of our knowledge of intimate life, and how the epistemological uncertainties which come to attend the subject of sexuality might come to affect the status of interpretative discourse, of history, and of the history of art.

To put it another way, this book consists of two chief strands of argumentation and exploration. The first considers gossip's role *in* history, approaching it as an important mode of communication for disseminating queer meanings in the 1950s and 1960s art world. The second entails a consideration of how gossip's narratives might operate *as* history, and how such unverified forms of knowledge might come to *queer* the very practice of historical accounting itself. These two aspects I shall now outline successively, and in more detail.

SUSPECT SEXUALITIES: 1948 TO 1963

I open the period of my study in 1948, the date of publication of Alfred Kinsey's report on male sexual behavior, and close it around 1963, the time of an increased concern in the popular press with the growth of so-called overt homosexuality in America's cities. This historical span broadly encompasses a period of popular concern about the incidence of male homosexuality in American society, one exacerbated by a concomitant crisis of the conventional means by which gay men were habitually identified and distinguished from their straight brethren. As a consequence of Kinsey's findings, I will argue, male homosexuality was not only taken to be much more widespread than had previously been thought, but it was also deemed to be hard to identify by attention to outward forms of masculine appearance alone. This caused much trouble for cultural structures of sexual differentiation which had hitherto put great store by the male body's capacities for evidencing sexual identity. For instance, the lack of reliable methods of visible "detection" proved a hindrance to, and was the cause of much anxiety for, the leaders of the McCarthyite witch hunts, who, in the early years of the 1950s, were attempting to purge homosexuals from government employment. For if homosexuality weren't readily evident on the body, how were gay men to be identified and ejected from their supposed positions of power and influence? How could the (homophobic) job of the state be carried out?

It is such widespread anxieties and uncertainties that comprise what I call

a culture of homosexual suspicion which came to attend male sexuality at this time. I consider how, in the absence of reliable evidence of sexual orientation—such as that provided hitherto by the visible codes of bodily comportment—even ostensibly "normal" forms of masculine appearance come to be haunted by the fears and fantasies of a supposedly insidious homosexuality "at large" within American society. Indeed my point here is to explore how the representation of masculinity *itself* comes to be culturally fraught at this time, especially as a result of sexual doubts entertained about the American male's sex life at various levels of postwar culture in the fifties and sixties.

My argument is that this kind of sexual suspicion was so endemic to cold war culture in America that it contrived to make the practices of gossip and rumor particularly apposite as discursive resources for addressing the subject of male sexuality. Certainly, McCarthyism, insofar as it was responsible for making federal employees the subject of a "hermeneutics of suspicion," gave rise to the proliferation of homophobic rumor about homosexuals working surreptitiously to undermine the American state.[16] In chapter 1, I will explore, for instance, how innuendo and suggestion, as well as rumors about masculine sexuality, come to pervade mainstream American culture in the 1950s and 1960s as a result of the popular reception of Kinsey's findings and the deep penetration of McCarthyite attitudes.

But it is perhaps the Hollywood gossip columns, which reached new levels of mass distribution and sensationalistic reporting in the 1950s and 1960s, where we can see how the culture of homosexual suspicion came to take a broader hold within the fabric of American society, expanding well beyond the narrow confines of political culture. Prewar gossip columnists such as Walter Winchell had given way by the early fifties to a whole industry of low-grade scandal rags with titles such as *Confidential*, *Tip-Off*, *Hush-Hush*, *Exposed*, and *Whisper*.[17] The bread-and-butter business of such publications was exposing "dirt" on Hollywood stars and celebrities, much of which formed "scoops" on the homosexual lives of figures such as Tab Hunter, Noel Coward, Johnny Ray, Marlene Dietrich, and Greta Garbo. According to Ehrenstein, in his highly readable account of this era of sensationalist reporting, such publications "relied for the most part on sources viewed by traditional journalists as 'unverifiable': waiters, hat-check girls, bouncers, bell-hops, private eyes, and prostitutes of both sexes" (90). As such these publications stand as testament to the growing public appetite for gossip and rumor in America in the 1950s and early 1960s, and particularly for dubious and titillating stories about the troublesome subject of homosexuality.

But even if Hollywood was the chief focus for the gossip industry at this time, such discursive attentions were also meted out to those in the arts more generally. McCarthyism, especially through the blacklisting activities of the House Committee on Un-American Activities, cast suspicion over the sexuality, and therefore the patriotic commitment, of many different types of cultural workers at the time: from film and theater directors, to artists, novelists, poets, and musicians. In chapter 1, after mapping out the development of a culture of homosexual suspicion in some detail, I will focus my attention largely on the world of fine art and consider how, as a result of fairly embedded assumptions about the effeminacy of artistic activity, the art world became the subject of phobic suspicions about the large numbers of homosexuals it supposedly harbored within its midst. Such rumors were fueled by McCarthyism's popular prejudicial agenda which attacked all elites, and especially ones removed from the tenor of everyday life, in the name of a heavily masculinized construction of the American patriotic body. I will explore how, in the light of these attacks, artistic identity *itself* came to be viewed as suspect in an art world presumed to be dominated by weakly effete male homosexuals.

But not all of the rumors about homosexuality circulating within the art world were necessarily of such homophobic derivation. Less malicious tales were being exchanged about the presumed homosexuality of male artists within avant-garde communities, particularly within the social and discursive networks of queer bohemia. Lesbian and gay artists gossiped about each other and were especially concerned with swapping stories about the presumed homosexuality of artists both contemporary and historically remote. It was through such networks of confidential discursive exchange that queer artists were able to share unofficial knowledge about art and homosexuality, while at the same time building some rudimentary form of sexual identity and community otherwise denied to them by a culture intent on seeing homosexuality as an isolating "affliction." I will therefore explore in chapter 2 how the circulation of gossip about "great" artists, as well as mythologies about the supposed queerness of artistic creativity, might have enabled figures as diverse as the composer Ned Rorem and the artist Jasper Johns to identify themselves as artists in ways that might have resonated with sexual significance.

In my attention to the circulation of gossip in queer artistic circles, my book seeks to revisit the myth which holds that gay men are peculiarly prone to gossiping. This assumption stems from the view that gossip is a specifically feminized mode of communication, and, given the stereotypical construct

of the effeminate gay man, it makes of it a special preserve of gay (as opposed to straight) men. I shall not, however, be concerned to simply argue against such assumptions. This is best left to others who have recently suggested that straight men actually gossip as much, if not more, than gay men and women.[18] Instead I shall concern myself here with making a more modest, historical, and political reappraisal of gay men's gossiping: namely, that gossip, though often dismissed as idle or small talk, was socially important for gay men in the fifties and sixties for conveying information which evaded the discursive taboos around homosexuality afflicting official modes of communication. I will be keen to stress the role it played as an "insider" discourse in the art world at this time, and to see how the identifications entertained within camp and bitchy talk might have been important in sustaining queer artists in the face of the cultural logic of compulsory heterosexuality. In particular, I wish to see how certain identifications of the queerness of artistic activity — which were passed around as gossip about this or that artist — can be seen to have sustained a form of pre-Stonewall queer subjectivity which resisted some of the more abject representations of homosexuality made within the homophobic culture at large.[19]

But even more than visiting the social value of gossip for gay men at this time, I want to address how it comes to play an important role in refashioning aesthetic practice. In particular I will stress how gossip's informal and trivializing mode of address comes to be elevated to the status of an artistic expression, particularly within one cross-disciplinary community of practitioners centered on the so-called New York School of poetry. This will form my subject in chapter 3 as I explore the paintings of Larry Rivers and their relation to the vernacular poetry of Frank O'Hara, the central figure of the New York School. This will be an important point in my argument, for it will allow me to consider how something as trivial as gossip comes to be the mode of address which Rivers and others artists such as Joe Brainard and Ray Johnson deploy in producing high art in the fifties and into the early sixties.[20] The downgrading of Larry Rivers's art at the hands of art history to only, at best, a marginal position within the canons of postwar American art is symptomatic, I suggest, of the attitude toward gossip more generally within so-called serious discourse. But rather than simply joining in with the resultant demotion of Rivers's work, I prefer instead to raise the question of the appropriateness of such structures of serious critical appreciation to his art; to ask how we might appreciate it otherwise, outside of such earnest and solemn frameworks of expectation.

Andy Warhol will form the subject of chapter 4, though not, as one might

expect, for his campy valorization of the conversational trivialities trailed between "A" and "B" in his *Philosophy* of 1975, or even for the gossipy interest in the lives of Hollywood stars and celebrities suggested by, say, his *Jackies* or his *Lizes* of the midsixties.[21] Rather I will focus on the building of the Warhol persona in the early 1960s and consider how, like that of any other Hollywood star or celebrity, it was sustained by the private and public circulation of particular kinds of personal information about him in the New York art world. In particular I will focus on how Warhol was seen as too suspect a character to become an artist before 1962, and how his abjection from the world of art was maintained by the circulation of malicious gossip — among both straight and gay bohemians alike — about his flagrant homosexuality. I will then go on to consider how such gossiping subsides in the wake of Warhol's success and how a new regime of talk begins to frame, and construct, him as the now familiar *a*sexual postmodern dandy. The shift will allow me to consider the role of gossip in making and breaking art-world careers and to see how its "insights" might come to be elided or ignored by more art critical and art historical constructions of artistic identity.

I am aware that, given all of the above, the focus in my book is almost exclusively on (gay) male sexuality. Although at various points in what follows I will consider women, as well as men, as purveyors of gossip inside and outside the art world of the time, I rarely consider women artists and their (homo)sexuality as *subjects* of gossipy conversation. I do briefly consider the lesbianism of Nell Blaine in chapter 3, but generally speaking I would contend that gossip about lesbian artists would require a separate study which would need to take into account the very different position of women in the art world and the distinct manner in which the subject of lesbianism was treated, or not treated, in cultural discourses of the time. For example, one would need to look at the generally disadvantageous condition of being a woman artist — gay or straight — in the masculine fifties art world, as well as considering how such a context might have made it, paradoxically, easier for "male" lesbians to live out their sexual identities in avant-garde culture.[22] Also, if we take the publication in 1952 of Kinsey's study on the human female, we can see that it did not generate the same degree of anxious response which greeted his male volume some four years earlier, even though McCarthyism spent perhaps as much time worrying about lesbians in government employment, and particularly in the military, as it did about gay men.[23] This meant that, even though I have no doubt that particular women artists *were* gossiped about within the localized confines of avant-garde society, female sexuality was subject to a different set of social

and discursive dynamics which would require a detailed form of attention beyond the scope of this present study.

This focus on the discursive construction of masculine sexuality explains the peculiar form of historical periodization which I employ in this book. I have already outlined my reasons for choosing 1948—the date of the publication of Kinsey's male report—as the opening moment of my period of study. The year 1963, on the other hand, closes the book's historical frame: the time around which numerous publications in the popular press began to run stories concerned with overt stagings of male homosexuality in American society. The concerns expressed here arose initially as a result of attempts by the New York City authorities to "clean up" the streets in preparation for the World's Fair of 1964.[24] As early as 1963, they had already begun to close down many gay bars as part of this operation, which also ran as a front page story in the *New York Times*: "Growth of Overt Homosexuality in City Provokes Wide Concern."[25] This was followed by a wealth of articles in mainstream magazines, including *Harper's*, *Life*, and *Time*, in the following couple of years which variously evidence a growing recognition of the social problems suggested by a homosexuality clearly visible in American society, whether it be in its "own" bars and restaurants or on the streets.[26] Indeed *Life*'s article "Homosexuality in America," from June 1964, was lavishly illustrated with photographs of "flagrant homosexuals," which purported to make the semiotic coding of gay visibility legible to its presumptively worried readers, for instance, in the sexually significant sartorial codes of tight pants, sneakers, and fluffy sweaters (fig. 1).

This marks a shift from the popular cultural episteme of male sexuality which forms the subject of this book, because its concerns are with the emergence of "obvious" gay male bodies in American society and culture rather than those which appear able to escape detection and definition. This press concern with overt homosexuality, beginning in 1963, also coincides, in the world of art, with the production of the first Warhol films, which, in contrast to his pop paintings and the paintings of, for example, Jasper Johns, can be seen to be concerned with relatively explicit representations of homosexuality.[27] By bracketing off such overt representations outside my historical frame, however, I do not wish to suggest that the problematic condition of homosexual visibility becomes stabilized after 1963, or that its codes can be deemed any more secure than the indeterminate constructions of homosexuality and heterosexuality that form my subject here.[28] Rather, it is simply that at roughly this historical moment there began a gradual transformation of the social and discursive *conditions* of gay male visibility, a transformation

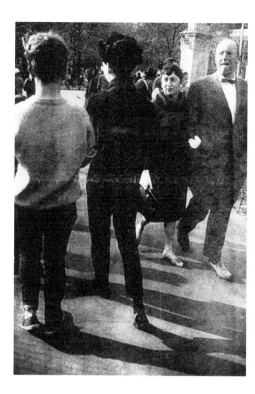

Figure 1. "Homosexuality in America," *Life* magazine, 26 June 1964. © Bill Eppridge–LIFE.

of the terms of the cultural field through which homosexuality is habitually lived and understood—a shift, that is, to notions of homovisibility figured through the metaphor of the closet.[29] This shift would usher in an understanding of homosexuality as that given to shuttle between an explicit "out" form of visibility and a hidden, invisible "in."

Insofar as I'm concerned with considering matters prior to the moment of the emergence of the closet, I will largely avoid using it as interpretative trope, and instead consider the sexual articulations and identifications entertained as gossip and rumor which fail anyway to stabilize within the closet's binary structure of signification.[30] The closet has played a privileged hermeneutic role in much lesbian and gay history, especially to the extent that it has been responsible for generating linear narratives of gay history which turn around the pivotal moment of the Stonewall riots in 1969, moving smoothly and inevitably from pre-Stonewall in to post-Stonewall out.[31] In adopting 1948 and 1963 as the significant framing moments for my inquiry, then, I write about male homosexuality in a way which eschews 1969 as historical turning point and resists its before and after effects upon historical interpretation. This novel periodization of my study allows me to

consider the ways in which the representation of male sexuality comes to be affected by the nonnormative evidence supplied by gossip and rumor, and to consider its effects in ways not reducible to the in/out dynamics of the closet.

WHISPERING IN THE ARCHIVE

In undertaking all of the above, I will make use of various forms of public documentation that attest to the circulation of rumors about artistic sexuality in the period. Some, such as the organs of the mainstream press, will demonstrate the kinds of accusations and denials of homosexuality ritualistically swapped both inside and outside the social and discursive contexts of New York bohemia. Others, such as the early homophile publications *One* and *Mattachine Review*, will allow me to consider the kinds of things that were being said about specific artists and about the "artistic" life in general, within the more localized circuits of queer and avant-garde communities.

But because, by their very definition, rumor and gossip reside in the oral traditions of everyday talk, much of what was said about individual artists' sex lives did not pass into the published discourse of the day, its very raison d'être being to entertain that which could not be articulated in the public realm. Hence I make much use of biographies and autobiographies, as well as interviews with artists, poets, and critics; written or conducted in subsequent, less oppressive times, they are invaluable sources which latterly make public those things kept semiprivate as gossip between intimates at the time.[32] Of course these resources are limited, as some artists still do not wish to talk about such matters, partly perhaps as a consequence of continuing to relate to their sexuality through those identities forged in the repressive contexts of the fifties, or out of fear that their work and their public reputation will be harmed or irrevocably transformed by giving credence to gossipy stories about their sexual lives.

Such limited amounts of documentary evidence therefore makes the business of interpreting the sexual meanings of 1950s and 1960s art extremely problematic, especially for conventional archivally based forms of historical research. This means that another important dimension of this book's work, in addition to considering the destabilizing effects of gossip's knowledge for the meanings of visual art in the period, is to reflect on how historical writing itself might forge an address to the various suspicions which may have circulated around particular bodies and images in the fifties and sixties.

Often, for instance, I trace the sexual identifications which can only be surmised from little more than the largely unwritten suggestion of a particular text or narrative, drawing out the connotations, or the presumed innuendo, that might be implied by the use of this or that particular phrase or word. Thus, in the manner of psychoanalytic inquiry, I am brought to the point of reading symptomatically the manifest documentation that remains, whether in the form of published writings or in the visible signs of works of art, in a bid to evoke those sexual meanings which might have only been imagined, let alone spoken aloud, in the relatively closed communities of the New York art world. I consider not only those things which were said and which we have records of, but also those identifications which, to quote Diana Fuss, failed to "come to light" but which may, nevertheless, have had an important role in animating the sexual affect of various bodies and images in the cultural contexts of America in the fifties and sixties.[33] In retrospectively reimagining such identifications which might have been entertained as (now unrecorded) gossip and rumor, or even as unarticulated thought, I necessarily turn to a speculative form of analysis which brings me close to the limits of conventional archival procedures for producing historical knowledge.

As Jacques Derrida has already argued in his 1995 book *Archive Fever*, psychoanalysis has necessarily engendered a different way of thinking about what it might mean to undertake archival work, especially insofar as it addresses itself to those unconscious phenomena which, by dint of their nature, do not become manifest as such in the conscious, public world of human utterance and discourse.[34] "Freud's intention," Derrida writes, was "to analyze, across the apparent absence of memory and of archive, all kinds of symptoms, signs, figures, metaphors, and metonymies that attest, at least virtually, an archival documentation where the 'ordinary historian' identifies none" (64). Thus, psychoanalysis, in reading the apparent absences within the archival record as significant—as symptomatic of some repression, as pregnant with psychodynamic meaning—has provided us with an interpretative legacy which can no longer remain satisfied with the horizon of meanings recuperable through a conventional attention to the archival record: of books, papers, images, and other avowedly important documents.

However, in motioning beyond the boundaries of conventionally founded modes of historical inquiry, what I am interested in exploring in this book is less an alternative model of professional interpretation (i.e., psychoanalysis) but rather the degree to which in writing about historical discourses of artistic sexuality, I come to be drawn along by my own distinctly *less profession-*

alized, and perhaps less academically defensible, curiosities and suspicions about my subject. In particular, I am interested in how my own discourse of interpretation — especially when faced with a lack of so-called appropriate evidence — often leads me into the realms of what might be construed as more idle speculation about the sexuality, and the sexual meanings, attributable to my chosen artists and artworks. Certainly, after working on this material now for over ten years, I have become accustomed to sharing these curiosities with others by gossiping about this or that artist with friends and colleagues working in similar fields, becoming acutely aware in the process of the importance of gossip in filling in the gaps left by the lack of documentary evidence and defensible argumentation. This is not just to reflect on the significance of gossip to a small number of specialist academics working in the field of queer art history but to ask what it might be like to admit such speculations *into* the discourse of art history itself, rather than leaving it bracketed off as the marginalia of history "proper." I do this in order to explore what it might be like to pay heed to the uncertain sexual meanings of the bodies and images which I analyze *as they register upon the body of this book*; as they elude the scene of my writing and its critical capacities to hold them in check.

As S. I. Salamensky has argued, gossip, as vocal performance, "leaves no permanent trace, no residue, no record of its brief existence or content."[35] Drawing upon Peggy Phelan's theorization of the "unmarked" nature of performance, she goes on to draw our attention to the real difficulties gossip offers up to economies of reproduction, including the archivally based ones of knowledge production. Gossip is invariably *un*recorded as cultural document, and it is preserved instead within a chain of individual speech acts; in the telling and retelling of certain stories as they are urgently swapped from one to another. But this mode of information preservation is one which departs sharply from archival protocols. For, as Salamensky puts it, "no retelling will be identical in form, and thus content, to the originary instance" (27). As one gossips, then, one therefore participates in a *viral* economy of communication, proliferating information while keeping authoritative "truth" forever stalled by means of the various mutations of narrative content and emphasis. Gossip's informational economy is therefore unlike the disembodied, text-based *episteme* of the archive because it relies on an expressly performed, "body-to-body transmission."[36] This *performative* character of gossip should not lead us to think, as some might suggest, that gossip has no epistemological value.[37] Rather it should alert us to the ways in which gossip's knowledges are differentially constituted, drawing their authority

from the dynamics of intersubjective exchange rather than any fidelity to the document.

In what follows, I sometimes, of necessity, import such a viral practice of repetition into the pages of my analysis, thus foregrounding the performative dimensions of my own historical discourse. For instance, in chapter 2, I spend much time speculating on the content of things that *might* have been said between queers in New York bohemia, with relatively little consideration given to the reproduction of actual individual speech acts themselves. Thus the chapter approaches the interactions of everyday talk as something beyond its documentary grasp, but nevertheless strives to (re)stage and (re)imagine the effect of what *could* have been said on artists' self-understanding. So when writing this way in the relative absence of evidentiary remains of specific, now long forgotten acts of speech, I come to write sexuality, *pace* Foucault, as something other than an object of professional knowledge. This allows me to drag the conventionally *constative* utterances of history, concerned primarily with questions of verifiability and truth, into the same "swamp of assessment and judgement" in which the speech-act philosopher himself, J. L. Austin, drags philosophy's "fetish of the true and the false—namely into the realm of the communicative *act*."[38]

This tension between the constative and performative dimensions of my discourse is played out throughout the whole of the book but surfaces differently in each chapter. Chapters 1 and 4 err more on the side of the constative in exploring the circulation of rumors, suspicions, and gossip about male homosexuality in the American art world of the fifties and sixties, while chapters 2, 3, and 5—though constative in some large part—explore perhaps more explicitly the performative enactment of my hermeneutic curiosities and pleasures.

In chapter 3 this takes the form of the blurring of my "academic" pleasures in researching the life and work of Larry Rivers with those of the interested gossip, as I respond to the invitation offered by both his paintings and his writings to join him in a gossipy economy of intimate exchange. In chapter 5, I mobilize an explicitly performative aspect of my inquiry by writing toward the silence which attends the effective censoring of a Jasper Johns painting, *Target with Plaster Casts*, in 1958. In asking why this painting might have been troublesome to its initial viewers, I amass much archival evidence, but, in pointing to the limitations of such evidence and the continuing pull of my curiosity, I also incorporate into my text another parallel set of narratives which, in mimicking the sensationalist narratives of pulp novels, allow me to entertain some of my more "idle" fantasies in a fictional form unhin-

dered by the burden of historical proof. In this way, the chapter motions beyond the boundaries of conventional historical inquiry—and its limited forms of "hard" evidence—by gossiping, so to speak, about those possible causes and meanings which might otherwise remain omitted from the art historical record.

This turn toward a more embodied mode of discursive address, bringing my own desiring body into the frame of academic writing, demonstrates how the practice of gossiping comes to recast the undertaking of historical inquiry. The, one might say, improper avowal of my desires and pleasures as interested gossip within the pages of an academic, art-history study introduces an uneasy tension into this book: namely, between gossip's expressly intersubjective and informal mode of address and history's impersonal formality, as well as between the former's "unsubstantiated" stories and the archivally sanctioned "facts" of history. My aim here is to complicate the modes of address by which academic study might go about attending to the history of sexuality—especially to the extent that the subject of sexuality itself appears to have an abiding tendency to challenge history's logic of documentary evidence.[39]

If all of this places the book in an experimental relation to the discourse of history in general, then it also raises methodological questions about the interpretative procedures of *art* history in particular.[40] For rather than reading the iconographic signs which might be deemed to make sexuality "evident" in a work of art, as much lesbian and gay art history has done, I pay heed in what follows to those meanings which exist, as it were, *to the side* of the image; ones which refuse to stabilize as visible sign but which nevertheless come to animate its significance or affect. I will therefore analyze specific artworks as they come to be articulated amidst the trafficking of gossip's discursive flows in order to better comprehend how the sexual meanings of visual art may not be, strictly speaking, *visible* at all and instead reside in the things whispered about, but not made manifest in, this or that particular body or image.

And since it is invariably bodies that are gossiped about, as opposed to objects, "the body" will form an important focus for my attentions alongside artworks. Drawing on the work of Judith Butler, I take it as axiomatic that any discourse of subjectivity is also a discourse of bodies, since the constitution of the subject is as a bounded entity, constrained within an imaginary structure of embodiment which Butler refers to as a "bodily ego" or "imaginary morphology."[41] Further, the very establishment of an imaginary bounding of the body, she writes, "is not a pre-social or pre-symbolic

operation, but is itself orchestrated through the regulatory schemas that produce intelligible morphological possibilities. These regulatory schemas are not timeless structures, but historically revisable criteria of intelligibility which produce and vanquish bodies that matter" (13–14). Thus bodies are produced contingently through historically specific constructs, through the shifting "criteria of intelligibility" which effectively determine what comes to be recognized as the body's materiality. But, crucially, the bodies which come to materialize in this way—and which come to materialize *in the field of vision*—only come to be so by dint of that which such criteria of intelligibility exclude, leaving in their wake rejected identifications with *im*material bodies, bodies which, in the pages that follow, are explored in the unofficial economies of meaning of gossip, rumor, and suspicion. Thus I explore the ways in which rejected or disavowed identifications come to haunt and contest the representational coherence of the male body within the cultural contexts of the period and, in the process, come to disrupt the seemingly *self*-evident meanings of the visible body.

This troubling of the evidence of the visible—of the body, of the work of art—is, in the end, my critical response to the legacy of some of the artists explored in this book who have explored the value of nonevidential evidence. For some, and most notably Warhol, the contingent meanings that might be attached to the artist's body come to be the materials worked with in constructing the artistic persona, whereas for others, such as Rivers and O'Hara, the work of art comes to be refashioned precisely through an attention to the marginalia of serious discourse. Thus, in writing this book in a kind of skewed relation to the object-based attentions of art history—in analyzing, and telling, and retelling various tales about homosexuality in American art—I set out to pay heed to these artists' investments in the power and pleasures of everyday talk, and to what such talk tells us about the limitations of our knowledge of sexuality, and of the sexual lives of others.

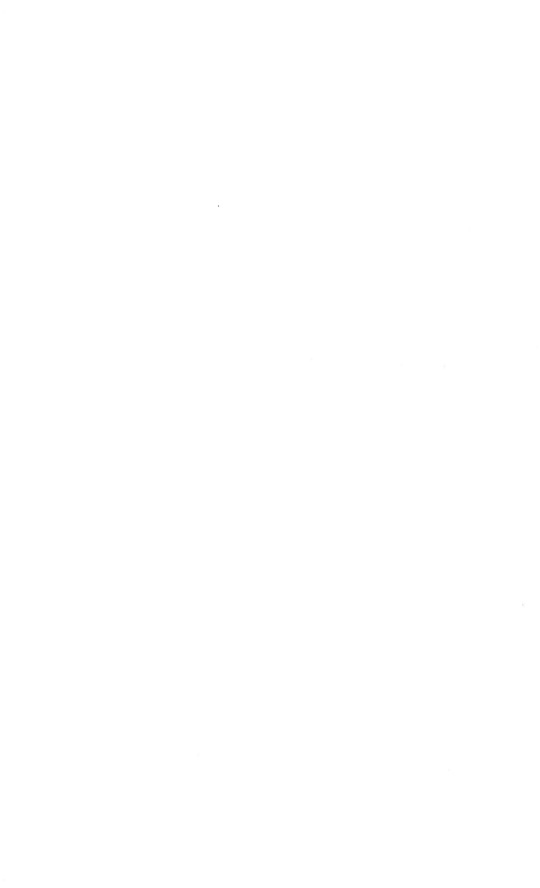

THE AMERICAN ARTIST

IN A WORLD OF

SUSPICION

In an article published in *The Saturday Review of Literature* in 1951, entitled "What's Holding Back American Art?" the artist Thomas Hart Benton provides a downbeat assessment of the condition of postwar U.S. art.[1] In part a lament for the waning influence of the Regionalist school of painting, of which he was the most public proponent in the 1930s, it tells the story of an art world tragically diverted from the task of producing an "American" art for the American people. Tragic because, for Benton, not only had his two chief compatriots in the Regionalist project, Grant Wood and John Steuart Curry, recently died, but, by 1951, support for the idea of a popular nationalistic art was dying out with them. Younger artists were no longer interested in making heroic images of laboring men toiling with a mythologized American land, nor were they concerned with making an art that would have mass appeal. Instead, Benton writes, they were increasingly drawn away from the "living world of active men and women into an academic world of empty pattern" (9). This "world," pejoratively invoked by Benton here, was that of modernist art—one in which the narrow Americanisms of the prewar years had no place, and in which the values of a certain kind of internationalism had come to hold sway.[2]

But in setting out his views in the *Saturday Review*, Benton does more than simply lament the passing of artistic fashion. He also elaborates a dramatic tale of art-world intrigue that purports to explain this shift in artistic priorities. Vividly evoking a profession held in the yoke of powerful and malignant forces, he ventures that modernism's rise, and Regionalism's concomitant fall, had been brought about by the concerted efforts of a few "cult-

ist groups" and their "disciples" working to control the direction of American art.[3] Led by the Museum of Modern Art in New York, Benton contends that various art professionals—including museum directors, curators, critics, and teachers—were working in concert to actively discredit the values of Regionalism and promote modernist art in its place. "Coteries of highbrows, of critics, college art professors, and museum boys," he writes, "the tastes of which had been thoroughly conditioned by the new esthetics of twentieth century Paris," were involved in a conspiracy to undermine American art in favor of securing the widespread acceptance of elitist, imported alternatives.[4] Modernism—invoked here as a distinctly foreign, European phenomenon—was simply being imposed upon the American art-world by means of the stealth and duplicity of its chief defenders. By readily accepting modernist values and priorities, young artists were doing little more, Benton suggests, than colluding unwittingly in a sustained campaign to erode American art from within.

As we shall see during the course of this chapter, similar kinds of conspiracy theories were common currency in American culture during the early fifties. In many ways Benton's assessment of the postwar art world here can be seen to typify McCarthyite concerns with rooting out an anti-Americanism presumed to be rampant within the nation's governmental and cultural agencies. But what concerns me here at the outset is how, in referring to the architects of this supposed conspiracy, Benton's fondness for vituperative innuendoes, such as "museum boys" and elsewhere "ivory tower boys," leaves us in little doubt about the more profoundly *sexual* basis of this institutional conniving. The use of the word *boys* here refers elliptically to homosexuality by suggesting "nancy-boys" and "sissy-boys," the most widely used terms to denote gay men at the time.[5] It is clearly intended to suggest the prevalence of gay men among the communities of America's museum curators and other art professionals. In addition, the word conjures up the objects of desire supposedly favored by these men, and it suggests a pederastic core at the heart of their attempts to influence young artists. Benton worries that gay men will turn young artists away from the world of "active men and women" toward the supposedly empty patterning of avant-garde art and in the process create a generation of effeminate and ineffectual, if not homosexual, artists. Drawing on the rich and allusive power of suggestion, Benton works to make his readers share this worry by imagining an art-world conspiracy profoundly motivated by a deviant, predatory dynamic; viewing modernist art as a kind of European homosexual sensibility being schooled into young artists by their pseudo-Wildean elders.

The stark outline of a gay conspiracy here will likely strike present-day readers as absurd, and, for those familiar with Benton's near legendary chauvinism and homophobia, as simply the paranoid imaginings of an arch reactionary.[6] This was also the view of many of Benton's own contemporaries who, by the early 1950s, had come to be largely incredulous of his prejudicial and abusive agenda. Cut off by the turn in the artistic tide, his regressive and provincial tendencies were paid scant serious attention by a generation of artists engaged in debates about "advanced" modernist art. Speaking perhaps for many in the art world at this time, the art critic James Thrall Soby dismisses much of Benton's diagnosis of American art as absurd invective. Writing in the same edition of the *Saturday Review*, Soby belittles the artist's argument on numerous counts, parrying it point by point with the "facts" to the contrary, including those to counter the accusations of homosexuality in high places: "That there have been a few homosexuals on the staffs of American museums no one can fairly deny. But they have been and are vastly outnumbered by normal men. Indeed, I can't think of a single major art museum in this country whose director's sex life is open to Mr. Benton's innuendo."[7] Soby hereby attempts to put an end to the idea of a gay conspiracy by denying any actual basis for it in reality. Benton's assertions of an art world overrun with gay men simply do not square, Soby contends, with the reality of a situation in which "normal" men outnumber them. And, of the most influential positions in the museum world, Soby confidently asserts, none are taken up by gay men.

Soby was a much more respected figure than Benton in the avant-garde circles of the early 1950s. He had written important catalogue essays and books on various modern artists throughout the 1930s and 1940s, and he was assistant director at the Museum of Modern Art in New York.[8] But even though spoken from a more socially and institutionally sanctified position than Benton, Soby's denials, I want to suggest, and others like it in American culture in the ensuing years, did little to curtail the growing suspicions about the prevalence of homosexuality in the American art world. Such suspicions were not consigned to the overactive imagination of a single virulent homophobe by dint of the simple and sober assertion of fact. On the contrary, what I want to suggest in the course of this chapter is that in the context of widespread popular anxieties about the presence of homosexuality more generally within American society, "facts" began to look increasingly dubious as any kind of ground for establishing the final word on matters sexual.

I am therefore not interested here in latterly adjudicating the sociologi-

cal truth or otherwise of Benton's and Soby's competing claims. I am not interested in prioritizing one account over the other, but rather in comprehending the *effect* that such claims and counterclaims had in terms of the production of what I want to call a culture of homosexual suspicion. The dialogue between Benton and Soby might be seen as part of the fabric of a culture in which homosexuality was brought into discourse as an object of epistemological *doubt*; in which it was discursively constituted, by turns, as being both everywhere and nowhere.[9] This is because the idea of widespread homosexuality in the art world was productively *kept alive* through the dynamic of assertion and counterassertion, of avowal and disavowal, which characterizes Benton's and Soby's dialogue in the *Review*.

But why should it be so difficult, for example, to believe in the truth of Soby's account? And why should such luminous accounts of deviancy in the art world be difficult to shrug off, especially when perpetuated by such a discredited figure as Benton? A further homophobic attack penned by Benton for his autobiography *An Artist in America*, reissued almost simultaneously with the publication of his *Review* article in December 1951, begins to suggest some possible answers to these questions.[10]

Spinning a line not dissimilar to the *Review* piece, Benton attacks the deleterious influence exerted by a "concentrated flow of aesthetic minded homosexuals into the various fields of artistic practice" in America's major cities (*A* 264). These men are described by Benton as being "for the most part, of the gentle feminine type with predilections for the curving wrist and outthrust hip" (*A* 265). They have "lisping voice[s] and mincing ways," and "specially conditioned psychologies" which render them weak and ill equipped to judge work dealing with the rough and tumble of everyday life (*A* 266). Graphically delineated for the purposes here of vilification, Benton's phobic imagination conjures a group of deviant men conspicuous by their effete bodily deportments and mannerisms. Not only do they have "predilections for the curving wrist and outthrust hip," but they also exhibit a "swing in (their) gait," "extraordinary manners," and a "simple preponderance of feminine characteristics" (*A* 265). In drawing attention to the homosexual's identifiable bodily features in this manner, Benton trades on the idea of (his) sexuality as a phenomenon evidently marked on the visible body. The coding of bodily styles—whether the turn of a wrist, or the swish of a hip—betrays the sexual identities of such men as familiar and stereotypical "fairies."

The faith that Benton places here in the truths revealed by bodily appearance was central to the project of much figurative painting in the 1930s, including his own. Regionalist painting, in its bid to make American society

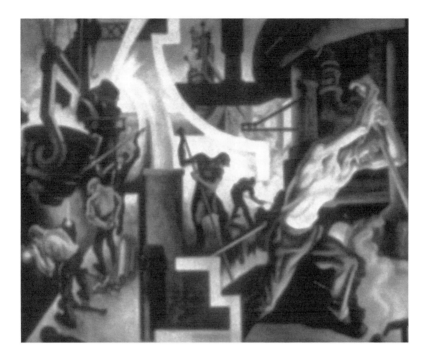

Figure 2. Thomas Hart Benton, *Steel*, egg tempera and distemper on linen, 1930–1931. New School for Social Research, New York. © T. H. Benton and R. P. Benton Testamentary Trusts/VAGA, New York/DACS, London 2001.

comprehensible to a popular audience, laid great emphasis on the ready legibility of social types through the codings of bodily appearance. From the muscled torso and heroic pose of a dramatically lit steelworker (fig. 2), to the city broker identifiable by his suit and ticker tape machine (fig. 3), such painting demonstrated a profound attachment to the truth-telling capacities of the visible body. The realities of American life were given visual form through a stereotyped taxonomy of socially marked bodies which, as Erika Doss has noted, Benton derived at least in part from his experiences of working in Hollywood.[11] The ready recognizability of social types common in Hollywood cinema was a feature that Benton worked to emulate in his painting as part of his bid to make it comprehensible to a popular audience. The graphic descriptions of the art world's mincing characters in his autobiography, as well as the sissy boys suggested by the *Review* article, might be productively understood as part of just such an economy of populist representation.[12] Immediately recognizable, because dramatically different from such

Figure 3. Thomas Hart Benton, *City Activities*, egg tempera and distemper on linen mounted on panels, 1930–1931. New School for Social Research, New York. © T. H. Benton and R. P. Benton Testamentary Trusts/VAGA, New York/DACS, London 2001.

iconic images of male normalcy as Benton's muscled and macho laborers, such descriptions sought to view homosexuality as identifiable by, and contained within, particular forms of deviant embodiment.

But buried amongst the torrent of Benton's homophobic accusation and stereotyping is something important in terms of the argument of this book. For even as Benton graphically delineates the registers of effete visibility through which gay men in the arts were identifiable, he paradoxically, at the same time, suggests that the insidious nature of their influence stems from their ability to "attain their positions by ingratiation or subtle connivance" and to "pass" unnoticed (*A* 265). Not only does this suggest a social agency seemingly at odds with their stereotypically effete and passive condition, but it also suggests the homosexual's ability to exceed or transcend his essentially feminized frame of appearance. Thus Benton performs a double move, insisting on the conspicuous visibility, and simultaneous *in*visibility, of gay men in art and society. This invisibility was, according to him, achieved by the willful deceptions practiced by gay men in order to hide their sexuality; their fondness for what he calls "obscurity" and "devious and indistinct meanings" being a clear indication of their fundamentally duplicitous nature.[13]

Benton's recognition here of an elusive homosexual agency evidences a troubling awareness on his part of the uncertainties attending the visually codifiable aspects of male identity. For if a gay man could pass in the art world unnoticed and unmarked as such, dissimulated as his normative heterosexual other, then what of the available resources for telling "straight" from "gay"?[14] How, or to put it more profoundly, *could* one tell the difference at all? And if one *couldn't* tell the difference, then what, for instance, might one think about Soby, and of the authority of his denials of homosexuality in the arts? If distinguishing between gay and straight was now something of a vexed problem, then what would stop us from fancifully (and phobically?) construing Soby as one of Benton's duplicitous queer types, and approaching his denials as simply the motivated and distorted "untruths" perpetuated by a gay conspiracy?

In the context of such unruly suspicions, it is not only Benton's account of homosexuality in the arts that might appear as motivated by political interests. If Benton's accusations could easily be construed as driven by his chauvinistic politics, then given the possible, though by no means provable, ubiquity of gay sexuality in the arts, it would have been feasible to imagine Soby's denials as motivated by the political agenda of a liberal/homosexual "elite." With possible ideological distortions on either side, the truth, as it were, about homosexuals in the art world would therefore have seemed elusive and far from easily available. Soby's social and institutional authority notwithstanding, his denials may have thus proved ineffective in curtailing Benton's lurid accusations, contributing instead to a culture of uncertainty surrounding the representation of homosexuality in American culture at this time.

KINSEY'S NEW WORLDS OF SUSPICION

As I have been trying to suggest thus far, such an epistemological unease was borne of the visible body's limited capacities for telling the truths of sexuality in the early 1950s. It was also an unease which had already become widely exercised in the popular imagination by the time the *Review* article appeared in 1951. A culture of homosexual suspicion had already been brought into being by the publication of Alfred Kinsey's scientific study of male sexuality, *Sexual Behavior in the Human Male*, published some three years earlier in January 1948.[15] The report proved instrumental in disturbing many popularly held convictions and assumptions about male identity

and sexuality. Contrary to what one might think about the marketability of a scientific study of some 804 pages, with only innumerable tables, charts, and graphs for visual relief, the book sold nearly one-quarter of a million copies in the first few months of its publication alone. Based on interviews with some 5,300 American men, the report presented a scientific challenge to legally and morally embedded ideas about so-called normal male sexual behavior. Foremost amongst its findings were those singled out by *Time* magazine in its January 1948 issue: 85 percent of the total U.S. male population was found to have had premarital intercourse; nearly 70 percent had relations with prostitutes; between 30 percent and 45 percent had extramarital intercourse; and 37 percent was found to have had some homosexual experience between adolescence and old age, with the highest rate among single males thirty-six to forty.[16] Such findings painted a picture of male sexual behavior radically at odds with the received image of middle-class American family life.

The report created a popular sensation, generating much discussion in households across America. A cartoon in the *Saturday Review of Literature* is testament to the report's status as a sensational subject of domestic debate, showing four elderly people (two heterosexual couples?), one of whom is falling asleep in his chair (fig. 4). "There goes Fred again," says one of the women, "quick, somebody start talking about Kinsey."[17] As Kinsey's biographer James H. Jones notes, Kinsey quickly became an "icon of popular culture."[18] Not only did his report sell in the thousands, and his findings become the subject of heated national debate, but also both he and his report seeped into the very fabric of American popular culture. Jones informs us of how popular musicians from Martha Raye to Tin Pan Alley wrote and recorded songs with titles such as "Ooh, Dr. Kinsey," "The Kinsey Boogie," and "Thank You, Mr. Kinsey" and how many new phrases and sayings were coined which highlighted Kinsey's role in bringing the subject of sexuality into popular American discourse. To say somebody was "Kinsey-crazy" was to say, of course, that they were crazy about sex, and Kinsey himself became known as "Dr. Sex" and his base of operations at Indiana University became known as "The Sex Center" (571). Thus the report incited American culture to produce a popular discourse about sex and sexuality of which the name Kinsey itself came to be emblematic.

If all of this demonstrates the popular determination of the contents of Kinsey's report as sexually transgressive and enlivening, then perhaps it was the (shocking) findings about male homosexuality which contributed most powerfully to this reputation. Thirty-seven percent of the total male popu-

"There goes Fred again—quick, somebody start talking about Kinsey."

Figure 4. Cartoon, "There goes Fred again," *Saturday Review of Literature*, 10 April 1948.

lation, Kinsey found, had at least some overt homosexual experience to the point of orgasm between adolescence and old age. This figure was far higher than previous estimates of male homosexuality in the human population, which put it at between 0.1 percent, as estimated by the army induction centers, to, at the most, 5 percent as estimated by Magnus Hirschfeld.[19] So just as Benton had suggested the high prevalence of homosexuality in the arts, so too did Kinsey for American society as a whole. But whereas Benton's assertions could be seen as clearly motivated by his prejudicial agenda, Kinsey's findings enjoyed the almost unassailable status of scientific fact.

Kinsey favored a behavioralist method in conducting his research which required that he calculate the prevalence of homosexual *acts* in the male population rather than attempt any calculation of the numbers of homosexual *persons* extant in society. This meant that he radically rejected the simplistic division of the male population into two discrete populations or types, heterosexual and homosexual. "It is a fundamental of taxonomy," Kinsey writes, "that nature rarely deals with discrete categories" (*S* 639). Instead Kinsey devised a more nuanced 0–6 hetero/homo rating in which individuals could be placed depending upon the ratio of homosexual to heterosexual activity in each person's sexual history: from 0 (exclusively

heterosexual) through to 3 (equally heterosexual and homosexual), to 6 (exclusively homosexual). Because of this varying mixture of homosexual and heterosexual relations in individual men's lives, Kinsey writes, "it becomes obvious that any question as to the number of persons in the world who are homosexual and the number who are heterosexual is unanswerable" (*S* 650). Thus, Kinsey presented an analysis of homosexual *activity* as the only defensible scientific approach to the subject.

However, though the report read as a discourse about homosexual acts as opposed to one about homosexual persons, it paradoxically had the effect of producing a widespread cultural concern for identifying or recognizing "homosexuals" (i.e., those who engaged in homosexuality) in everyday social life. The 37 percent of men who had at least one homosexual experience would account "for nearly 2 males out of every 5 *that one may meet*," writes Kinsey (my italics, *S* 650). Or, in another formulation: "This is more than one male in three of the persons that one may meet as he passes along a city street" (*S* 623). Written like this, it translated what were statistical data, and a "scientific" sexual phenomenon, into a powerful imaginary social scenario for its readers, and also made his findings more than amenable to being reproduced as sensational headline material in the popular press. The high probability of meeting men *in the street* who engage in homosexual activity was perhaps one of the most psychologically and socially troubling revelations contained within Kinsey's report.

But, as with Benton's comments about "devious" homosexuals in *An Artist in America*, what made these findings even more anxiety inducing to Kinsey's largely phobic reading public was his "scientific" questioning of the popular and stereotypical conceptions of homosexual identity. The report provides an inventory of such constructions and, in doing so, returns us to the effete and temperamental "fairies" sketched out by Benton above:

> It is commonly believed, for instance, that homosexual males are rarely robust physically, are uncoordinated or delicate in their movements, or perhaps graceful enough but not strong and vigorous in their physical expression. Fine skins, high-pitched voices, obvious hand movements, a feminine carriage of the hips, and peculiarities of walking gaits are supposed accompaniments of a preference for a male as a sexual partner. It is commonly believed that the homosexual male is artistically sensitive, emotionally unbalanced, temperamental to the point of being unpredictable, difficult to get along with, and undependable in meeting specific obligations. (*S* 637)

In addition to describing such stereotypical body styles and temperamental particularities, Kinsey goes on to outline the male homosexual's supposed physical characteristics and his definitive professional preferences (for example, music, the arts, hair dressing, dress design, window display, acting, nursing, and social work). "The converse" of all of these things, he writes, "is supposed to represent the typical heterosexual male" (S 637). But it is just these distinct types, this binary order of sexual difference in the human male, which Kinsey unpicks. In arguing for an understanding of sexuality along a more variable homosexual/ heterosexual continuum, Kinsey que(e)ries the scientific truth of such popular assumptions, and the whole binary visual schema implicit in popular modes of recognizing and separating supposedly normative bodies from their deviant others. Thus the report questions the reliability of conventional markers of gay visibility, not only for identifying homosexuality but also for establishing the heterosexual legibility of normality. This it does while insisting on the widespread incidence of homosexual acts between men in American society. The popular understanding arising from such findings was, therefore, that not only was the "average person" highly likely to meet someone who had engaged in homosexuality but also that this average person would be unlikely to know about it when he/she did.

As a result, the report gave rise to a culture of suspicion surrounding male identity and sexuality. Many of the cartoons that appeared in the press at the time are highly illuminating in this regard. One cartoon by Herb Williams, originally appearing in the *New York Times Book Review* and reprinted in *Life* magazine in April 1948, shows a middle-class domestic environment (fig. 5). A female reader, surreptitiously reading the report between the pages of her copy of *The Home Gardener*, warily eyes her husband—who sits on the other side of the room reading his newspaper—her head full of Kinsey's statistics and conclusions. Contrary to what I have said so far about the report being a topic of popular conversation, Williams images a world in which Kinsey's conclusions are *not* discussed, in which they remain as the unarticulated other to everyday domestic discourse. The revelatory findings of the report, and the concomitant suspicions about the American male's sex life (has he been unfaithful to me? with whom? and with men or women?), remain unvoiced, turned over again and again in the female reader's mind without resolve. The caption in *Life* acknowledges this: "New worlds of suspicion . . . were opened to doubting wives by Kinsey's revelations on men."

What is especially significant here is that it is the husband, represented through the iconic codes of the middle-class family man—the besuited pro-

fessional relaxing from a day's work at the office, drawing on his pipe and leisurely reading his newspaper — who is positioned as the chief object of this "new world." That is, he becomes positioned as the object of a world of epistemological and sexual *doubt*. The codes of normative masculine appearance are thus thrown into crisis, suddenly appearing unfamiliar, if not *queer*, in the wake of Kinsey's findings. Sitting in her chair, pondering the report before her, Kinsey's female reader is struck by the way in which the everyday appearance of her husband appears crossed with a new strangeness and uncertainty. And this is what I take to be an important effect of the popular reception of the Kinsey report — the ushering in of a culture in which the codes of normative masculinity become loosened from their heterosexual moorings; rendered semiotically unstable as they become subject to the play of perverse thoughts about what they may harbor.

This culture of suspicion extended to press speculation about Kinsey's own sex life. Another cartoon reproduced in the same issue of *Life* pictures another strikingly similar middle-class environment, the wife, again, reading the report, the husband, buried in his newspaper (fig. 6). The difference here is that the wife is overt about reading the report and asks her husband for his opinion. But rather than asking him about *his* sex life, she focuses her suspicions on the author of the report: "Is there a *Mrs.* Kinsey?" she asks. This was a question that was frequently asked, focusing the suspicions and uncertainties fueled by the report on to the sexuality of its author. This could be understood as an interpretative response to the book that worked to contain or nullify its destabilizing consequences for normative conceptions of masculinity by positioning it as the tendentious product of a queer mind.

As if in response to this question, on the facing page of the magazine, *Life* prints a photograph of Mr. and Mrs. Kinsey in their comfortable home (fig. 7). "Mrs. Kinsey," the caption reads, "knits a sock for her husband while they listen to records from their large collection. On weekends they often give concerts for guests." The couple appear relaxed, looking directly into each other's eyes. The accompanying article gives further details of Kinsey's heterosexual home life, including references to their ideal and happy marriage, their children, their social life, even down to the pet names (Mac and Prok) that Mr. and Mrs. Kinsey call one another. Mr. Kinsey himself is described as rugged and hardworking, in keeping with other press reports which frequently comment upon his masculine appearance, his well-preserved fifty-three-year-old looks. In this respect *Life* serves to allay suspicions about Dr. Kinsey's sexuality by providing the textual and photo-

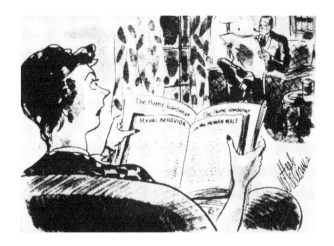

Figure 5. Herb Williams cartoon, "New Worlds of Suspicion," 1948.

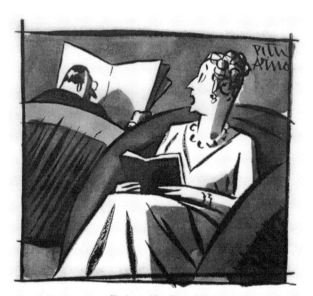

"Is there a <u>Mrs.</u> Kinsey?"

Figure 6. "Is there a Mrs. Kinsey?" © The New Yorker Collection 1948, Peter Arno, from cartoonbank.com. All Rights Reserved.

Figure 7. Dr. Alfred Kinsey and his wife, Bloomington, Indiana, 1948. Photo by Wallace Kirkland/Timepix/Rex Features Limited.

graphic evidence to the contrary, the *proof* of his normality. But, given Kinsey's findings, of course, such evidence has already been stripped of its evidential status, and fails to stabilize its signification as document of his heterosexuality, even when it appears to be explicitly called upon to do so. Kinsey's wife seems wise to this and is happy to further engender the perverse play of meaning. In speaking about the time Kinsey has spent away from home while conducting the interviews for his sexual research, Mrs. Kinsey tells *Life*, with her tongue firmly planted in her cheek, "I hardly ever see him at night any more since he took up sex."[20] And what "sex" signifies, of course, in post-Kinsey 1950s culture is a highly ambiguous, if not perverse, range of sexual activities.

Newsweek at the time refers to Kinsey as a "big man with a well-filled dinner jacket," while *The New Yorker* notes that he was a "big, husky fel-

low, appearing to be younger than his fifty-three years, wearing a double-breasted blue suit, a dark red bow tie with white dots, unruly brown hair, a friendly smile, and an air of repose."[21] Nothing, except perhaps his "unruly" hair (or, as *Newsweek* puts it, his "shaggy brown head"), could have positioned Kinsey as deviant within any extant 1940s and 1950s iconography of male deviancy.[22] You probably couldn't search out a more iconographic imaging of what was then considered to be a normal life than *Life*'s representation of Mr. and Mrs. Kinsey at home. As Barbara Ehrenreich has argued, in 1950s American culture, the dominant conception of normative adult masculinity was as a married, breadwinning family man.[23] The photograph of the Kinseys, and *Life*'s accompanying commentary, would therefore appear to be an emblematic representation of this norm. This contrasted starkly with then emerging forms of deviant masculinity in American society which signaled the birth of postwar rebellious subcultures. Figures such as the criminal and irresponsible teenager or the bohemian hipster or beatnik, the latter which forms my subject in chapter 3, were conspicuous by their appearance and lifestyle, as well as by the values that they espoused. Concerned organs of authority, from cultural commentators to politicians to psychologists, attended to such differences of masculine appearance as symptomatic of sexual, as well as social and political, differences. The beatnik, for example, was often castigated for his immaturity and lack of adult (i.e., family) responsibility, which blurred into his imputed homosexuality.[24]

But Kinsey didn't *appear* deviant at all in the various representations made of him in the media. Nevertheless, despite the absence of any then recognizable codes of deviance, his, to all intents and purposes, "heterosexual" appearance can be seen to be shadowed by a phantasmatic queerness instilled within the popular cultural imaginary by the report's findings. What this demonstrates is the effect of Kinsey's book in destabilizing the meaning of the very codes which were habitually being performed within American culture as the male norm; of exacerbating the anxieties evident within Benton's homophobic discourse about gays in the arts into a fully fledged popular suspicion about the prevalence of homosexuality in the so-called ordinary world. This can be seen to have undermined almost any attempt to inscribe the heterosexuality of normative masculinity within culture at this time, and marked instead its conflictual and unstable representational condition. If the visible body could no longer be counted on as a reliable indicator of sexual identity, evidencing the truths of sexuality, then what of the mechanisms for producing knowledge of sexuality, and of homosexuality in particular?

As a consequence of such intractable problems attending the representation of homosexuality, the suspicions surrounding the "average" American male's sex life in the late 1940s became channeled into suspicions and rumors about government employees and certain cultural workers, including artists, in the early 1950s.

This is because Kinsey's findings were instrumental in developing the conclusions of the 1950 American Senate report "Employment of Homosexuals and Other Sex Perverts in Government."[25] This report was commissioned in the wake of an admission made to the Senate in February 1950 by a State Department official, John Peurifoy, who admitted that most of the ninety-one employees dismissed from the department for "moral turpitude" up to that point had been homosexuals. The publication of the report was a green light for the ensuing campaign, led by republican senators Joseph McCarthy and Kenneth Wherry, to discredit the then Truman administration as a government "riddled with" homosexuals in important and sensitive positions. This entailed a high-profile witch-hunting and firing of homosexuals in government employment lasting well into the mid-1950s.[26]

According to John D'Emilio, the authors of the report "culled information from the Kinsey study of the American male — that homosexual behavior was widespread, that homosexuals came from all walks of life, and that they did not conform in appearance or mannerism to the popular stereotype — in order to argue that the problem was far more extensive and difficult to attack than they had previously thought."[27] The report charged federal agencies with adopting a "head-in-the-sand" attitude, calling for a stricter enforcement of regulations while acknowledging that detection was not an easy task, because too many gays lacked what the report called the "outward characteristics or physical traits that are positive as identifying marks of sex perversion" (43). Despite the fact that the dismissal of suspected homosexuals from government office rose steadily from 1947 onward until Eisenhower's inauguration in 1953, sensationalist newspaper columnists such as Lee Mortimer were still claiming in 1952 that "10,000 faggots" had escaped detection and the government remained "honeycombed in high places with people you wouldn't let in your garbage wagons."[28]

This kind of paranoid projection was the form taken by popular "knowledge" of the supposedly high numbers of homosexuals who were in government employment at the time. In this context, as with the apparent nor-

mality of Kinsey in *Life* magazine, the heterosexuality of so-to-speak normal or ordinary men was rendered ironically *in*secure by a culture obsessed with national security. This is particularly true of any employee of the State Department in the early 1950s, which, as the historian Stephen J. Whitfield writes, came to be represented in political discourse as a place "dominated by an all-powerful, super-secret, inner circle of highly educated, socially highly placed sexual misfits."[29] That is *all* employees of the State Department, regardless of their outward appearances, came under suspicion, their sexuality cast as the object of doubt and uncertainty. In this way the State Department became the occasion of a highly phobic discursive regime which variously constructed it as a haven for "cookie pushers," and its employees as those weakly effeminate "striped pants boys in the State Department" (44). Such discursive constructions passed into everyday innuendo. Whitfield comments on Roy Cohn and David Schine, two key McCarthy witch-hunters: "When Cohn and Schine, investigating the International Information Administration, had been assigned a double room in Munich, Cohn slyly protested to the room clerk, 'Hey, we're not the State Department'" (44). Ironically, of course, despite resorting to such homophobic innuendo himself, Cohn later turned out to be gay, which only goes to further underline the unreliability of denial in the context of a culture of accusation.

If State Department employees were cast in this way as probable—if not provable—homosexuals by the widespread ideological effects of McCarthyite suspicion in the early 1950s, then so too the "artistic types" in New York's art world. One can quickly identify striking similarities between McCarthyite political rhetoric, fueled by the popular and selective deployment of Kinsey's findings, and that of Benton's attack on gays in the arts in the *Saturday Review of Literature* in 1951.[30] By doing so, we quickly become aware of the ways in which homosexuality comes to be entertained in American culture at this time as an object of suspicion, produced within paranoid constructions of the disproportionately high numbers of homosexuals supposedly at large within government employment and the arts. Whereas the State Department is cast in McCarthyite rhetoric as a space dominated by weakly effete homosexuals, it is the network of influential art professionals in New York's art world, according to Benton, who supposedly flounce around with unwitting feminine affectation. Where it is the "striped pants boys" of the State Department that occasion suspicion and innuendo in political circles, it is the "museum-boys" and their like that are the objects of homophobic rumor in art criticism.

It would be tempting to think of such paranoid views of homosexuality

as limited to conservatives such as McCarthy in politics, and Benton in the arts. But just as the phobic suspicion of gays in government crossed political divides (liberals such as Arthur M. Schlesinger Jr. were similarly partial to gay baiting and rumor mongering[31]), the rumors about gays in the arts were more widespread than my singular focus on Benton so far would belie. True, Benton's writing was the most explicit form of such suspicions published at this time, but other articles attest to the general circulation of such rumors, which often did not find their way into print and so are no longer available to be studied through attention to historical documentation.

In an article from the April 1956 issue of *Tip-Off*, one of the scandal magazines of the 1950s, entitled "Why They Call Broadway the GAY White Way," a fairly explicit line of homophobic reporting was adopted. It outlines, in a way not dissimilar to Benton, the existence of a gay "stranglehold" on the theater.[32] This, according to the article, supposedly took the form of predatory gay casting directors and producers who were maintaining exclusively gay casts, or forcing young actors to exchange sexual favors for the chance of a part. The article ends with an appeal to the then familiar trope of homosexuality-as-sickness, advising that some immediate treatment be found for this "growing cancer." This supposed dominance of gay men within the theater was the subject of a few journalistic exposés in the 1950s and early 1960s. However, as Martin Duberman notes in an introductory preface to the *TIP-Off* article in his book *About Time*, the "knowledge" about gays in the theater was hardly news to him at all, but rather the standard currency of gossip and rumor at the time: "Despite its pretence to being a daring exposé, the article's 'revelations' amounted to little more than a compendium of gossip already widespread at the time; as someone who came out (sexually) in the mid-fifties and had also become involved in the theater world, I can attest to the commonplace nature of the rumors then current about 'queers' controlling the assignment of parts and the fate of careers. If memory serves, the 'news' that many gay people worked in theater would hardly have come as a surprise" (220).

Such news, as it were, would hardly have come as a surprise to those working in the 1950s art world either. Here a similar concern about the numbers of gay men involved in the arts was centered on rumors about the existence of a "homintern." Not always invoked in a homophobic way, the term *homintern* is sometimes credited to W. H. Auden, who is supposed to have been the first person to write of it in print in *Partisan Review* in the early 1940s. The poet Harold Norse, though, disputes this, claiming that he invented the word as early as 1939, Auden picking it up from a letter Norse had sent him that same

year. According to Norse, he initially coined the word *homintern* as a campy "takeoff on *Comintern* (Communist International)" and was "meant to convey the idea of a global homosexual community."[33] Norse invokes the term approvingly and uses it to distance himself from the straightness and seriousness of the Communist Party and its members: "As for me, I believe in the Homintern; leave the Comintern to the Party" (77).

Derived thus, it is nevertheless easy to see how the cultural conditions of the late 1940s and early 1950s would pave the way for the term's passage from gay subculture to straight mainstream, and to become phobically deployed within rumors and suspicions about the postwar art world. If the Comintern, especially by the early 1950s, was seen to operate by means of secretive and highly organized groups of infiltrators within the American establishment, then the notion of a homintern by this time simply transposed the idea of a "secret society" of subversives onto an understanding of homosexuals in the arts. As Gore Vidal notes in his 1995 memoir *Palimpsest*, "even in 1948 there was a suspicion that far too many creative people were inclined to same-sexuality . . . [but] . . . By the 1950s, an all-out war was declared on the homintern's control of the arts (so like the Comintern's control of the State Department)."[34]

Such a notion persisted strongly even into the 1960s. Calvin Tomkins recollects, in his book *Off The Wall* (1980), that the homo- or bisexuality of some late 1950s and early 1960s artists, and the money "lavished" on them, led to contemporary talk of a homintern, "a network of homosexual artists, dealers, and museum curators in league to promote the work of certain favorites at the expense of 'straight' talents."[35] And in an article published in *Esquire* as late as 1965, promising an analysis of a New York art world "full of Money, Gossip and Anxiety," Harold Rosenberg remarks on a relatively new phenomenon in the art establishment. This was the existence of social "groupings based on sex," including the "banding together of homosexual painters and their non-painting auxiliaries in music, writing and museum work."[36] Undoubtedly Rosenberg is referring here to the social, artistic, and perhaps sexual relationships between artists such as Jasper Johns, Robert Rauschenberg, and Larry Rivers, and such "non-painting auxiliaries" as John Cage, Merce Cunningham, Frank O'Hara, John Ashbery, and John Bernard Myers. Such "bandings," in particular the one made up of the relations between the painter Larry Rivers and the New York school of poets centered around Frank O'Hara, forms the subject of my analysis in chapter 3.

For now, though, it will suffice to note how Rosenberg's snippet of obser-

vation here was put to more homophobic use when quoted in *Time* magazine's feature essay "The Homosexual in America" in January 1966.[37] Even though, as *Time* acknowledges, things were beginning to change by this date ("increasingly deviates were out in the open, particularly in fashion and the arts"), the notion of a homintern was still newsworthy enough to warrant a whole subsection on its own alongside others on "The Gay Subculture," "The Wolfenden Problem," and (sanctimoniously) "The Moral Issue." In its headlong rush toward its final pronunciation of homosexuality as "a pernicious sickness," *Time* states:

> On Broadway, it would be difficult to find a production without homosexuals playing important parts, either on stage or off. And in Hollywood, says Broadway Producer David Merrick, "you have to scrape them off the ceiling." The notion that the arts are dominated by a kind of homosexual mafia—or "Homintern," as it has been called—is sometimes exaggerated, particularly by spiteful failures looking for scapegoats. But in the theater, dance and music world, deviates are so widespread that they sometimes seem to be running a kind of closed shop. Art critic Harold Rosenberg reports a "banding together of homosexual painters and their non-painting auxiliaries." (40)

So, even as the article seems to distance itself from perhaps some of the more "exaggerated" constructions of the homintern, at the same time it reiterates its suggestive force through reference to a gay closed shop, a metaphor which, though shirking the anti-Communist language of the McCarthy era, is still broadly antilaborite in its connotation.

This idea of a network of homosexuals, connecting up the diverse social worlds of the creative arts from dance, to music, to theater and the visual arts, is also evidenced in the work of the period: "Homosexual ethics and esthetics are staging a vengeful, derisive counterattack on what deviates call the 'straight' world. This is evident in 'pop,' which insists on reducing art to the trivial, and in the 'camp' movement, which pretends that the ugly and banal are fun" (40). Tomkins reiterates this line of argument. Following up his remarks on the homintern, he writes: "It was even suggested, without too much conviction, that there was such a thing as homosexual art, and that its characteristics—narcissism, camp humor, and decorative intent—were visible on all sides." Tomkins is, however, quick to criticize and belittle any such idea, going on to say that the very idea of a homosexual art "did not bear very close scrutiny. There were elements in the work of Cage, Cunningham, Rauschenberg, Johns, and Warhol, and others that

could be described as decorative or even 'campy,' but these were outweighed and overshadowed by other elements that clearly had nothing to do with the so-called homosexual sensibility."[38] The sexuality of these artists therefore, while being momentarily figured in discourse, is, at the same time, given short shrift by Tomkins, denying it any hermeneutical import in terms of a discussion about the meaning and value of their works. What Tomkins is trying to do here is to contain homosexual meaning in the "closet" of rumor and tittle-tattle from which it threatens to engulf the presumed straightness of the works in question. This is typical of the ways in which homosexuality is routinely dismissed by discourses of criticism as a (scandalous) subject proper only to delegitimated, and distinctly unserious, forms of everyday informal discourse.

This denial of a homosexual presence in art can be seen as an attempt to nullify the potential effect of rumors of a homintern on the meanings of particular artworks from the 1950s and 1960s. However, given that suggestions about a homosexual art were largely conveyed as the subject of gossip and rumor rather than serious critical appraisal, any such discrediting of the idea was bound to be largely ineffective. On the contrary, and like Soby and others before him, perhaps by simply entertaining the idea in print, Tomkins contributes to its further propagation rather than curtailing its currency. He thus *spreads* the rumor within "serious" critical discourse, even as he attempts to put an end to it by denying its truth.

This is because, as I have already noted above, rumors, by their very nature as unproven speculation, do not derive their force in economies of meaning from their truth or falsity. According to the various psychological and sociological perspectives explored in Ralph L. Rosnow's and Gary Alan Fine's book, rumor instead serves differing motivated interests, both individual and collective.[39] As *Time* notes above, rumors about the existence of a homintern might, for instance, be put into circulation by "spiteful failures" in order to provide a rationale for their individual inability to achieve their desired goals (this reference could certainly be seen to incorporate Benton, who began to write his gay-baiting attacks once his own painting began to fall from favor). Alternatively, rumors might be understood as discursive ways of perpetuating phantasmatic realms of collective life, of expressing the fears and desires entertained by particular communities. According to one branch of psychological thinking, such fears and desires might be motivated by a lack, or an uncertainty, of meaning. Rosnow and Fine summarize the psychological theory of rumor put forward by Gordon Allport and Leo Postman: "Human beings are motivated to make sense of their environment;

there is an 'effort after meaning.' Our minds strive to eliminate chaos and uncertainty. When the truth is not directly forthcoming we piece together information as best we can, giving rise to rumors, rationalizations, and the search for a definition of the situation. The reason that rumors circulate is that they explain things and relieve the tensions of uncertainty" (51).

If we are to take the sense of some of this (though I balk at the way Allport's and Postman's theory here claims, somewhat ironically, to "know" the psychodynamics of the mind), then we can see how rumors of a homintern might be taken as a rationalization of the fears and anxieties, whipped up by McCarthyism, about the "foreign" infiltration of American institutions by its political and sexual Others. In a culture obsessed with national security, and in particular with the security of America's masculine and heterosexually gendered body politic, the figment of a secretive homosexual society at large in the arts perhaps went some way toward giving coherent expression to unsettling phobic anxieties. Given, though, that these fears and anxieties were focused upon the representationally troublesome male body, no simple denial of the homintern "story" would make such fears vanish overnight.

This is because the currency of such a tale was in large part dependent on the impoverishment of then conventional technologies of "knowing" male sexuality. As Rosnow and Fine suggest, most rumors can be quashed at some stage by an "authoritative" denial of their truth value, especially by some individual or agency which inspires trust in the public. But as regards the rumors about gays in the arts, how could the charge be countered if there was no means to authoritatively *show* its falsity? As I have been arguing, in post-Kinsey culture the epistemological faith in the sexual evidence offered by masculine visibility had been severely undermined by the recognition that appearances *could indeed* be deceptive. What discourse or agency would be able, in this context, to definitively quell such rumors by an appeal to the values of truth and reliability, especially when faced with the problem of whether or not homosexuality, and by extension heterosexuality, could be deemed knowable *at all*? In this context then, far from "relieving the tensions of uncertainty" — as certain theorists of rumor might assert — the circulation of tales about a homintern only had the effect of exacerbating the already conflicted sexual meanings of male bodies, and of artists' bodies in particular, in the culture at large.

Therefore, in the absence of any reliable signifiers of homosexual difference, and given the widespread rumors about the large numbers of gays in the arts, what I want to suggest is that artistic identity *itself* becomes phobically charged with queerness in the cultural contexts of the 1950s art world.

The figure of the male artist, though no self-evident figure of homosexuality, as a result of phobic suspicions, paranoias, and rumors, becomes a kind of sexually *liminal* figure. Neither securely straight nor fixedly gay, he is constantly shadowed by queer meaning, which now appears, now disappears, within the various social and discursive contexts of American culture. To be an artist at this time was to occupy a subject position criss-crossed with sexual ambiguity, to be, perhaps, like the "guys" in the State Department, the occasion of popular innuendo and homosexual suspicion.

THE TROUBLE WITH NORMALITY

To see the effects of this we can turn to another iconic representation of heterosexual normalcy, this time an artistic one: Hans Namuth's 1953 photograph of Willem and Elaine de Kooning in a studio in East Hampton, Long Island (fig. 8). This image is now conventionally read in art history as a particularly vivid elaboration of the patriarchally defined image of the male abstract expressionist artist.[40] As a consequence of much work by feminist and other art historians, we are now familiar with the gendered schema of representation which divests Elaine de Kooning of her identity as an artist, photographically positioning her instead as "artist's wife" and/or muse. In this respect, and as Michael Leja has argued, the image of Elaine here serves primarily as a foil for the definition of Willem's artistic identity, reaffirming, at one and the same time, his masculinity and heterosexuality. She appears as the stereotypically feminine other to Willem's masculine self, sitting off-center, more or less in the doorway, of what is clearly the male artist's space (in another image from the same shoot she actually stands *in* the doorway as if hovering between the studio and the space beyond — the kitchen perhaps?). Willem commands the space of the studio, standing proprietarily in the center, arms folded with his gaze meeting directly that of the camera, while Elaine looks off-frame distractedly. Behind him on the wall is one of his "Woman" paintings.

Clearly it is the representational logic of the photograph to position both Elaine and the painted woman as *his* women. In doing so, it is an image which insists on conventional and vivid gender polarities as the condition of its legibility, affirming Willem's conventional masculinity through the heterosexual dynamic of artist and wife. This is in keeping with other similar "artist-and-wife" portraits from the period, notably those taken by Lawrence Larkin and Hans Namuth, of Jackson Pollock and Lee Krasner a little

Figure 8. Willem and Elaine de Kooning, East Hampton, Long Island, 1953. Photo by Hans Namuth © 1990.

earlier in 1949 and 1950 respectively (fig. 9). Here too Krasner typically appears as a marginal or subordinate figure within Pollock's studio, usually sitting watching the action painter as he goes through the ritualized production of his paintings on the floor of his studio — thus becoming, as Caroline Jones has suggested, a paradigmatic "passive" spectator of active painting.[41]

But what intrigues me about photographs like these, and of the Namuth image of the de Koonings in particular, is less the patriarchal representational schema through which the male artist's identity is constructed, but rather *that which they attempt to disavow and displace*, that is, the queer meanings which accrue to the figure of the artist in the cultural contexts I have mapped out thus far. The rumors about the existence of a homintern, I want to suggest, are determining of the photograph's particular staging of artistic masculinity, especially given that 1953 was the high point of

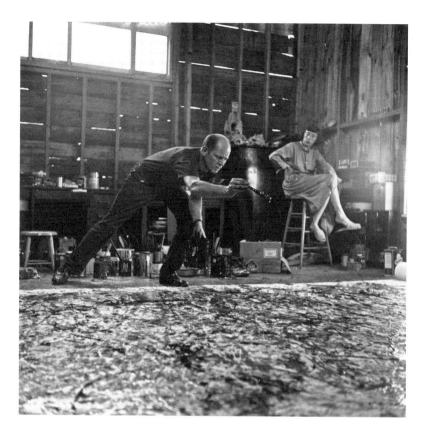

Figure 9. Jackson Pollock and Lee Krasner, 1950. Photo by Hans Namuth © 1990.

McCarthyite attacks. It is precisely such queer insinuations about artistic identity, I would contend, which the Namuth portrait of the de Koonings works to both deny and repress. Leja remarks that the photograph keeps Willem's image "within certain limits," effectively disavowing the phobic accusations of the likes of Benton et al.[42] It does this by staging the male artist as a normatively masculine figure, clearly demarcated from his significant feminine other. By figuring Willem's artistic masculinity through the iconic codes of "husband" as opposed to Elaine's "wife," the image partakes of the same function and status as the photograph of Mr. and Mrs. Kinsey in *Life* magazine. Whereas the photographic representation of Kinsey's home life is marshaled as proof of his normative heterosexuality, its function determined by its position within a culture of homosexual suspicion and doubt, so too for the production of Willem's artistic straightness.

In this manner, such photographs and, by extension, the various displays of masculine potency and virility now much a part of the mythology of abstract expressionism (the brawls in the Cedar Tavern on Eighth Street, etc.) can be read, in a psychoanalytically inflected way, as reaction formations to then current fictions concerning homosexuality in the arts.[43] Jonathan Katz relates an interesting account in this context of the history of the Cedar Tavern, the main social hangout of the abstract expressionist painters:

> a dirty neighborhood bar that had been adopted by the painters and their hangers-on in part because of its seediness. Definitionally bohemian, it was so bad it was good. When fame finally arrived and the owners responded to the influx of artist's cash by promising new interior decor, the artists threatened a boycott. They wanted to avoid at all costs the impression of an artist's bar, with its connotations of an effete elite preoccupied with questions of beauty. Unwilling to countenance that, the abstract expressionists created a facsimile of the Wild West.[44]

In seeing how patrons wanted, then, to avoid "the impression of an artist's bar, with its connotations of an effete elite," we are alerted to the power and currency of a feminized, if not homosexual, image of the artist in the social imaginary of the abstract expressionist art community. This was an image which, as performative theorist Judith Butler might argue, needed to be abjected as part of the process of establishing a heterosexual artistic identity, in particular the cowboy machismo so dear to de Kooning and Pollock. Normative heterosexuality, Butler argues, is habitually produced through a "full-scale repudiation and rejection of homosexuality."[45] This means that at the heart of heterosexuality resides a refused identification with homosexuality. Or, more precisely, this refused identification, better understood as a *disavowed* one, is one that has already been made and denied within the unconscious as part of the very identificatory process of constituting heterosexual identity. This may actually represent, Butler writes, "an identification that one fears to make only because one has already made it."[46] Thus the disavowal of an abject homosexuality can be seen to be continually and performatively reinscribed at the heart of the heterosexuality of the abstract expressionist artist, whether by dint of the photographic disavowals encoded within Namuth's photograph, or through the homophobic jibes which Pollock was famous for uttering in the Cedar.[47]

So even though Namuth represents Willem as an icon of normality, in the manner of *Life*'s photographic representation of Dr. Kinsey, the meanings of such an image are not completely exhausted by a conventional iconographic

reading. Indeed, the dynamics of heterosexual performativity played out through this image can only be comprehended by attending to those meanings that are not expressly visible at all, but which nevertheless would have circulated around it, constituting it from without, as discourses of suspicion and rumor. Leja remarks, while analyzing Namuth's photograph, that for the male artist in the early 1950s to appear "upstaged, idle, or doting," as the artist's wife usually appeared, "was *unthinkable*" (my italics).[48] True enough, it was certainly unthinkable in the sense of being too terrible to imagine any deviation from masculine norms and what that might suggest in terms of homosexuality. But, on the other hand, such a deviation certainly *was* thinkable, perhaps *all too* thinkable, within the homophobic imaginary of 1950s American culture. And such imaginings were what haunted the stability and security of the apparent heterosexuality made visible by dint of Namuth's photographic lens.

It is the degree to which homosexuality was *imaginable* in the American art world which has been the subject of this chapter. Rumors about gays in the arts variously attest to the currency of fantasies of an effete male homosexuality at large in the arts and, perhaps more threateningly still, of a homosexuality that was taken to exceed its supposedly feminized frames of appearance. The circulation of such rumors and suspicions, I have been trying to suggest, threw doubt upon the visible coding of even the most normative forms of artistic masculinity. Thus, I am reminded of Lee Edelman's words: "once sexuality may be read and interpreted in light of homosexuality . . . all sexuality [becomes] subject to a hermeneutics of suspicion."[49] As the art and music critic John Gruen has attested, despite being himself an apparent icon of heterosexual masculinity, even the most sexually normative character in the art world came under suspicion at this time: "I was always looked upon with suspicion myself because I was cavorting with all these gay people even though I had this ravishing wife, beautiful child." He recalls how, when working at the *New York Herald Tribune*, his colleagues there would "roll their eyes" or take offense if he walked into the office wearing a beret or if he wore "colorful things, velvet pants" (obvious sartorial signs, *of course*, of an effete artistic temperament!).[50]

In this chapter, I have set out the conditions which made artistic identity so readily suggestive of homosexuality. From the accusations of Benton, to the denials issued by Soby, Tomkins, and countless unnamed others, I have been arguing that artistic masculinity came to be widely entertained as a subject of sexual and epistemological uncertainty. I have argued that fueled by the more general suspicions about male sexuality given rise to by the pub-

lication of the Kinsey report, the discourses which attempted to establish the "truth" of artistic sexuality in the period can be seen, ironically perhaps, to have contributed to a regime of uncorroborated tales which formed the very discursive field in which questions of artistic sexuality were customarily entertained in this period. Even though Benton's greatest fear was that homosexuals in the arts would lead people to "confuse all art with sexual oddity," I have tried to demonstrate how Benton's own discourse might have perpetuated the queer meanings of art he most abhorred.[51] I have tried to convey how feeding a culture in which male (homo)sexuality was entertained as phobic figment, Benton and his detractors worked to reiterate an identification with an uncertain or disputed homosexuality, thereby maintaining it as phantom meaning in American culture in the period.

This is a phantom meaning which haunts Namuth's photograph of Willem and Elaine. For even as it represents Willem as conventionally masculine, it would have nevertheless, in the cultural contexts of the McCarthyite 1950s, have failed to secure Willem's straightness beyond all doubt. Indeed, just as the *Life* photograph of the Kinseys would have failed to finally allay all suspicions and stabilize a reading of Dr. Kinsey as a confirmed heterosexual, so too for Namuth's image of the de Koonings. Indeed, in this context, the performance of the heterosexuality of the male artist, self-conscious or otherwise, looks precariously maintained and unstable. This is because male heterosexuality was *in need of affirmation* given the suspicions circulating about queerness in the art world at this time. For some, including De Kooning, and *particularly* Pollock, such a precariously maintained sexual identity was the cause of much anxiety, even anger and violence. As Andrew Perchuk has noted, Pollock for one was threatened by the prospect of seeing his heterosexual masculinity as something performed, as something that *needed to be proved*, and which couldn't be taken for granted as natural and inevitable.[52] For others, as we shall see in subsequent chapters in this book, the disputed queerness of artistic identity formed part of the very attraction of being an artist in the first place and was embraced as part of the process of creating an identity.

The sexual ambiguity of the male artist was further energized by the circulation of mythologies about artistic "genius" and homosexuality—the idea that gay men, in particular, were somehow predisposed to creative endeavor as a function of their sexual orientation. Such ideas were particularly current, and the subject of much edifying gossip, within the queer communities of the 1950s. It is to these that I turn my attention next.

{ CHAPTER 2 }

IDOL GOSSIP:

MYTHS OF GENIUS AND

THE MAKING OF QUEER WORLDS

In his book of 1951, *The Homosexual in America*, Donald Webster Cory writes that the most profound and overriding experience of being gay in the postwar years was that of being *different* from mainstream society.[1] "The dominant factor in my life," he writes, "towering above all others, is a consciousness that I am different. In one all-important respect, I am unlike the great mass of people always around me, and the knowledge of this fact is with me at all times, influencing profoundly my every thought, each minute activity, and all my aspirations. It is inescapable, not only this being different, but more than that, this constant awareness of a dissimilarity" (*H* 6–7). This profound dissimilarity from "the great mass of people" was one which, according to Cory, permeated every aspect of homosexual consciousness. It saturated every waking moment, every thought and feeling. As a gay man in the 1950s, Cory writes, one could not help but think "the fateful words: *I am different*" (*H* 9).

This was a difference, of course, which was widely insisted upon by prominent figures of church and state, as well as by the experts of the specialist professions. Moreover, it was a difference which was seen by many to mark a falling away from a valorized heterosexual norm, and was therefore widely lamented and deplored by public figures and institutional authorities alike. From Joseph McCarthy's denunciations of the assumed moral weaknesses of homosexuals in government to the various psychiatric, legal, and religious definitions of homosexuality as illness, criminality, and sin respectively, the life of the gay man was cast as abject and unworthy—inferior in almost every way to his heterosexual counterpart.[2] As a result of such char-

acterizations, gay people tended to feel guilty and shameful of their pre-
sumptively degenerate sexuality; these emotions, in turn, led to a painful
awareness of their supposed inadequacy compared with those lucky enough
to be possessed of a "normal" sexual orientation.[3]

Cory's book, however, countered such dominant and abjectified con-
structions of homosexuality by reframing the gay man's difference (and, to
a lesser degree, that experienced by lesbians) in terms of membership of
a hitherto unrecognized "minority" group. Similar in many ways to other
ethnic and religious minorities who found themselves discriminated against
by mainstream society, Cory argued that gays—far from being isolated,
sick, and fundamentally irredeemable individuals—formed a specific so-
cial group, replete with their own culture and identity. In arguing for a
better understanding of this minority, and for granting it rights and lib-
erties, Cory's book thus recasts the difference of homosexuality in a more
politically defensible light and, as a result, he soon became a leading intel-
lectual figure within the "homophile" movement—the name adopted by the
early gay rights group the Mattachine Society.[4] Cory's writings were well
known and appreciated by many homophile activists as well as by readers
of the journal *One*, the most prominent journal associated with the move-
ment.[5] Thus Cory's ideas provided the intellectual basis for the development
of a political consciousness of sexual identity which anticipated gay pride
by nearly two decades.[6]

For a homophile writer such as "Lyn Pedersen," the point was to celebrate
and assert the difference of the homosexual precisely on Cory's terms: "Vive
la différence," as he put it in an article in *One* magazine in 1954.[7] But what
interests me here is the degree to which this call to mark, defend, and cele-
brate homosexual difference is carried in an article entitled "The Importance
of Being Different" (fig. 10). This reference to Oscar Wilde's *The Importance
of Being Earnest* serves to invoke the nineteenth-century aesthete—at least
phantasmatically—as an embodiment of the very sexual difference about
which Pedersen writes. That this difference is figured through the body of
a distinctly "artistic" type is what intrigues me here, and forms the subject
of this chapter, for it was at this time that the artist came to be particularly
vivid as a socially and, above all, *sexually* nonnormative figure, especially
within postwar American queer subcultures.

In what follows I will explore how Cory's book is important in clueing
us in to the ways in which artistic identity came to be variously imbued
with contested ideas about the homosexually different. I will examine how,
among other things, the socially atypical figure of the artist-genius comes to

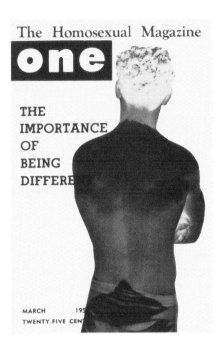

The Homosexual Magazine

one

THE
IMPORTANCE
OF
BEING
DIFFERE[N]

MARCH 195[4]
TWENTY-FIVE CEN[TS]

Figure 10. "The Importance of Being Different," front cover of *One* magazine, March 1954. Courtesy of ONE Institute and Archives, Los Angeles.

be suggestive of the figure of the "outsider" homosexual in queer discourse of the 1950s and early 1960s. Equally, I will explore how, at this time, the world, so to speak, of the creative arts — set apart from the social and professional norms of everyday life — seemed to carry with it the promise of a more desirable queer life where one's dissimilarity from the "great mass of people" could be tolerated, accepted, or even be taken as a boon rather than a burden.

Such perceptions of a link between artistic practice and homosexuality were underwritten by the circulation of various mythologies about the supposed predisposition of homosexually oriented peoples to artistic creativity, as well as by the hungry exchange of gossip in queer bohemian circles about the individual sex lives of those "great" artists who were presumed, or rumored, to be gay. That such ideas were largely entertained as unexamined belief or hearsay is what interests me in the context of this book. For even though such ideas were oftentimes not taken seriously or given little in the way of any express credence, they were nevertheless entertained *idly* by gay men and lesbians in such a way that lent shape to the phantasmatic meanings which accrued to artistic identity in fifties and sixties culture.[8]

Ideas about the queerness of art and artistic identity were already enjoying broad appeal within postwar queer culture by the time Cory's book was

published in 1951. *The Homosexual in America* testified to the circulation of such ideas but also, as we shall see, served to further bolster and propagate them as subjects of contentious debate well into the 1950s and beyond. But how, exactly, were the connections between homosexuality and artistic practice arrived at?

A SUPERIORITY COMPLEX?

Cory writes in *The Homosexual in America* about a common understanding among gay people about the special creativity of homosexuals:

> If we are to believe in ourselves, we must reject the entire theory of the inferiority status which the heterosexual world has imposed upon us. And therein we find a reaction common among people who live in a special minority category: we create a new set of beliefs to demonstrate that our world is actually a superior one. For some reason or other that few of us stop to investigate we come to believe that homosexuals are usually of superior artistic and intellectual abilities, we seize upon outstanding examples of brilliant people, either in our own circles or in the public domain, who are gay, or who are supposed to be gay . . . Whether or not there is a factual basis for this belief in our own superiority is of secondary importance. Whether illusion or reality, the belief exists, and it stems from a desperation deeply imbedded in people who find themselves despised by the world, and who require a belief in themselves in order to bolster an ebbing confidence and enable themselves to function in society. (*H* 13)

Thus, Cory testifies to the belief, held by many gay men at the time, that having "superior" artistic and intellectual abilities was some kind of compensation for the abject status of gay sexual lives. This was a belief, Cory suggests, which drew its energies less from reasoned argument or from factual accounts about the lives of gay artists, and rather more from the psychic and emotional needs of members of a homosexual minority who found themselves scorned by the straight majority. Motivated instead by a need to counter the damaging representations meted out by dominant culture, such beliefs were embraced as a token of homosexual faith in more positive representations of same-sex desire rather than as the consequence of any watertight case to be made for the superior creativity of gay people.

The circulation of various mythologies about artistic practice and homo-

sexuality in American culture in the postwar years formed the ether from which such beliefs drew their life breath. By the time Cory was writing in 1951, there was, for instance, a general understanding in both mainstream and queer cultures alike about the social contiguity of art and homosexuality. Based on the reputation that had come to accrue to communities in areas such as Greenwich Village in New York, artistic society had come to be renowned as a place which harbored and tolerated sexual "deviants." Indeed the social and cultural nonconformities of artistic bohemia were often taken as the visible forms of queer society, which, to all intents and purposes, bohemia was presumed to be. So much so in fact that, in the right context, calling men "artistic" became code for calling them gay.[9] Similar connections were being made in literature too. In 1950 Andre Gide's *Corydon* had its first English publication, which introduced to a wider American readership than hitherto his polemical defense of the nonreproductive uses to which the male libido might be put, including art and homosexuality.[10] In asserting that male sexual output was in excess of reproductive needs, Gide argued that exclusive heterosexuality was unnatural and that homosexuality could therefore be seen as a natural and civilizing outlet for the male libido, especially by taking into account the sexual mores and cultural achievements of classical Greece.

But it is to the pages of the homophile journals, particularly to *One* magazine and *Mattachine Review*, that I wish to turn my attention here, for these provide an insight into the kinds of things that were understood about the relationships between artistic practice and homosexuality in queer discourse in the 1950s.[11] Both magazines were driven by an activist zeal, and deliberately set out to educate their readers about the "problems" of homosexuality, to challenge homophobic theories, and to convince them of the "cause" of homosexual rights. To this end, many articles, especially in the more scholarly *Mattachine Review*, tended to adopt the language of academia in order to pursue the epistemological dimension of the struggle for gay rights.[12] But I am less interested in appraising whether or not the arguments carried within such magazines might have been academically defensible, and rather more concerned to see how they might clue us in to "insider" discourses about art and homosexuality that might have been circulating amongst gay and lesbian artists, musicians, poets, and other creative types in the period under review in this book. Given that, as Cory notes, academic argument and factual knowledge were of little consequence for the belief in a homosexual superiority in the arts, I am interested instead in how these magazines worked to proliferate beliefs founded more on the *desires and needs*—or, as Cory

puts it rather more dramatically, the "desperation" — of a group despised by mainstream society.

The idea of the superior creativity of homosexual people was the subject of many articles in the homophile press in the 1950s and early 1960s. In addition to reporting, like Cory, the general beliefs that many gay men and lesbians had about the special creativity of homosexual people,[13] *One* and *Mattachine Review* provided much discussion of what specialist discourses such as psychoanalysis, psychology, and sociology had to say on the subject. Thus the magazines served to popularize otherwise elitist theories, Freudian ideas about the sublimation of libidinal drive for instance, which enjoyed considerable influence in shaping a queer consciousness about artistic practice at this time. Freud's study of Leonardo Da Vinci, in which he elaborates his theory of sublimation in relation to the artistic act, was newly available at this time with an English reprint in 1947 and, subsequently, a new translation in 1957.[14]

Freud's ideas were introduced to a popular queer readership through the publication of Cory's book (a whole chapter on sublimation) and articles in the homophile press such as "Immortal Beethoven — a Repressed Homosexual?" which appeared in *One* magazine in 1958. Such texts proffered a Freudian or quasi-Freudian line of argument by representing great art and music as the products of an elevated or sublimated homosexuality. William H. Kupper, the author of the *One* article, wrote that "chaotic sexual drives which possibly never having been expressed physically, were eventually channeled for the good of society into creative endeavors of the loftiest and most profound order."[15] "Beethoven," he claims, "at no time displayed normal sexual drives, and that on closer analysis there stands revealed an unfulfilled homosexual whose sublimated genius has redounded to the greatest glory of mankind" (8). Thus Kupper's article provides a specifically homosexual gloss for artistic genius.

Also influential in generating a popular consciousness about the queerness of genius were turn-of-the-century ideas about the homosexual as an intermediate or "third" sex. Ideas propounded variously by sexologists Edward Carpenter, Karl Ulrichs, and Magnus Hirschfeld still enjoyed a degree of popular currency in the fifties and enabled gay men (and lesbians) to conceive of homosexuality as offering a special position between the heterosexual genders of man and woman. This served as explanation as it were for their supposed unusual artistic talents and abilities. As Cory writes, the chief idea was that

inverts constituted a third sex. They were neither males nor females, but an intermediate group having unusual talents, inclinations, and instincts derived from a special position between the sexes. The invert, according to this method of thinking, had a better understanding of women than had normal males; had a superior sense of form and enhanced proclivities for aesthetic appreciation. Certain writers claimed that in many respects he was a superior person, and this gave homosexuality a place in the scheme of things, a reason for being. Such reasoning, being a response to the group and individual degradation to which people were subject, answered the concept of inferiority with a contention, frequently obscure, of superiority. (*H* 61)

Carpenter's line on the superiority of the third sex, originally developed in his studies on Walt Whitman, was given an airing in A. E. Smith's scholarly study "The Curious Controversy over Whitman's Sexuality." Published in the *One Institute Quarterly* in 1959, it gave an overview of various perspectives on Whitman's sexuality, including an account of Carpenter's changing views on the subject.[16] Carpenter is quoted as characterizing Whitman as a type of human "so far above the ordinary man and woman that [he] looks upon both with equal eyes" (9). Another article, published in a 1954 issue of *One* bearing the legend "The Mystery of Walt Whitman" on its cover (fig. 11), considered the ambiguity of Whitman's masculinity, rendering him as "no dainty, dolce affetuoso" but not quite straightforwardly masculine either.[17] Thus it contrived to represent Whitman as an indeterminately gendered individual, if not quite masculine then certainly not quite feminine either — his specific gender identity a consequence of his homosexual or "inverted" desire.

It was by drawing upon such psychoanalytical and sexological forms of argumentation that the homosexual's belief in his/her artistic superiority was able to establish at least some degree of academic credibility. But even if such theoretical propositions were available to make better sense of general assumptions about the special nature of homosexual creativity, some commentators nevertheless ventured forth their total opposition to any idea of it. Some in the national press asserted that homosexuals were simply attempting to "hide behind great men," betraying a homophobic imagining of gay men cowering behind the presumptively straight creators of civilized culture while at the same time being in a position to metaphorically fuck genius in the ass.[18] Other, more progressive, souls thought the idea of homosexual superiority too politically regressive, and a distraction from the democratic

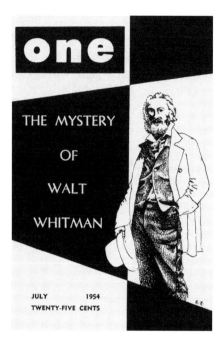

Figure 11. "The Mystery of Walt Whitman," front cover of *One* magazine, July 1954. Courtesy of ONE Institute and Archives, Los Angeles.

struggle for homosexual equality. Norman Mailer perhaps sums up this argument best, writing in *One* in 1955: "If the homosexual is ever to achieve real social equality and acceptance, he too will have to work the hard row of shedding his own prejudices. Driven into defiance, it is natural if regrettable, that many homosexuals go to the direction of assuming that there is something intrinsically superior in homosexuality, and carried far enough it is a viewpoint which is as stultifying, as ridiculous, and as anti-human as the heterosexual's prejudice."[19] The psychologist Albert Ellis also took issue with the idea, but less on a political and more on a scientific basis. The "widespread belief," he writes, "that an unusually high proportion of artists and individuals who are interested in art are homosexually inclined" is largely a myth, one fostered "by prejudiced observers" such as Carpenter and his Victorian counterparts Havelock Ellis and John Addington Symonds.[20]

IDOL GOSSIP

But however wrong-footed or specious some of these arguments might have appeared then—or indeed appear to us now—we should recognize that it was nevertheless partly on the basis of such understandings that a significant

relationship between homosexuality and artistic genius came to be forged in popular queer consciousness in the 1950s and early 1960s. Such understanding enabled a new, and distinctly *queer*, appreciation of the work of genius. Cory writes that it is "in the light of the intimate relationships between the fact of being homosexual and the personality and intellectual characteristics derived therefrom that one can appreciate the genius of a Leonardo, a Whitman, and a Proust" (*H* 154). Seeing genius in this way as a kind of queer personality trait was one way in which homosexuality could be seen to inhere in a quality valorized and legitimized by mainstream culture, thereby challenging the otherwise abject condition of gayness within American social and cultural life.

Many within 1950s queer communities, therefore, looked to figures of outstanding achievement in the artistic and cultural world as part of what Cory calls their "search for a hero." This was the name given to one of the chapters in Cory's book which addressed the tendency of the homosexual minority to idolize (what it presumed to be) its own artists and writers. The idea was that, in proving some kind of link between the values of artistic greatness and homosexuality, mainstream culture would have to revise its homophobic definitions of gay sexuality and accept it as a worthy and legitimate expression of the human libido.

Many articles appeared within the homophile press which analyzed the relationships between genius and homosexuality, and as such, they should be regarded as early examples of gay art and literary history. By considering the homosexuality of such artistic types as Leonardo, Beethoven, Michelangelo, and Whitman, homophile discourse worked to confer a more positive status on the homosexual minority.[21] As Cory puts it: "In identifying a great personality with a minority, the members of the [minority] group are actually identifying themselves to a large extent with their hero's greatness" (*H* 157). Viewing themselves as possessing a superior artistic predisposition, and legitimating themselves in terms of a fine historical pedigree — that is, a history of great artists — it was possible for gay men to construe themselves as worthy and productive human beings. It was also through identifying themselves with these supposedly gay artists that homosexuals came to constitute themselves as members of a distinct minority group. As George Chauncey writes, "claiming certain historical figures was important to gay men not only because it validated their own homosexuality, but because it linked them to others. One of the ways groups of people constitute themselves as an ethnic, religious, or national community is by constructing a history that provides its members with a shared tradition and collective ancestors."[22]

But this identification of a minority group through creative geniuses of the past was, according to Cory, "a particularly difficult task for homosexuals" (*H* 158). This was because of the general lack of biographical facts which might purport to prove an individual artist's sexual orientation, as well as the willful falsification and distortion visited upon the lives of artists by homophobic biographers, critics, and art historians. As Kupper notes in his article on Beethoven cited above, "no evidence has ever turned up that [proves that] Beethoven had any homosexual experiences. This would not be surprising even if Beethoven were an overt homosexual, since his life is now cloaked by the mantle of time, conventions, and greatness."[23] And yet this does not stop him, nor others in the 1950s, in identifying homosexual geniuses in history, even if such an identification can never be established — as the logic of the archive might lead us to desire it — as "beyond doubt," provable, and demonstrable with reference to documentary evidence.

Kupper, for instance, develops a Freudian line of inquiry by suggesting that Beethoven may have been a repressed homosexual, a "tortured genius" who sublimated his "powerful subconscious, chaotic sexual drives . . . for the good of society" (8). He lists a number of pieces of biographical information — including his overattachment to his mother, his intimate correspondence with "several young men," and his failed attempts at heterosexual marriage — to support his reading of this particular "homosexual" genius. This Freudian line was particularly suitable to such early gay art historians because it allowed them to read homosexuality in the absence of conventional evidence of overt homosexual behavior and against the archive's apparent desire to expunge homosexuality from history. As such Freudian and quasi-Freudian accounts were popularized through the homophile press, new forms of evidence of sexuality — biographical details or character traits which might be read as symptoms of some repressed or unspoken desire — came to be introduced into the everyday parlance of queer culture.

This lack of conventional hard evidence of the queerness of genius meant that many famous artists came to be queered through the circulation of rumor and suggestion, whether psychoanalytically inflected or otherwise. Certain kinds of insider evidence came to be significant to those in the know. Particular aspects of an artist's life — on the face of it perhaps immune to any queer understanding or meaning — would be sufficient to raise at least the suspicion of homosexual identity to those who shared the interpretative codes. For example, for those who were apt to see it that way, like the readers of *Fizeek Art Quarterly* — a muscle magazine where the artistic appreciation

of the male body stood as a barely veiled invocation of homoerotic plea-
sure — particular biographical details of Michelangelo's life could be high-
lighted in such a way as to make them pregnant with queer significance.

In an article entitled "The Art of Michelangelo," which appeared in FAQ
in 1962, we find a bastardized history and appreciation of the artist's great-
ness.[24] Bastardized because, for a brief (three-page) synopsis of such a life,
it is unusual in its inclusion of comments about Michelangelo's dishonesty
as a forger of antique sculptures, as well as details of the blackmail he suf-
fered at the hands of one of his apprentices and of how he engaged with the
problems of "temptation, sin and atonement" through his later work (5).
In addition, the article gives much space to a lengthy citation of one of the
artist's love poems to Gherardo Perini. The narrative of genius, such as it
survives here in this kitsch and clumsy rewrite, is thus transformed into a
narrative of a gay life. The foregrounding of such elements as Michelangelo's
willful deceptions would have made it readily identifiable as gay narrative
to its 1960s queer readership, to whom dissimulation would have been part
of everyday life in mainstream social circles. But it does not name or de-
scribe homosexuality as such, therefore underscoring its generally closeted
construction of the gay artist.[25]

In this way, such a narrative instances the ways in which specific artists
from the history of Western art came to be subject to the phantasmatic pro-
jections of queer gossip and innuendo, in which the figures and achieve-
ments of certain geniuses came to be suggestively imbued with gay meaning,
especially within the discursive contexts of 1950s queer subculture.

Such a queering of, for example, the life and work of Michelangelo can
also be deduced from the front cover of the April 1960 edition of One maga-
zine which sports a close-up photograph of the artist's David (fig. 12). Inside
this particular issue of the magazine there is no commentary, no article or
feature, that is directly connected to this image. Therefore, the relation of
the cover to the magazine's content is not illustrative. But, given the rumors
already circulating about the artist within queer subculture, it still serves to
function — independently — as a signifier of homosexuality.

This was true of many of the covers of One, which began in the late 1950s
to utilize a particular coded representation of the male body, often suggest-
ing the homoerotic through the anal erotic viewpoint proffered to its readers
(see chapter 5 for more on this). However, the cover image of the April 1960
edition works quite differently from these more erotically coded ones. With
the David image, the body, albeit a sculpted one, is off-frame, leaving visible

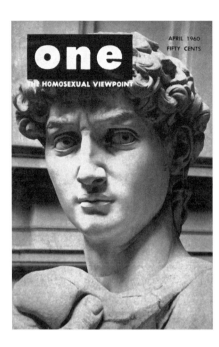

Figure 12. Michelangelo's *David*, front
cover of *One* magazine, April 1960.
Courtesy of ONE Institute and
Archives, Los Angeles.

only a powerful physiognomic icon. Although this may have operated in
part as a signifier of the displaced (homoerotic) body, I think it would also,
and perhaps more potently, have operated as a signifier of "Michelangelo"
or, more generically, "art." Such signifiers would, of course, be already im-
bued with homosexual connotations by dint of the various stories about the
artist's sex life — perhaps half-heard or half-remembered — circulating in the
conversational communities of *One*'s queer readership.

This double-coding of the seemingly "innocent" signifiers of art also un-
derpins the widespread ownership and display of small-scale plaster repro-
ductions of *David* in many gay men's homes at this time. Such figurines
would signify, in a safe and respectable way (i.e., to those in the know), the
homosexual orientation of its owners. Such reproductions were regularly
advertised in the pages of *One* magazine and were symptomatic of a kitsch
queer investment in Michelangelo's artistry (fig. 13).[26] Such an investment,
expressed through the consumption of a mass-produced object, would have
largely been undertaken by those queer men for whom homosexuality ap-
peared as something bound up with, or representable through, the languages
of art and class. Buying signifiers of high culture like this was therefore a way
of accruing a gay identity, anticipating what was to become the widespread
commercialization of gay culture in the 1960s and 1970s.

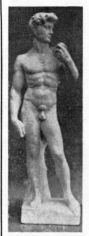

MICHELANGELO'S DAVID

a 24 inch
plaster statue

shipped
anywhere
in U. S.

$12.00
postpaid.

additional in-
formation and
three photos
50c

THE PAPER MATCH
6727 ⅛ Hollywood Boulevard
Hollywood 28, California

Figure 13. *David* advertisement, *One*
magazine, 1960. Courtesy of ONE
Institute and Archives, Los Angeles.

But what interests me for the remainder of this chapter is less how such stories about artist's sexual lives would have affected mass gay understandings of the generically "artistic," but rather more how artists might have viewed *themselves* in relation to such understandings and—even more—how they might have come to *recognize themselves as queer* through the projections of queer gossip and innuendo about "great" artists from the past.

We know that creative practitioners from the worlds of art, music, and other fields in fifties and sixties America were aware of rumors about gay artists, both contemporary and historically remote. The composer Lou Harrison, for instance, in an interview in *Gay Sunshine* in 1973 remarked that "the gay world has always known about Tchaikovsky, of course, and there have been rumors about Schubert, for example, and his friend."[27] In the visual arts, Andy Warhol clearly reveled in the news about his gay literary hero Truman Capote, and there is evidence in the Warhol archives that he was a consumer of the homophile press and physique magazines and therefore would likely have read some of their occasional pieces on great gay artists.[28] But did such rumors and mythologies necessarily inform an artist's

self-understanding? The playwright Tennessee Williams, for one, has suggested that this indeed may have been the case. He has gone on record saying that, in his opinion, homosexuals could be viewed as being generally "indistinguishable from the straight man, except that they have more sensibility and they are more inclined to be good artists."[29] This observation of the supposed tendency of queerness toward the artistic is echoed, as we shall see in the next chapter, by Larry Rivers's understanding of the commensurate nature of being homosexual and being an artist—one which was to have a formative influence on the development of his own artistic identity.

Viewed in the light of the various fictions which were circulating about the sexuality of artists at the time, then, it becomes possible to phantasmatically locate queerness within the spaces of high culture in 1950s America. The writer Seymour Kleinberg, for instance, sees it as being almost coterminous with certain high cultural practices and institutions: "in 1952 . . . if we were discreet, later known as closeted, if one acquired manners and taste and discrimination by going to the opera and ballet and theater, if one saw foreign movies and read *Partisan Review* and modern poetry, one would uncover in himself that finer clay."[30] He goes on to recall how he came to set his sights on academia, to be involved with cultural life and become an English professor: "what was perforce denied by [communist] radicalism or [Jewish] ethnicity was still allowed to perversity. I had quickly noticed that my literature professors made less fuss about sexual propriety than others. If there was any place to store this baggage, it was academia" (33–34). This identification of the world of high culture with homosexuality wasn't limited to the United States either, and it finds comparable expression in the personal recollections of British film theorist Richard Dyer. For him, growing up gay and getting into high culture in 1950s Britain felt to him like much the same process, "namely the process of establishing an identity":

> It is easy to see how easily I formed an equation between this [being queer] and being interested in culture. In an all boys school in the late fifties and early sixties, culture was as peculiar, as "other," as being queer. To begin with the connection between culture and queerness was spatial—culture seemed to be the place where you were allowed to be queer. This is partly because I had picked up on the folklore about cultural milieux being full of, or tolerating queers. Ballet and hairdressing above all, but coteries of painters and writers, for instance, were supposed to be very queer. At a minimum, the world of culture just seemed to be a place you could go if you were queer.[31]

Although, of course, this is a book about American identity, I cite Dyer here because he provides a useful formulation of the *world*ing of queerness within the context of an artistic life. Dyer writes, "there was no place else that I could identify as 'riddled with it,' no place else that seemed at least to accord queerness recognition" (note the McCarthyite overtones here) (177). Tellingly, this "world"—this place—was signaled to him, Dyer writes, by an "idea" of high culture suggested by "gossip includ[ing] the usual dirt on Shakespeare, Wilde, Tchaikovsky, Gielgud and the rest" (177).

This brings me to what I want to call, borrowing from the work of performance scholar José Esteban Muñoz, the *queer world-making* powers of gossip.[32] By this I mean the ability of hearsay about great "gay" artists to create an understanding of culture *as a queer space*, one which offered possibilities for minoritarian forms of sexual being otherwise denied within the majoritarian spaces of heterosexual culture. Muñoz writes in his book on "disidentificatory" performance that the practice of queer world-making is one which both transforms, and transports, its subjects to a new place—to novel worlds both present and yet to be actualized in the future. For those queers getting into high culture in the fifties, it became—by dint of the mythologies circulating about it—a space scripted for the minoritarian performance of the homosexually different. This difference was to be actualized through "a distinct way of reading and enjoying culture," one underpinned by a certain kind of knowledge of art's queerness. For the fifties "queen" armed with an understanding of the artistic tendencies supposedly secured by his "condition," culture became, as Dyer puts it, "the place to go—and a way out"; a way out, that is, of mainstream society's compulsory heterosexuality (177). In this context, the simple act of identifying oneself as cultured or artistic *performed queerness* by embracing it as a marker of sexual difference.

This queer performativity of artistic identity can perhaps be glimpsed in the following childhood recollections of two 1950s U.S. artistic types: the first by a gay composer, Ned Rorem, and the second by a gay artist, Jasper Johns. When asked by Winston Leyland in an interview for *Gay Sunshine* in 1974 to what extent his sexuality was interwoven with his work, Ned Rorem replied:

> How can one know? As an infant, almost from the time I knew how to talk, I knew what I wanted to be. It was just a question of tossing a coin—which kind of artist should I be: a performing musician, or a so-called creative musician? or shall I be a writer, or a dancer, or a whatever? . . .

I never wanted to be what other little boys wanted to be, a fireman, or Tarzan, or . . . Oh, I did aspire to be a pastry cook for a while. Still, it never occurred to me that everybody in grammar school wasn't exactly like me; it never occurred to me that when they went home in the afternoon they didn't sit down and play Ravel on the Piano, and then try to write pieces that sounded like Ravel. It never occurred to me that they didn't read Hawthorne or Gide. It was a rude awakening: the lack of curiosity I found in my fellow man.[33]

A similar perspective comes from Jasper Johns, in an interview with Emile De Antonio for the film *Painters Painting* in 1972, delivered in Johns's typically ponderous, halting prose:

It had been my intention to be an artist since I was a child. And, in the place where I was a child, there was no art so I really didn't know what that meant and I think it meant I would be able to be in a situation other than the one I was in. I think that was the primary fantasy. Whereas the society there seemed to accommodate every other thing I knew about but not that possibility. So I think the idea of being an artist was that kind of fantasy—being out of this.[34]

What strikes me upon reading these two accounts is the profound sense of *difference* that their early artistic inclinations and desires confer upon them. For Rorem, his piano playing and reading came to signal to him his difference from other boys; whereas for Johns, becoming an artist meant "othering" himself from the dominant and provincial culture of his native South Carolina, creating a new identity for himself, one "other than the one [he] was in." The sense of otherness afforded by artistic identity, evidenced in these childhood recollections, forms, I think, the phantasmatic potentiality through which Rorem and Johns might have come to comprehend a Cory-esque, minoritarian construction of gay male difference. Reading both of these symptomatically, I would venture that for these two figures at least, becoming an artist may have served as a mode of becoming homosexual.

One of the key aspects of Muñoz's idea of queer world-making is that such queer worlds are forged through a *dis*identification with normative structures of being and belonging. For Rorem and Johns, we can see how—in these narratives of childhood desire and fantasy—the powerful drive to become an artist is founded upon an equally potent disidentification with the reality of the cultures in which they find themselves. This early phantasmatic structuring of artistic selfhood in terms of a kind of "outsiderness" is de-

Figure 14. Ned Rorem, 1953. Photo © Man Ray Trust/ADAGP, Paris and DACS, London 2001.

Figure 15. Ned Rorem, 1953. Photo © Man Ray Trust/ADAGP, Paris and DACS, London 2001.

veloped in both the composer's and the artist's more mature performance of artistic identity in the fifties and early sixties.

In Rorem's case, his artistic (and sexual) otherness is derived out of a snobbish contempt for mediocrity ("sheer mediocrity is killing the planet," he writes in his published diaries from the 1950s) and a celebration of the highbrow as a marker of difference within a world of sameness: "people are mostly alike; one hopes for a difference. When a crippled girl entered the restaurant tonight I mused that there at least, by definition, was a difference. But then she brought forth *The Readers' Digest*."[35] Thus Rorem signals his removal from the low cultural tastes of mass society and signals instead his aristocratic investment in the supposed superiority of high culture. In this way, Rorem styles himself in the manner of a Wildean dandy, trading on the supposed superiority of his artistic subjectivity. The codes of appearance of this model of artistic identity we can see in Man Ray's photographs of the composer, taken in Paris in 1953 (figs. 14, 15). His clean shaven and dashing good looks — the subject of much pride and later anxiety in his diaries — are evident here, topped by his carefully dyed and coiffured hair. Sporting a trench coat and jacket, with a scarf carefully arranged in a different way

for each exposure, Rorem cuts a dandyish figure as he gazes off-frame in an almost hackneyed romantic pose, eyes focused on some imaginary point of inspiration.

The construction of Jasper Johns's artistic identity depends less on such European constructions of the romantic artist, however, and rather more on a model of "Americanness" riven with uncertain and disputed queer meanings: one which pivots around the figure of the American poet Walt Whitman. Whitman was the subject of much heated debate in literary circles in the 1950s about the homoerotic meanings or otherwise of his "Calamus" poems, as well as about whether or not Whitman could be construed as homosexual. The controversy, detailed exhaustively in Smith's *One Institute Quarterly* article cited above, was largely focused on the details of Whitman's sex life. It had begun with publications by Symonds, Ellis, and Carpenter around the end of the nineteenth century and beginning of the twentieth and had continued to run in the various Whitman studies published by G. W. Allen, Malcolm Cowley, and others in the 1950s.[36] The "to-ing and fro-ing" of debate took the form of a series of avowals and disavowals of Whitman's homosexuality based on variously disputed facts about his life: whether or not his letters to "friend" Peter Doyle could be construed as love letters; whether or not he fathered six illegitimate children; whether or not he had any lasting sexual relations with women; and whether or not his interest in working men was erotically motivated.

This veritable snooping into Whitman's sex life and, in particular, the constant play of assertion and counterassertion, made it difficult to finally determine the truth about Whitman's sexuality. This would have made of him a figure highly charged with queer meaning but one subject to an "abiding deniability."[37] These are D. A. Miller's words from an article which usefully characterizes homosexual meaning in postwar culture as invariably "elided even as it is also being elaborated . . . at once developed [as it is] denied" (124, 125). Thus Whitman would have been available as a queer figure for someone like Jasper Johns to identify with, and to model himself on, without fear that this queer identification would *necessarily* be read *as such*.

Bearing in mind Cory's arguments in *The Homosexual in America* about the importance to gay men of identifying with "great" gays from history, we can usefully speculate here on the possible significance of Johns's identification with Whitman — in particular the phantasmatic and indeterminately queer "Whitman" which emerges from the incessant speculation around him. Kenneth Silver has written about the ways in which Johns signaled his identification with a tradition of gay artists and poets, such as Marsden Hart-

ley, Charles Demuth, Hart Crane, and, of course, Walt Whitman through his paintings. Silver has read Johns's works, such as *Periscope (Hart Crane)* from 1963, as significant attempts to situate Johns within a gay tradition, linked "hand-in-hand" with Crane and Whitman, thus aligning himself within a preexisting gay cultural tradition.[38] In this way, Johns can be seen to invest in a structure of queer identification in which the name Whitman and those of other gay poets were writ large. This was one that had its roots in the nineteenth century. As Eve Kosofsky Sedgwick has written of a burgeoning homosexual culture in Victorian England: "photographs of Whitman, gifts of Whitman's books, specimens of his handwriting, news of Whitman, admiring references to Whitman which seem to have functioned as badges of homosexual recognition, were the currency of a new community that saw itself as created in Whitman's image."[39]

Looking at such direct references and allusions to Whitman within Johns's paintings is only one way, however, through which we might trace the artist's (queer) identification with the poet. We may also consider how this identification comes to manifest itself within the gendered performance of Johns's artistic identity. As we have seen in the debates within the homophile press, Whitman was frequently seen to embody a nonstereotypical form of homosexual identity, one deemed to be more "manly" than the effete sissy or fairy type. However, this was no *straightforwardly* masculine form of embodiment either (as *One* noted, the poet's masculinity was "the most ensnarled question regarding Whitman's character").[40] This made Whitman a figure of "artistic" difference not reducible to the conventionally masculine or effete.

We can see such a Whitmanesque coding of the artistic body in photographs of Johns in his studio from the mid-1950s (figs. 16, 17). Compared with the Namuth photograph of Willem de Kooning which I analyzed in chapter 1, these images eschew some of the more overtly masculinist presentational codings of the artistic body. Gone is the explicitly proprietorial stance of de Kooning as he stands, arms folded, before his work. On the contrary, in figure 16 Johns appears seated, slightly off-center, almost usurped as the focus of the photograph by one of his *Target* paintings hanging on the wall behind him. However, he's significantly *not* as off-center as Elaine in Namuth's image; he doesn't exactly appear "upstaged, idle, or doting." He does, however, in comparison with Willem de Kooning, or maybe the surly, self-asserting gaze of Pollock in the famous *Life* magazine spread from 1949, look withdrawn and slightly inscrutable. Further, with his clean-cut and clean-shaven appearance, wearing a close-fitting jumper, and, in figure 17, a crisp suit and tie, Johns displaces the proletarianized persona of the ab-

Figure 16. Jasper Johns and *Target with Four Faces*, c. 1955. Photo © Robert Rauschenberg/DACS, London/VAGA, New York 2001.

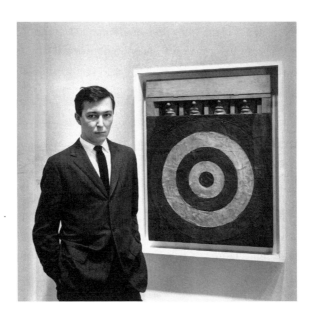

Figure 17. Jasper Johns, 1959. Photo © Ben Martin/Getty Images.

stract expressionist artist. All of these things point to a slightly more dapper, bourgeois performance of artistic identity but one which falls short of the effete, dandyish pose of, say, Ned Rorem.

This not-quite-masculine but neither-quite-feminine construction of Johns's artistic body is echoed within recent studies of Johns's work. In the context of a subtle and nuanced reading of Johns's painterly touch, Fred Orton examines the ways in which critics are unable to resolve it as either masculine or feminine.[41] "The move away from de Kooning's abstract expressionism," he writes, "is by way of a practice gendered in the feminine but [one] not so completely gendered as to be corrupted by 'the usual cosmeticism'" (121). That is, Johns's difference from the machismo of abstract expressionism is one that while perhaps *signaling* the feminine cannot be made over into a wholesale identification *with it*. It is a disavowal of a masculine coded touch, Orton argues, that does not "abolish" masculinity but rather avows instead the possibility of an "other kind of touch, [one] that has to be understood as, or associated with, a kind of non-masculine masculinity." This "non-masculine masculinity," he concludes, "surfaces as an allegory of homosexuality made at a moment when there was no space in avant-garde art practice for its self-representation or identification" (124). That is, in appearing as neither securely masculine nor securely feminine, homosexuality comes to be figured in Johns's work as unrepresentable — at least, that is, on the terms of the gendered codes of abstract expressionist painting. His painterly handling evinces a kind of "queer touch," one which works at the limit point of the heterosexist constructions of gender difference purveyed within the languages of 1950s painting.

If, as Seymour Kleinberg has written, "being homosexual in the fifties meant not really male," then for Johns, constructed in this Whitmanesque mold, it meant not really feminine either.[42] His queer world-making performance as a Whitmanesque subject can be seen to engender a performance of a minoritarianism not accepting of rigid gender binaries, and, as Muñoz suggests, this may be one which motions toward a subject and a world still yet to be made, or a nation — "America" — still yet to come. As many commentators have noted, including those in the homophile press in the 1950s, Whitman's democratic vision of an America united through "adhesive" or manly love is riven with homoerotic ambivalence.[43] His celebratory declarations of the joys of masculine comradeship exhibit an instability of meaning, sliding incessantly from the homosocial to the homoerotic and back again. This ambivalence might be seen to resurface in the instabilities which attend Johns's own evocation of American identity in *Flag* (fig. 18). As many com-

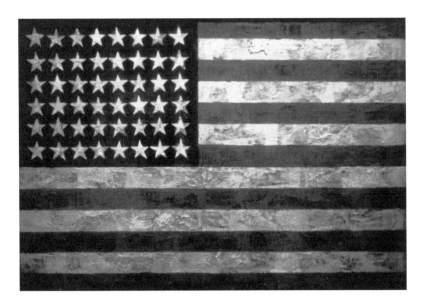

Figure 18. Jasper Johns, *Flag* (1954–1955; dated 1954 on reverse). Encaustic, oil, and collage on fabric mounted on plywood, 42 ¼ × 60 ⅝″ (107.3 × 153.8 cm). The Museum of Modern Art, New York. Gift of Philip Johnson in honor of Alfred H. Barr Jr. Photograph © 2002 the Museum of Modern Art, New York. © Jasper Johns/ VAGA, New York/ DACS, London 2001.

mentators on Johns's art have remarked, by choosing the stars and stripes as his subject, the artist worked to efface his own individual identity from his art. However this effacing might also be understood, in the light of what I have been arguing in this chapter, as clearing the way for an Americanness which as yet could barely be represented within art. This was an identity which in the 1950s had little in the way of its "own" representational codes and which I have approached here through its largely imaginary invocation — through the varying projections of the queerness of artistic identity.

As we have seen in the previous chapter, for artists such as Benton, de Kooning, and Pollock, such queer determinations of the artist were necessarily disavowed as part of the performative work of constituting a heterosexual artistic subjectivity. For other artists, however, especially gay ones, embracing such mythic and queered fictions of the artist in the formation of their own identities enabled them to construe an understanding of themselves as sexual subjects, carving out a homosexual identity for themselves simply through performing the queerly inflected "being" of the artist. What

I have been attempting to highlight in this chapter are the complex levels of cultural discourse through which this queer performativity of artistic identity might be understood — the way in which the artistic life, so to speak, could be experienced as a specifically queer form of existence and the figure of the artist him/herself a specifically queer form of embodiment. Of course, this was no outward performance of "gay" identity through the explicit sexualization of bodily codes, as we might understand it in a post-Stonewall sense, but rather a relatively hidden and interiorized projection of queerness onto the otherwise "merely" artistic body. This was a kind of social and psychic investment enabled by the circulation of myths about the artistic tendencies afforded by homosexuality, one which enabled gay artists to enjoy a valorized construction of themselves as artist-homosexuals, and to partake of a degree of social worthiness and acceptability otherwise denied to gay men at this time. Becoming or being an artist in such contexts, then, can be viewed as an act or a state full, and yet empty, of queer significance — one which affords the constitution of a sexual selfhood while never risking the dangers of having it marked outwardly, and undeniably, *as such* on the body.

{ CHAPTER 3 }

THE GIFT OF THE GAB:

CAMP TALK AND THE ART

OF LARRY RIVERS

Writing in *The New York Times Magazine* in 1966, Grace Glueck paints a vivid picture of the vibrant and dynamic life of the artist Larry Rivers.[1] In detailing Rivers's prodigious activities as a painter, draftsman, sculptor, poet, and jazz musician, Glueck suggests that he represents a remarkable character as a creative individual. So remarkable in fact that she ventures, "if Larry Rivers didn't exist . . . the movies (both Hollywood and underground) would have to invent him" (*R* 35). Certainly his multiple talents, often cited in the literature on Rivers, make him an artist ripe for celebration in terms of a mythic genius. But it is also, Glueck goes on, the compelling story of Rivers's *life* which lends his persona a curious mixture of Hollywood aura and bohemian cool.

The "script" of his life, she writes, "is foolproof": "a Bronx boyhood as Yitzroch Loiza Grossberg, gilded youth as a professional saxophonist, a meeting with a Girl Who Changed His Life, a struggling apprenticeship to Art. And then success—a flying leap to critical acclaim, public fame" and, she ends dryly, "a fat black Cadillac."[2] Such a life story could not better resemble the typical rags-to-riches narrative so beloved of Hollywood, Glueck suggests, and is indicative of the degree to which Rivers's persona appeared to many at the time to be made out of the very stuff of myth.[3] This kind of success story, replete with the trappings of American consumer capitalism, would normally have put one out of step with the values of the postwar avant-garde community. As Glueck quips, to be successful in this vein was more likely to be seen as a sign that you were doing something wrong rather

than as a marker of artistic achievement. But it is precisely because of the fact that Rivers was able to make it big in the world of avant-garde art, and on such spectacularized terms, which Glueck takes as one of Rivers's most remarkable accomplishments.

As for Glueck, so too for this writer. For what fascinates me about Rivers, and what leads me to take him as a subject for this book, is the way in which he appears as a kind of star persona in an art world where Hollywood values would have been fairly explicitly, and routinely derided as superficial and insignificant. Coming of age in the 1950s, well before Andy Warhol's critical canonization as the definitive artist-celebrity of the 1960s (more about this in the next chapter), Rivers emerges as a figure who scandalously flirts with sensationalized narratives of art and artistic identity. According to those around him at the time, this meant that Rivers was often taken to be the art-world exhibitionist. His beatnik dress ("tight pants, boots, far-out ties") and his "brash behavior" at parties (R 80); his involvement in jazz music; his drug taking; his tendency for self-aggrandizing and self-mythologizing statements; as well as his appearance on a television quiz show *The $64,000 Question* ("where he matched wits and arts expertise with a jockey and a minor movie star"[4]), were all variously seen as evidence of Rivers's essentially showy and theatricalized relation to being an artist. Many saw Rivers as being chiefly motivated by a desire to be in the limelight rather than by any serious investment in his art. As one "devoted enemy" puts it, Rivers was a kind of "professional character" (R 80). Or, alternatively, as Jane Freilicher, a close painter friend and sometime lover, suggests, such a self-conscious staging of his artistic self might be seen more favorably as evidence of Rivers's proto-Warholian values: "I think of his talent for publicity as simply one among his many gifts" (R 80).

Whatever the critical assessment here, it seems clear that Rivers made it his business to fashion himself into a subject to be talked about, exposing his life to public scrutiny in an audacious manner that certainly placed him at odds with the typically inward-looking perspective of 1950s artists such as Jackson Pollock. Given that Rivers seemed to be so much more self-serving than other artists around him, I want to consider in this chapter how such an "attention-seeking" gambit played in the contexts of the 1950s and early 1960s art worlds. Did Rivers succeed in arousing people's interest in him? And, if indeed Rivers's life *was* as charmed and dynamic as Glueck would have us believe, then to what degree did it become the subject of that most preeminent kind of Hollywood treatment — gossip? Did Rivers's life become

unusually prone to the attention of gossip both within and without the art world at this time? And, if so, what consequences might this have had, and might it continue to have, for the critical appreciation of his art?

The answer to the question of whether or not Rivers became the subject of gossip is certainly yes, he did get gossiped about, though perhaps not wholly in the ways that one might expect. Undoubtedly, like most of us, Rivers was gossiped about by his close compatriots and, particularly, by his friends and lovers. People gossiped about whether or not he was a good artist or just a pretender, and about his sexual and artistic relationships, particularly his liaison with the poet Frank O'Hara. Brad Gooch's 1993 book *City Poet: The Life and Times of Frank O'Hara* is full of such snippets of gossip—some credited to named individuals, others anonymous. Lines about how Rivers was no good as an artist without the guiding presence of O'Hara ("it was like the college girl sleeping with the professor"); and recollections of O'Hara and Rivers canoodling behind a drape on their first meeting at a party, are testament to the degree to which Rivers was a lively subject of talk in the social contexts of New York bohemia.[5]

Unlike what happened to most subjects of gossip, however, it wasn't friends and colleagues who were doing most of the gossiping but *Rivers himself*, working in his self-publicizing mode. Or, more precisely, as Glueck's article suggests, it was Rivers's *paintings* that were doing the gossiping for him: "In fact, Rivers' work is a direct expression of his personality—in a sense, he paints himself right into the canvas. Not only is his art like his talk—spontaneous, full of swift images, making sudden jumps from outline sketch to flashy bravura passage—but its subject matter is mainly drawn from his life—'a kind of autobiography, even a visual gossip column,' he says" (*R* 78–79). Of course, some of this is standard fare for any art criticism considering the relations between an artist's life and work in the wake of abstract expressionism. The idea of an artist somehow being present within the canvas had become a staple feature of a popular, quasi-existentialist understanding of art ever since Pollock made his now famous pronouncement about being "in" his paintings.[6] But what is interesting here is that if Rivers could also be deemed to be in his paintings, then he was so in a way radically distinct from the presentist ethos of abstract expressionist practice. As Glueck suggests, Rivers's presence in his art owes more to the fleeting and unprogrammatic observation of various different aspects of his life, a passing form of attention which reflects Rivers's penchant for casual observation and idle talk rather than any metaphysical embodiment of his artistic Being.

Rivers's own characterization of his work as a "visual gossip column" is

particularly illuminating here, suggesting that the analogies which Glueck draws between his talk and his art are anything but idle and, instead, point toward a specific discursive inflection of his painterly practice. Rivers further underlines this by suggesting that his painting had come to replace the actual talking, transposing his fondness for gossiping to the level of his art: "Maybe putting so much of myself into my work is a kind of exorcism — if I get it all into the painting then I don't have to talk about it" (*R* 80). In this way the paintings can be seen, and in some novel ways, to be *speaking themselves* as they gossip about the life and loves of their creator in his New York artistic milieu.

I will return later to this rather awkward anthropomorphic casting of the work of art (can a work of art, indeed, be said to gossip?). Suffice it to say for the moment that the kind of people that Rivers's paintings might be seen to gossip about — however this might be construed — are his immediate circle of family, friends, and lovers. Many of these also happened to be his fellow compatriots in the worlds of painting, poetry, and art criticism. This doubling of intimate and artistic connections alerts us, I think, to the social basis of Rivers's peculiar mixture of personal information and artistic form which brands his painterly practice. Looked at as a whole, his paintings from the period feature the key figures in his life at this time: his two sons, Steven and Joseph; his mother-in-law Berdie; and friends, lovers, and fellow bohemian types such as Howard Kanovitz, Frank O'Hara, Jane Freilicher, and John Bernard Myers.

Rivers's paintings certainly "chitchat" fairly openly about his sex life, which, given that he slept with both men and women in the 1950s and early 1960s, is a remarkable achievement in the context of the generally closeted treatment of homosexuality in the art of his contemporaries. He celebrated such homosexual relationships in his art, sometimes in terms of daring portraits, such as his *O'Hara Nude with Boots* from 1954 (fig. 19). By painting O'Hara in nothing but his boots, Rivers echoes contemporaneous representations of men from physique photography which similarly stage the homoerotic appeal of the near naked (rather than nude) male body. At other times Rivers's work "speaks" of his homosexuality through artistic collaboration, such as in a series of lithographs he made with O'Hara in 1958, which carry references to their sexual relationship as well as to the bitchy comments made about it by others in the art world (fig. 20).[7] In addition to the homosexuality, and as part of his quest for unconventional experience, Rivers also had sex with his mother-in-law, Berdie, who forms the subject of a number of Rivers's unflinching portraits of nakedness from around this time (fig. 21).

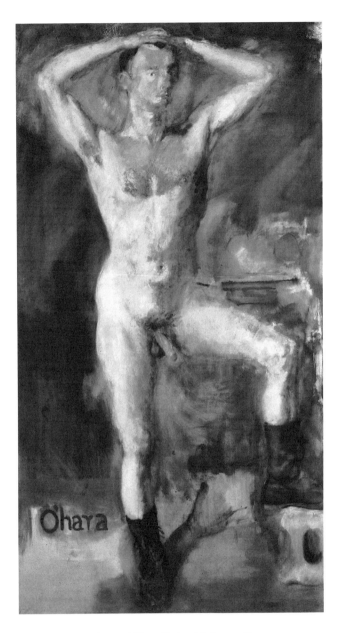

Figure 19. Larry Rivers, *O'Hara Nude with Boots*, oil on canvas, 1954. Collection of the artist. © Larry Rivers/VAGA, New York/DACS, London 2001.

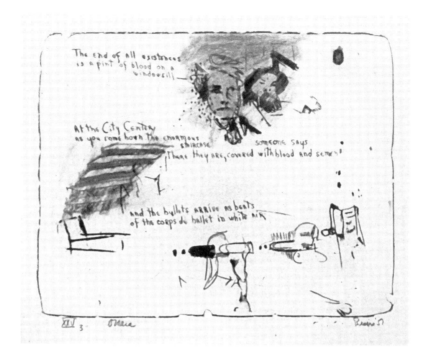

Figure 20. Larry Rivers and Frank O'Hara, *Stones: The End of All Existences*, lithograph, 1957. © Larry Rivers/VAGA, New York/DACS, London 2001.

In this way, and in a manner akin to the circulation of gossip, Rivers's early oeuvre might be seen as supplying us with intimate glimpses of Rivers's social and sexual life, providing us with confidential information about his life and loves. Or, as Kanovitz has put it: "He [Rivers] gets the smell of his bedroom into [his art]" (*R* 79).

If, as Rivers suggests, the painting had taken the place of the talking, this is not to suggest that he has otherwise remained silent or coy about such intimate matters within public discourse. On the contrary, as one caption puts it in the *New York Times Magazine*, Rivers has "the gift of the gab" (*R* 34). This is consistent with other commentators such as Gooch, who describes him as a "big talker" prone to exploding in "disorderly loud blarings" (*C* 175–176). Glueck too remarks on his skills as a conversationalist, which, she notes, seem to serve him well on the academic circuit. She quotes an enthusiastic member of the audience at one of his lectures who recalls: "It was a gas . . . He talked about sex, marriage, drugs—wildly funny, and the students loved it" (*R* 80). This remark points interestingly, I think, to the transgres-

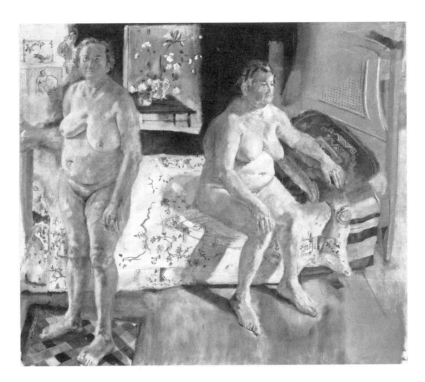

Figure 21. Larry Rivers, *Double Portrait of Berdie*, oil on canvas, 1955. Collection of the Whitney Museum of American Art, New York. Gift of an anonymous donor. Photograph © 2001, Whitney Museum of American Art. © Larry Rivers/ VAGA, New York/ DACS, London 2001.

sive nature of Rivers's public discourse. It highlights his tendency to exploit the formal setting, with its attendant expectation of high seriousness and significant meaning, for comedic purposes by speaking incongruously of so-called low matters such as his sex life and his drug taking. Such an obvious flair on Rivers's part for turning the details of his intimate life into enter-taining narrative leads Glueck to suggest that "what can be printed of [his autobiography] ought to be lively" (*R* 35).

Indeed, Glueck's statement has subsequently been borne out by the pub-lication in 1992 of Rivers's autobiography entitled *What Did I Do?*[8] The verve and disarming candor, as well as the wit and entertainment value, of Rivers's earlier public pronouncements is matched by the highly informative and compelling read of his mature autobiography. *What Did I Do?* in addition to offering insights into Rivers's personal and professional development, pro-

vides an invaluable archive of information about New York bohemian life in the postwar decades. In particular, it furnishes us with accounts of 1950s beat and drug cultures, as well as supplying illuminating insights into the sexual and social dynamics which underpinned the artistic lives of Rivers and his close compatriots. But this observation is already to make his book over into a significant *document*, highlighting its value for the production of art historical and other knowledges of the period, and it misses out on what I take to be the other, less legitimate pleasures which his biography importantly offers up to its readers.

These are, of course, the pleasures of gossip which *What Did I Do?* offers, at least to this reader, in abundance. It provides juicy pieces of gossip to savor about Rivers's most intimate circle of friends and lovers, as well as nuggets about such well-known figures as W. H. Auden, Clement Greenberg, and Helen Frankenthaler. In a chatty, confessional tone, Rivers happily divulges details about his sex life, with particularly revealing passages on his relationships with Frank O'Hara, John Bernard Myers, and Jane Freilicher. There are also many narratives of parties attended, of scandalous events witnessed, and of the interpersonal intrigue and professional rivalries which animated the New York bohemian scene. My personal favorite is a story about a sailor at one of W. H. Auden's parties who, after imbibing sufficient quantities of an alcoholic cocktail, caused a stir which ultimately brought about the wrath of his host. Rivers reports that the drunken sailor put on a pair of black silk stockings and sheer lace panties and, while singing "Anchors Aweigh," proceeded to "demurely" insert a kosher salami into his anus. Auden, apparently, then ordered his lover, Chester Kallman, to "get that hidee-ola out immediately" (*W* 110). This, Rivers recalls, was not because of any prudishness on Auden's part but rather because he felt that such a spectacle may have offended one Mrs. Noah Greenberg of the Pro Music Antique Ensemble who had brought the salami to the party with the expectation, perhaps, that it be ingested in a decidedly less lewd manner than demonstrated by his errant guest.

As I was reading *What Did I Do?* I therefore became aware of the degree to which my attentions as an academic historian became entwined with my pleasures and investments as an interested gossip. To try and pass off my interest in Rivers's biography in terms of a conventional academic reading practice—to legitimize it as instrumental in the production of disinterested knowledge—would be to miss out on what I think is a crucial, and intriguing, aspect of Rivers's practice as a whole: that as a writer, a painter, and a public speaker, Rivers addresses us as fellow intimates in a gossipy economy

of meaning and pleasure. What I want to suggest in what follows is that by incessantly painting, writing, and talking about himself through the various informal modes of address available to him—the fleeting observations in his paintings, the snippets of gossip in his autobiography, the garrulous nature of his public speech—Rivers encourages us to exercise and appreciate our "idle" curiosities about the sexual lives of himself and his fellow artistic compatriots. In doing so, I want to propose, he raises some thorny issues about the place of gossip—in particular of the pleasures of its unsanctioned knowledge—within art and art history.

Such issues I want to explore in particular as they impact upon a consideration of Rivers's paintings. Another photo caption in the *New York Times Magazine* describes Rivers's art as "colorful, witty, and joyfully spontaneous" (*R* 35). Such a characterization alerts us, I think, to what might be construed as the gossipy determination of Rivers's art, to its condition as painterly equivalent to the jokey, entertaining narratives of small talk and sexual tittle-tattle. But what are we to make of the information that such a gossipy practice offers up? If, indeed, Rivers's painting draws us to the incidents in the artist's bedroom, as Kanovitz would have us believe, then how are we to appreciate what we find there? How might an appreciation of the informality and intimate content of Rivers's art stand in relation to the ostensibly serious tasks of evaluation and interpretation commonly imputed to art criticism and art history?

In order to begin to address these questions, I want to start by exploring Rivers's formative fascination with a specific conversational community in New York from the late 1940s onward. This was the bohemian community made of up lesbian and gay artists, poets, critics—a community which Rivers himself was to become part of in the early 1950s. More specifically, it is to the queer modes of discursive performance characteristic of gay society at this time—of *camp talk*—that I want to turn to in opening up these questions around Rivers's art.

QUEER EXCHANGES

In *What Did I Do?* Rivers fondly recalls the parties he frequented at a loft rented by the painter Nell Blaine in the late 1940s and early 1950s. Blaine was one of the chief movers of the Jane Street Gallery artists and, as a lesbian, was also a pivotal figure in queer bohemian society at this time. It was at her parties, Rivers recollects, that he encountered a space "brimming" with

Figure 22. John Ashbery, Nell Blaine, Barbara Epstein, and Seymour Krim, 1949. Photo by Robert Bass. Courtesy of Tibor de Nagy Gallery, New York.

male homosexuals and where he came to appraise himself of what it meant to be an artist (*W* 109) (fig. 22). Rivers became acquainted with, and soon became part of, a largely gay male milieu which provided him with inspirational figures, as well as with friends and lovers, including the poets Frank O'Hara and John Ashbery; his dealer, John Bernard Myers; and the gallery owner, Tibor de Nagy, to name but a few. Such a social environment was to sustain him in his personal and professional life well into the midsixties.[9]

Blaine was the first "proper" artist that the young Rivers had met, and, on the evidence of the overlapping of gay society and bohemian life in her immediate circle of friends, he took it that "there was some connection between when you're in the art world or something like that, maybe you're queer—like you'd have to be queer."[10] Rivers soon embraced this recognition of an apparent and definitive connection between being in the art world and being queer as part of his own bid to become an avant-garde artist. Reading *What Did I Do?* leaves you in little doubt about the fascination and admiration that Rivers had for his homosexual fellows in the 1950s and 1960s, and, as I have already mentioned, Rivers had sex with men as well as women at this time in his life. "In the opening years of the '50s, I behaved pretty

much as though I were gay," he has since recalled. "It seemed to me that queerdom was a country in which there was more fun . . . there was something about homosexuality that seemed too much, too gorgeous, too ripe . . . it seemed to be pushing everything to its fullest point."[11] But even if Rivers found homosexuality attractive enough to have gay sex himself, he nevertheless continued to maintain his heterosexual orientation: "I was in a rather conventional tradition of men who are mainly heterosexual, or have had mostly heterosexual experience, who when they get with men who are homosexual act as if they are allowing themselves to be had" (*C* 229). This marks Rivers as a *straight* artist—at least nominally—but one whose identity is forged through a self-conscious embrace of the forms and activities of queer society.[12]

One such aspect of queer culture that drew Rivers's admiring attention, and which was to have a formative impact on his work as a painter, was the gay chatter that Rivers routinely encountered at Blaine's parties. His imaginative reconstruction in his autobiography of snippets of such conversation is worth quoting here at length:

> "My Dear, I've been reading Dostoyevsky's *Raw Youth*. It's marvelous. I found the spirit of the book to be—"
>
> "Spirit, my ass," someone interrupts. "He filched it all from Dickens, who has everything Dostoyevsky has, plus being—"
>
> "What, a social historian? How about the honorable Honoré? You're not telling me that Dickens had more balls than Balzac."
>
> "Ronald Firbank held more balls than Balzac."
>
> "Where?"
>
> "In a ballroom, honey. Where do you hold balls?"
>
> "I don't hold balls in a ballroom. I hold them in a bedroom."
>
> "I hold them in a men's room," someone chirps up from the end of the couch. (*W* 109)

Rivers writes that he was impressed by the pressure exerted in such exchanges "to exhibit a talent for the well-turned phrase," as well as noting the unusual value attributed to "silly bits of information" (*W* 109). This is clear here in the degree to which the discussion (such as it is) about the relative merits of different authors is overtaken by the imperative of each successive respondent to counter the previous comment with a more biting quip. Such an imperative lends the conversation an aesthetic dimension as style and wit come to predominate over and above any "serious" discussion. And even though the exchange takes the form, at least superficially, of an elevated

discussion about the great figures of literature, it is clear that this is being willfully debased here by the slide into a "trivial" exchange of innuendoes about gay sex.

Rivers's imaginative recollection probably tells us as much about what he found impressive about such conversation as it tells us about the kinds of things that were actually said. And, from this example at least, it seemed that what impressed him most was the conjunction of a performance of high cultural sophistication along with the banalizing effects of sexual innuendo, making for a peculiar mixture of "high" seriousness and "low" triviality.

The emphasis here both on the discursive performance of a bitchy exchange of witty and well-honed lines, and on the vulgar pleasures of sexual humor, demonstrate the typical features of postwar camp talk. As a term within gay male argot in the 1940s and 1950s, *camp* usually referred to an effeminate homosexual or "queen," and particularly to "her" bodily deportment and the bitchy talk that was characteristic of "her" speech. By referring to one another through such stereotypically feminine forms of address such as "my dear" and "honey," the gay men at Blaine's parties demonstrated their penchant for such camp talk, and particularly for its parodic citation of conventional gender norms. Rivers writes approvingly of the extent of this parodic speech in the circles of artists and poets he knew at the time: "men often referred to one another by women's names. Even things and places were given female proper names. Out at the beach in the Hamptons, if our new friend Waldemar went for a swim, either Frank O'Hara or Jimmy Schuyler flat on the wicker would sit up: 'Oh, look! There goes Wilma, off to Ophelia Ocean for her afternoon dip'" (*W* 109–110).

Such an affected, and evidently incongruous, adoption of feminine gender codes drew attention to the fact that such codes were being performed. As one of the characters in Christopher Isherwood's 1954 novel *The World in the Evening* comments, it is precisely a "swishy little boy with peroxided hair, dressed in a picture hat and a feather boa, pretending to be Marlene Dietrich [that] in queer circles they call . . . camping."[13] To earn its moniker as camp, the male body had to make it apparent that feminine gender codes were being quoted and that they were not, at some level, being taken seriously. Camp was a mode of "being," therefore, that owed more to the logic of performance—to artifice and acting—than to conventional, naturalized constructions of gender identity. That the objects of camp performance, in this case Marlene Dietrich, were in themselves artificially staged constructions of femininity went only to underscore camp's performative aspect and its proximity to, and overlap with, the practices of gay male drag.[14] In de-

livering lines such as "In a ballroom, honey," echoing the retorts perhaps of countless Hollywood screen goddesses, Blaine's guests exhibited a preference for camp's typically theatricalized and hyperbolic forms of exchange.

Rivers was impressed by the novelty of such talk: "Their language was so new and fresh and marvelous — I mean, like switching the roles, and calling everybody we knew by girl's names. That was very funny."[15] He recalls that upon hearing such exchanges for the first time, he "began spinning in an ever expanding reality" (*W* 109). This was, in large part perhaps, because Rivers was forced to rethink most of his ideas about homosexuality. Rather than striking him as an expression of a degraded, effete homosexuality, so common to mainstream representation in the early 1950s, camp talk seemed, on the contrary, to promise all that was desirable and different about an artistic and cultured life. In his desire to escape the supposed cultural paucity of his lower middle-class Jewish upbringing, the cultured references of such talk impressed the young Rivers as markers of class and sophistication. Most of Blaine's guests, he recalls, "if not as well read as they tried to sound, showed a great interest in literature" (*W* 109). Similarly the effeminate deportment of the camp queer body, which, Rivers remarks, your "average Joe would call a fairy" was something he related to as "class" (*W* 47). Such an appreciation of gay style as an upper strata way of being made homosexuality appear as an integral component of an artistic life, which Rivers assumed he would therefore have to embrace himself as part of his bid to become an artist. As the painter Anne Tabachnick has remarked on Rivers's investments in homosexuality at this time: "Larry didn't have gay episodes to have sex but to improve himself. He thought that by hanging out in gay company he would learn to be classier . . . He really wanted to know how to dress and talk . . . No, it wasn't the homosexuality, it was upward mobility" (*W* 133).

This reevaluation of gay styles, however, cannot be properly understood without also understanding Rivers formative involvement in the "hip" subculture which was emerging in New York bohemia in the late 1940s and early 1950s. As I have written elsewhere, Rivers styled himself on the hipster or beatnik, and he celebrated various forms of "street" and vernacular culture as opposed to the values of both traditional high culture and the commodified products of the mass media.[16] Black culture was particularly attractive to Rivers, an enthusiastic jazz saxophonist at the time. Rivers found in the music, the drugs, and the "hep" talk of the black jazz scene the essence of hip: from the improvisational musical arrangements of bebop to the semantic transgressions of a black vernacular (where standard American English meanings were often reversed, "bad" meaning "good," etc.), jazz offered to

hipsters such as Rivers a culture that was both formally and socially disassociated from middle-class white society.

If the dynamics of hipsterism underpinned Rivers's investments in blackness, then so too for his appreciation of homosexuality. As Catharine R. Stimpson has written, given that the beats also celebrated unfettered sexuality as a political ideal, the queer came to be seen, though not without some hesitation, as an agent of sexual freedom.[17] Sexuality, and in particular perverse or deviant sexuality, came to be valorized as an important form, if not the ur-form, of political and cultural transgression. Certainly, homosexuality was attractive to Rivers precisely because of its transgressive status, running as it did counter to the so-called square values of 1950s mainstream America. Frank O'Hara had astutely recognized the nature of Rivers's interest in homosexuality, and specifically in him, in a poem from 1953 which includes the line: "to him my affection's as pleasing as an insult/to a nun" (C 240). And if we return to Rivers's nigh deification of Blaine as artistic role model, then it becomes apparent that it is not only Blaine's lesbianism, but the fact that she is an active lesbian *who is married* that both attracts and fascinates Rivers, this making her a doubly transgressive figure: "I thought being a lesbian and married was so fantastic it became a lighted gateway into art, the jazz, the parties, the banter that went on in her studio. If anything could be the relieving opposite of 'square,' Nell's life of avant-garde sex, abstract art and a loft was it!" (W 105). Blaine is held up by Rivers here as representative of a hip person with a hip lifestyle. The fascination and attraction is for the Otherness that she embodies. Her social, sexual, and artistic unconventionality are all seen to be part of the same bohemian equation as is demonstrated by the slippage Rivers effects between the transgressive values accorded to the avant-garde and those of Blaine's lesbianism in his reference to a "life of avant-garde sex."

"Avant-garde sex" is precisely what Rivers was interested in, and the more of it the better. According to him, gay men such as O'Hara and Ashbery represented to him the "beginning of another much more sexy, more groovy situation. They had more energy. They had more sexuality. They had more ego, drive . . . They seemed to be more equal to my notion of what things should be about."[18] All their talk about "beautiful asses and burgeoning baskets and the ins and outs of sucking cock" was taken by Rivers as linguistic evidence of their sexual condition, one presumed to be all about *doing* it (W 110). As Rivers recalls: "My idea of homosexuality was that it was about sex. You were sort of trying to make it everyday, wherever you were, that was the point" (C 249). His sexual relations with men have to be understood in

this light: "Homosexual sex, for me at around twenty-seven, was an adventure, for a while on a par with trying a new position with a woman" (*W* 227). That is, while maintaining his heterosexual orientation, Rivers's interest in queer bohemia and gay sex can be understood as being a typically "adventurous" move within the hipster's self-othering game: a defining maneuver of Rivers as a gay acting straight.

One of the key resources through which Rivers comes to effect this queer artistic performance, I want to suggest, is that of camp talk. Steeped as he was in the values of a hip sensibility, the camp vernacular would not only have appeared to Rivers as the peculiar discursive modality of artistic society, but also as a mode of utterance which transgressed the forms and values of serious (read "square") conversation. Highlighting style over substance, discursive performance over argument, and an incongruous, and evidently artificial, enactment of gendered speaking positions, such talk suggested not only how Rivers might come to "speak" as an artist, but also how this necessarily entailed speaking *differently*. Furthermore, in wanting to establish himself as hip, the decidedly unserious pronouncements of his queer bohemian fellows, replete with their vulgar hilarity, seem to have held a certain kind of alternative authority for him. Rivers in *What Did I Do?* writes that, in his immediate circle of artist and poet friends, both gay and straight picked up on aspects of queer talk as part of their own forms of expression.[19] But if Rivers picked up on such talk and made it his own, to what degree was such queer speaking an important influence upon his painting? How did his fondness for campy banter translate into his work as an artist, especially if we follow Rivers in accepting his painting as a kind of substitute for his talking? And what consequences might such campness have for a "serious" appraisal of artistic meaning?

YOU CANNOT BE SERIOUS . . .

A consideration of Rivers's perhaps most famous painting, *Washington Crossing the Delaware* (1953), should prove illuminating here (color plate 1). The painting takes as its subject a patriotic moment from the American war of independence: General George Washington's crossing of the icy Delaware River with some 2,400 troops on Christmas night 1776. By adopting Washington's historic crossing as his subject, and in attempting to do it as a modern History Painting, with its attendant expectations of significant meaning and high grandeur, Rivers acknowledges that it was to do something that

"no one in the New York art world would doubt was *disgusting, dead*, and *absurd*."[20] This is because in 1953, with the continuing dominance of abstract expressionism in the arts, and the high point of McCarthyism in the world of politics, such a seeming celebration of patriotic history would have put him out of step with the artistic and political sympathies of most of the New York art world.[21]

But Rivers embraced this situation as part of the challenge of doing the impossible and the corny. If anything, being "out of step" was the *very reason* for doing it: "I guess I wanted to paint something in the tradition of the Salon picture, which modern artists hold in contempt" (*L* 24). The idea of the painting, therefore, courted derisive criticism from the outset. There was little that Rivers himself could imagine as being "dopier" than doing a painting "dedicated to a national cliché" (*WH* 98). In this respect, and by offering up *Washington* as a serious contender in the stakes for avant-garde art at the time, Rivers knew that he was embarking on a perverse painterly gambit. By compromising both the seriousness of abstract expressionist painterly gesture by putting it to work as History Painting, and the seriousness of History Painting by doing it at a time when it was considered to be an impoverished and passé genre, Rivers's painting posed a problem to critical appreciation. Exactly how was such a painting to be taken seriously? Indeed, *could* it be taken seriously at all? Was *Washington* a serious attempt at a modern History Painting or was it the product of bad faith, a joke? Or, even more confusingly, was it somehow an unthinkable mixture of the two?

According to Rivers's own testimony, there seems to have been at least some degree of levity toward the subject in his intentionality for the piece. His disidentification with the "hand-on-chest heroics" of Emanuel Leutze's nineteenth-century academic rendering of the subject, which Rivers had seen in the Metropolitan Museum of Art, appears to have been rooted in one of those "silly bits of information" characteristic of the gay male chatter at Blaine's parties (fig. 23). Apparently, Rivers thought that it just looked *too chilly* to be getting onto a river around Christmas time to be putting on any kind of swaggering, militaristic performance.[22] But to assume from this that Rivers's intention was to upstage his subject by painting ironically, to suggest that *Washington* is a joke, perhaps with an antipatriotic or anti-Republican message, is to go too far in the opposite direction, and to miss the point of what I want to suggest is Rivers's *campy* evocation of Washington here.

As recent theory has suggested, to conflate camp with irony is to miss out on camp's wider potential for undermining the conditions of meaning.[23] Irony only works to shore up binary structures of signification by produc-

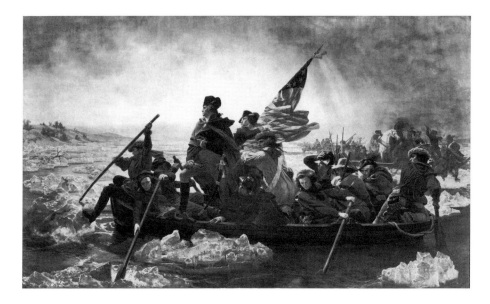

Figure 23. Emanuel Leutze, *Washington Crossing the Delaware*, oil on canvas, 1851. The Metropolitan Museum of Art, Gift of John Stewart Kennedy, 1897.

ing oppositional meanings to the stated or apparent. What I want to suggest here is that camp, on the other hand, might be understood as a cultural practice which forestalls the process through which *any* determinate meaning is produced. This does not mean that "serious" meanings are evacuated from camp culture altogether. According to Isherwood's character Charles in *The World in the Evening*, camp "always has an underlying seriousness," but one which comes to be entertained as an object of *fun and humor*.[24]

The question of pleasure, therefore, is central to my appreciation of Rivers's work here. Rivers writes in *What Did I Do?* that the Leutze painting was not at the forefront of his mind while he was making the painting, nor was Leo Tolstoy's *War and Peace*, which had initially given him the idea to do a grand historical work. Rather, he notes that he was thinking "mainly about the patriotic grade school plays . . . [he] . . . sat through or participated in": "I never took them seriously, even at seven or eight years old, but I enjoyed them and still have a pleasurable feeling remembering the experience" (W 312). This remark is highly significant, I think, and suggests a way of understanding Rivers's painting, or at least his intentionality in producing it, as bound up with camp's peculiar and pleasurable relation to meaning. For Rivers's attitude toward his subject was, I would venture, neither serious

("I never took them seriously"), nor was it as a joke or ironic comment, but rather one which allowed him to endorse his "pleasurable feeling" for a discredited subject and outmoded genre of painting, while at the same time recognizing and reinscribing its outmodedness and illegitimacy. In this respect, Rivers can be seen to partake of what Andrew Ross has called the "necrophiliac economy which underpins the camp sensibility," with its "amorous resurrection of deceased cultural forms," making it the very substance of his avant-garde gambit in the New York art world in the 1950s.[25]

This emphasis on warm feelings, and the pleasures to be gained from entertaining a historically discredited subject, demonstrate how *Washington* fails to operate within conventional frameworks of signification. Neither affirming patriotic meaning nor disaffirming it, neither playing History Painting "straight" nor as a joke, it refuses any final determination of meaning, as either the one or the other. Thus the painting keeps the binary possibilities of meaning in play, not as any marker of epistemological weakness, but rather *as the very substance of its campy pleasures*. Even if Rivers has told Sam Hunter that "what I was saying is that America as you know it wasn't true," this should not be taken to suggest that *Washington* is a painting which works, in a time-honored critical fashion, to deconstruct the ideology of "America."[26] Rather this "truth" is quoted, held in suspension, and entertained as the object of camp humor. This suggests a campiness which resides in the particular ways in which it holds on to knowledge, forestalling any final considerations of truth or falsity in favor of *making fun*. As Isherwood's Charles goes on to say, with camp "You're not making fun of it; you're making fun *out of it*."[27]

Moreover, he goes on, with camp "you're expressing what's serious to you in terms of fun and artifice and elegance" (125). This has been picked up on by critics such as Harold Rosenberg, who has remarked on Rivers's art as "Broadway"- or "Hollywood"-style painting, suggesting that it is overblown and theatrical, "too much" to be taken seriously.[28] Rivers himself can be seen to have contributed to such a view by saying that he was more concerned with what the subject could offer him in terms of painterly spectacle than anything else: "there was plenty in Washington Crossing the Delaware to dazzle me—horses, water, soldiers, and so on" (*L* 24). Rivers made numerous sketches of costume details and poses for the various elements of his composition (fig. 24), according to Hunter, using a children's illustration book as his guide and inspiration (this only further underlining Rivers's grade-school relation to patriotic sentiment).

Such an interest in the minutiae and surface detail of his subject is evi-

Figure 24. Larry Rivers, study for *Washington Crossing the Delaware* (1953). Pencil on paper, 13¾ × 11″ (34.9 × 27.9 cm). The Museum of Modern Art, New York. Given anonymously. © Larry Rivers/VAGA, New York/DACS, London 2001.

dent in the final composition. Unlike Leutze's painting, with its focus on Washington and his statuesque pose etched against a cold and luminous December sky, Rivers's painting seems by contrast to lack dramatic focus and the iconic presence of its subject. Although the figure of Washington is centrally placed within the compositional schema, standing in a flattened and tilted perspectival representation of a boat, it is the intensity of light on his trousers which Rivers seems most interested in picking out with the use of some thickly encrusted and heavily brushed white pigment (can it be that Rivers is suggesting Washington's "burgeoning basket" here with his use of paint, a kind of vulgar insistence on the genital display so apparent in, for example, Leutze's portrait of *Washington at Dorchester Heights* of 1853?; fig. 25).

The face of Washington, by comparison, is barely sketched in against a fleshy patch of pigment which exceeds its contours, melding into the surrounding painterly brushwork. His right hand, raised and clawed as if forming a fist, is sketched in outline only over a gray/white area of pigment which figures the icy river. His hands and face appear "unfinished" in relation to the degree of modeling evident on his waistcoat and pants. In this way, Washington appears stripped of a strong iconic presence, as his upper body is literally dispersed into the surrounding areas of paint. By contrast, the emphasis and interest of his lower body are heightened by what appears to be an unshod right foot. This appears stockinged only, the straps of his white "jodhpurs" clearly visible under the arch of his foot. This contrasts starkly with the dark swatch of paint on the lower part of his left leg, which could be read figuratively as a knee-length boot, akin to the one he is sporting in the Leutze painting. All of this amounts to a carnivalesque inversion of Leutze's heroic pose, the attention focused on Washington's lower body and its rude visibility, as opposed to the heroicizing significance of his head and upper torso. This attention to the lower body is also evident in various nude portraits that Rivers executed around this time, including *Double Portrait of Berdie*, from 1955, and *Joseph*, from 1954, and can be seen as akin to the vulgar dimensions of the camp banter that Rivers encountered at Blaine's gay parties and elsewhere.

This focus on such "improper" elements of his composition widens out to Rivers's more general attention to inconsequential detail, evident in the equal attention that he pays to the various incidents, both figurative and abstract, that litter the rest of *Washington*'s vast expanse. From the soldier on horseback in the top left, complete with pentimenti of the horse's head, to the relatively free gestural brushing in the bottom left corner, many diverse

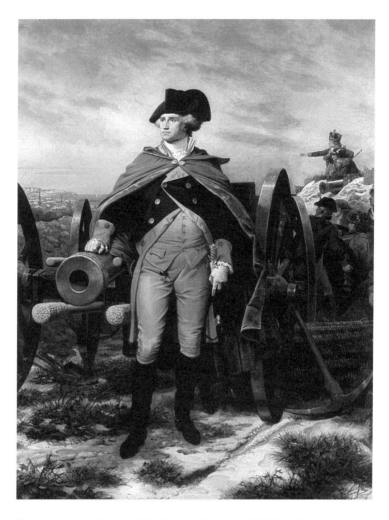

Figure 25. Emanuel Leutze, *Washington at Dorchester Heights*, oil on canvas, 1853. Courtesy of the Trustees of the Boston Public Library.

elements seem to jostle for the spectator's attention. These various elements fail to coalesce into any unified *image* and rather work as localized areas of incident which, by turns, catch the spectator's attention. Rivers seems to have achieved this by focusing on each component part at the expense of the overall design, as if his attention were distracted by the various details in the making of the painting. Such a distraction, one might argue, is the condition of the spectator's gaze as he/she looks upon *Washington*—one in which the eye is kept mobile due to the variety of visual incident, never being allowed to rest on any single point of focus. Thus, even though the figure of Washington is center stage, as viewers we find ourselves attending equally to parts of the painting which might not appear loaded with the same degree of narrative significance—a dragging of the brush, a snatch of outline, an outcrop of barely treated linen, and so on. Indeed, as I shall go on to argue, one of the problematic aspects of Rivers's painting generally in the 1950s is its particular structuring of the painterly surface, giving rise to a distracted mode of appreciation.

But what gave him the courage to produce a work of the order of *Washington*? And what were the conditions which made it possible, or even desirable, for Rivers to consider such a campy gambit as an art practice in the early 1950s? This, I would suggest, is because the so-called authentic art of abstract expressionism came to appear played out to Rivers in the early 1950s, and it was to a group of distinctly "inauthentic" men that Rivers looked instead for artistic direction. Paradoxically, Rivers found in these men a *more* authentic and vital mode of artistic being and expression. These men were a group of poets, with Frank O'Hara primary among them.

THE ART OF TALKING QUEER

Camp modes of address are key features of Frank O'Hara's poetry. His work is therefore important for my analysis, as it was for Rivers in the 1950s, in offering a way of thinking of the features of a camp vernacular as a mode of artistic expression, of elevating the culturally "low" to the status of the artistically "high."

There is no doubt that Rivers was impressed by O'Hara and his poetry. As Rivers himself has written, around the time of meeting O'Hara and fellow poet John Ashbery, "the poetry became more important to me. I used to read their work. I even began to try to write poetry."[29] Much has been written about the formal similarities between the work of the so-called New

York School of poetry, centered around O'Hara, and the visual arts at this time, including the work of Rivers and the abstract expressionists.[30] These similarities can be explained in part by the degree to which both cultural practices shared the same vaguely antiestablishment relations of production and consumption. O'Hara and his poet friends Ashbery, Barbara Guest, and Kenneth Koch socialized in New York art circles, spending much time in the Cedar Tavern, and the Club on Eighth Street, as well as in more literary bars such as the San Remo. The painters constituted the main audience for their poetry at this time, since, as O'Hara has written, "the literary establishment cared about as much for our work as the Frick cared for Pollock and de Kooning."[31] The poets also wrote art criticism, or rather a poetic version of it which has been dubbed "parallel poetry" by filmmaker Rudy Burckhardt, and they collaborated with artists on so-called poem-paintings.[32] There was, then, a real sense of poets and painters working together in mutual support and inspiration, and for their mutual benefit.

O'Hara has often been criticized for his supposed superficiality and frivolity as a poet, and for his perceived inability to work earnestly and symbolically with subjects of great import. His poems are often taken to be too much like chatty conversation or gossip, lacking in normative syntax and any hierarchy of significance to warrant critical approval.[33] Such criticism has been read as a response to what Alan Feldman calls O'Hara's "queer talk"— "a pattern of speech characteristic of certain homosexuals."[34] This speech, he goes on, "is related to the 'feminine' speech patterns of women. It suggests that the poet and the reader are joined in a private understanding of the world that is set apart from the ordinary public rhetoric of straight society. The poet is placing his poem 'between the two of us,' between himself and the reader, creating a kind of gossipy intimacy, and a shared set of private values and truths that displace the false values of public speech" (49).[35] Thus, some of the distinctive features of O'Hara's poetry—its associative rather than linear meanings, and its informal rather than public mode of address— can be taken as identical with some of the distinguishing features of campy gay male vernacular in the 1950s.

Such features of O'Hara's poetry are the ones that O'Hara himself emphasizes in his mock 1959 manifesto for "Personism," for "while I was writing I was realizing that if I wanted to I could use the telephone instead of writing the poem, and so Personism was born" (fig. 26).[36] In writing thus, O'Hara embraces in his poetry those very characteristics which some critics abhor in his work: the emphasis on the poem as an intimate utterance between two people, and as a form of conversation where conversation means *chatting*,

Figure 26. Frank O'Hara in
the kitchen at 791 Broadway,
1963. Photo by Mario
Schifano. © DACS 2004.

with no necessary intention, aim, or endpoint. Such a poetry, he asserts, challenges both the propagandists of form, on the one hand, and of content, on the other, thus going beyond the binary positions of then contemporary poetry.

His much discussed "Poem [Lana Turner has collapsed!]," from 1962, which, with its "breathless, scatterbrained, feminine" prose (Feldman again!), perhaps best exemplifies some of the typical features of O'Hara's queer talk.[37] All the characteristics are contained in this poem: a concern with the seemingly trivial, with a dispute about the weather ("you said it was hailing/but hailing hits you on the head/hard so it was really snowing and/raining"); a campy, sympathetic identification with a female screen goddess ("oh Lana Turner we love you get up"); and the simply enumerative way in which the various events and observations are reported. For Bruce Boone, the latter is very important. The lack of any "proper" connectives other than the nonconnective "and" leads him to suggest that the poem, like many of O'Hara's poems, functions by a displacement of the connectives through which normal grammatical sense is made in favor of a *paratactical* organization of its poetic narrative.[38]

A similar structuring principle can be found at work in the organization

of Rivers's painterly surfaces, making them into a kind of painterly gossip. For instance *The Studio*, painted in 1956, is made up of isolated, seemingly disconnected fragments of painterly detail (color plate 2). Looking at this painting is, as one critic put it, a "roving, multiple, and episodic" experience, particularly because its sheer size (6'10" × 16'1") doesn't allow you to take it in at a single glance.[39] And Rivers makes little or no attempt to join up all the bits, to assemble and relate them in some grand overall scheme of meaning or design. Loosely based on Gustave Courbet's *The Painter's Studio* of 1855, which functioned as an allegory of the artist's life, Rivers's *Studio* mimics the composition and intent of Courbet's work. According to Betty Kaufman, however, Rivers's painting is "flat-footed" in its appropriation of Courbet as scheme.[40] Like Courbet's painting, Rivers's *Studio* contains (multiple) por-traits of some of the key people in Rivers's life in 1956 — from left to right: Frank O'Hara; his sons, Joseph and Steven; and his mother-in-law, Berdie; as well as the centrally placed figure of the black "muse" (Rivers's hip reinven-tion of Courbet's own). This latter figure can also be read as the lynchpin for a temporal reading of the painting, scrolling away to the left "toward winter which includes the past and the stuffed hawk; and counter-actively to spring blossoming in, among other things, a nude and a tropical bird."[41] However, just as *Washington* fails to offer up the heroic patriotism that its subject and genre promise, Rivers's *Studio*, though appearing on some level to abide by the rules of grand allegory, frustrates any attempt to fully recover or con-struct any coherent allegorical meaningfulness for it. Any such attempt soon runs aground on the isolated fragments of painterly detail that litter the sur-face of Rivers's canvas, for example, the free-floating patterning of Berdie's dress on the right, or the detailed modeling of Joseph's brown boot to the left. These have the effect of freezing the intensity of the spectator's gaze, isolating each fragment of surface within the viewer's field of vision.

In this way, such fragments displace the whole architecture of allegorical meaning of which they are supposedly constituent parts. This is the effect that Parker Tyler refers to as the "purple-patch of fetishism" in Rivers's paint-ings — the uneven picking out of figures, or fragments of figures, by means of a kind of "italicizing" intensification of detail.[42] This, Tyler writes, has the effect of making the constituent parts of the composition break free of the whole, making the painting necessarily "statistical and reportorial."[43] Hence, the painting structures our looking in terms of an amalgam of loosely related points of focus — a "smorgasbord of the recognizable," as Rivers has described it.[44] If Rivers's organization of his imagery is "casual," its compo-

sition "patchlike," then our viewing of it is comparable.[45] As our eye wanders over the huge expanse of whiteness from incident to incident, unable to focus on the whole or take it in a single glance, we are kept at the level of surface, unable to make the bits add up to anything meaningful, to make it cohere.

If, in "Poem [Lana Turner]," O'Hara appears concerned with the trivialities of the weather, and Rivers's *The Studio* focuses the spectator's attention on seemingly insignificant detail, then what I want to suggest is that we consider the subject of these works to be located less in the referential field of meaning and rather more in the realm of the pleasures of their textuality or painterliness. The lack of grammatical connectives in O'Hara, and the deferral of allegorical meaning in Rivers, means that neither appear to be concerned with the conventional communication of an artistic message per se. Rather, they seem primarily engaged with engendering a play of interpretation across the composite elements of their textual and painted surfaces. In this way, I want to suggest, the camp vernacular, as a "feminized" mode of masculine utterance, appears to emerge transformed in both O'Hara's poetry and Rivers's painting as a particular kind of *textuality*, one in which metaphysical constructions of meaning are deferred due to the particular structuring of poetic narrative and painterly composition alike.

"Where much of the art of our time has been involved with direct conceptual and ethical considerations," writes O'Hara, "Rivers has chosen to mirror his preoccupations and enthusiasms in an unprogrammatic way."[46] Rivers's "program," such as he has one, is to be *un*programmatic, to passively paint those things, people and places, which "flow by" in his everyday life (79). Or, if his subject is of the grand manner as in *Washington*, then he busies himself with the spectacle of it all. Like O'Hara, he is not interested in making any major political or moral statement through his art, for he does not deploy the languages of serious art in such a manner.[47] He does not, for example, occupy or promote any moral or political position through history painting in the *Washington* picture, nor is there really any grand allegory to be recovered from a reading of his *Studio*. If O'Hara's poems are written as if like speaking on a telephone, then Rivers—who has been described by O'Hara as a "demented telephone"—makes art that is similarly concerned with the "superficial" pleasures of informal, everyday talk.[48] As the art and music critic John Gruen has commented, Rivers "delights in gossip, though not in moral judgment" and therefore, even when addressing so-called serious subjects, he refrains from making any statement of ideology or belief.[49]

If both O'Hara and Rivers keep their readers and their spectators at the level of surface in this way, then, the effect is to displace their own ideas and views, their selves as authors and producers, from being read as the centered meaning of their work. As Thomas Hess has written of Rivers's work in 1965, even though you are invited to "come . . . all the way into his painting . . . it must be understood (that) Rivers won't be there waiting for you . . . There are no shreds of tortured ego dangling from the edges of his forms."[50]

SUPERFICIAL PLEASURES

In absenting the moralizing subject from the field of artistic utterance, O'Hara's and Rivers's works might be read as subverting dominant constructions of subjectivity in poetry and painting at this time. As suggested by writers such as Boone and Rudy Kikel, the refusal of a metaphysical "bodying forth" of the subject might be taken as evidencing camp's critique of normative constructions of sexed and gendered utterance. Their rejection of depth models of meaning, their refusal to write and paint seriously about any of their subjects, and their lack of any avowed moral or political stance in their work—these features can be seen to subvert then-conventional models of the subject-in-representation, ones heavily codified as masculine and heterosexual. For Kikel, the camp aspects of O'Hara's poetry are rooted in a refusal of a "stuffiness, self-importance, and a 'seriousness' that he may well have associated with 'manliness,' heterosexuality, and the 'closed . . . artistic railway stations' they represented for him."[51]

In keeping their readers and viewers preoccupied with the surface of their respective artistic forms, both O'Hara and Rivers can be seen as working within a campy "homosexual tradition" which, as Harold Beaver writes, has been typically concerned with replacing "truth" and "value" with the demands of "elegance, style, [and] art."[52] Such a concern returns us to the linguistic performances of the gay men at Nell Blaine's parties. For just as the campy banter of Blaine's guests highlights the value of a witty response over and above any substantive counterargument, the paratactical organization of O'Hara's and Rivers's works serves to displace any determinate meaning or intentioned message in favor of the pleasurable play of surface elements. The full epistemological consequences of this we can now finally appreciate by turning to his 1964 painting *The Greatest Homosexual* (color plate 3).

Basing his work on Jacques-Louis David's portrait of Napoleon (fig. 27), Rivers concentrates on the significance of the subject's pose:

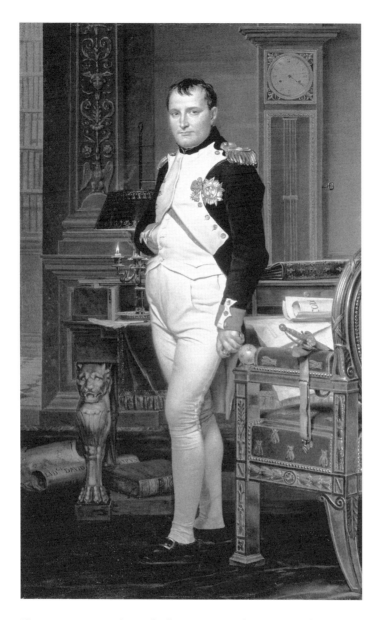

Figure 27. Jacques-Louis David, *The Emperor Napoleon in His Study at the Tuileries*, oil on canvas, 1812. Samuel H. Kress Collection. Photograph © 2002 Board of Trustees, National Gallery of Art, Washington.

> The Greatest Homosexual is a work in the tradition of a contemporary
> artist 'paying homage' to some brilliant ancestor . . . After many days
> of drawing, brushing, cutting, gluing, stenciling, etc., on canvas . . . I
> couldn't avoid some obvious non-technical conclusions. Given a right
> hand nestling in the split of the cream vest, a gesture which by itself
> has come to represent Napoleon, the plump torso settled comfortably
> on the left hip, the careful curls and coif, the cliché of pursed lips and
> what self-satisfaction I read into the rest of the face, I decided Napoleon
> was Gay. Now if he wasn't history's "Greatest Homosexual," who was—
> Michelangelo?[53]

This is truly fascinating stuff, for it demonstrates how Rivers comes to happen upon his subject accidentally by dint of some whim that occurs to him while making the painting. It shows how he cannot resist making what might otherwise be a serious homage into some fanciful painterly gossip about Napoleon. This gossip then comes to be the *subject* of the painting, at least if Rivers's pointed title—The Greatest Homosexual—is anything to go by.

Rivers's inventory of significant body parts here—significant, that is, in terms of the sexual identity they purport to reveal—further demonstrates his familiarity with, and appreciation of, the camp/queer forms of bodily deportment I have already explored in the contexts of 1950s bohemian society. But what is most striking is that on the basis of a cursory assessment of some supposedly giveaway signs, Rivers is prepared to make a painting out of nothing more substantial than the kinds of suspicions about artistic sexuality we considered in chapter 1. There would have been little else which might have led Rivers to paint a "homosexualized" Napoleon—except, perhaps, the significance that might be imputed to his famous declining of heterosexual marital relations: "not tonight Josephine." Nevertheless Rivers goes about deploying all his artistic skills in foregrounding Napoleon's apparent gayness.

By repeating the pose of David's original painting a number of times, sometimes incompletely, across the surface of the canvas, Rivers is able to have fun with exaggerating different aspects of Napoleon's deportment. This is particularly evident with the overlapping of the two most sketchily realized depictions of Napoleon in the center and to the right of Rivers's composition. The single greeny-blue area of paint to the upper right of the painting, which melds together the local color of the military coats of the "two" Napoleons, has the effect of creating the appearance of a more exaggerated pose on the right-hand Napoleon, the outline of his right shoulder running into

that delineating the concave edging of the central Napoleon's cream waist-coat. This gives the appearance of an angling of the right arm as the hand is placed on the hip, suggesting an exaggerated, effeminate pose. This gives further visual credence to Rivers's sexualized reading of Napoleon's body in David's original image.

It is quite plain, however, that Rivers's painterly manipulation here is not meant as a serious or "scurrilous" accusation. Judging by Rivers own words, as well as the work's title, it appears to me that the painting should perhaps best be taken as a kind of campy observation: "Look at her!" Rivers might be construed as saying "Have you ever seen such a Big Mary?" Moreover, when considered in the form of a question ("if he wasn't history's 'Greatest Homosexual,' who was?"), Rivers's painting can be seen to playfully engage with questions of "greatness" in a similar manner to the bitchy infighting at Blaine's loft about the virtues, whether artistic or erotic, of the great figures of literature.

If Rivers, then, plays his queering of Napoleon as witty suggestion, then he also busies himself, typically, with the superficial details of his painterly conceit. Like with *Washington* and *The Studio*, there is much visual incident here: both highly modeled and more brushy areas of paint; sketchy, linear passages; stenciled lettering; and collaged material, much of which is liter-ally sewn to the surface of the canvas. However, the emphasis on rendering the figure in outline with only minimal tonal filling, and on the pieces of collaged material which are ready cut in the shape of Napoleon's garments, makes it more suggestive than any other Rivers's painting of fashion illus-tration and the dressmakers art. Typically seen as the preserve of gay men, such practices, and such features of Rivers's painting, conspire to make *The Greatest Homosexual* particularly suggestive of homosexuality.

If Rivers's painting then, both in terms of subject and technique, connotes homosexuality, then what, if anything, might it suggest about its maker? Especially in the context of the New York art world in the 1950s and early 1960s, what aspersions might be cast upon such a purveyor of campy painted gossip? Even though the publication of Susan Sontag's "Notes on Camp" in *Partisan Review* in 1964 meant that camp had, by this time, become signifi-cantly loosened from its gay meanings, it was still a mode of cultural expres-sion which remained, at the very least, *suggestive* of homosexuality.[54] Rivers, as we have seen, was more than aware of this. He was also acutely aware of the things that were said about him by others, and he would have been well aware of the possible personal insinuations that such a painting might have generated. But such potential suspicions are precisely what Rivers courts as

Figure 28. Larry Rivers in his studio, New York, 1965. Photo by Peter Moore, © Estate of Peter Moore/VAGA, NYC.

the substance of his insubstantial art. For just as Rivers entertains gossip about the queerness of Napoleon in *The Greatest Homosexual*, so he does about himself in a photo-portrait taken in his New York studio by Peter Moore in 1965 (fig. 28).

Here he stands flanked by two paintings picked out for special consideration by the critic John Adkins Richardson in a consideration of the campness of Rivers's art.[55] On the right is *Dutch Masters with Cigars* and, on the left, *The Greatest Homosexual*. Rivers stands before this painting, with his hands on his hips, a smile, I like to think, almost breaking out across his face, as he too adopts an affected, almost effeminate, pose. This might well be understood as a joke shared between artist and photographer, between artist and viewer, as he mimics the pose of the affected and painted Napoleon. This campy put-on, I want to suggest, is the medium through which Rivers entertains himself as a subject of representation. He presents himself precisely as a subject of gossip, as the indeterminate subject of sexual curiosity: Is he or isn't he? Is he "really gay" or just joking? That there is no resolution to such questions is testament to the ways in which Rivers works to stage the subjects of his art — himself, of course, being the primary one — as the focus of curiosity and speculation. Refusing to stabilize as either true

or false, as "straight" or "gay," Rivers's photographic self-staging here gives license to the play of our interpretative curiosity, rather than providing us with any easily assimilable and definitive self-image of the artist.

It is in this way, then, that we might appreciate how Rivers's art could be said to engage its viewers in a "gossipy" spectatorial relationship. We are drawn into Rivers's expressly performed "truths," encouraged to pleasurably appreciate the play of sexual identifications within his work rather than approaching it as any ontological embodiment of artistic Being. Thus Rivers eschews—and subverts—the earnest authority of "serious" art and culture.

Nowhere more so, perhaps, is this subversion of authoritative discourse flagged than in Rivers's autobiography *What Did I Do?* Returning to this book as I close this chapter, I want to finally alight upon its subtitle: "the *un*authorized autobiography" (my italics). For even when writing from a position which is customarily invested with power and knowledge—with the superior self-knowledge which is supposedly possessed by the autobiographical author—Rivers chooses instead to signal his *lack* of any such epistemological prowess. This, as I have already suggested, clues us in to the ways in which documentary value may not have been paramount for Rivers in writing it, nor perhaps should it be for us in reading it (indeed as Rivers's friend, the poet John Ashbery, has recently noted, it may be that up to 60 percent of the "teeming facts in that fascinating, salacious and barely readable book" are wrong).[56] Written in a fairly haphazard manner, shunning any clear linear narrative, and reading instead as a delineation of events written as they were remembered, his biography—much like his paintings—appears to eschew the epistemology of a subject given-to-know. It reads as a life remembered in fragments, partially recounted by a manifestly fallible and interested witness—one addressed to the artist's equally interested, and decidedly intimate, readers.

{ CHAPTER 4 }

DISHING

ON THE SWISH, OR,

THE "INNING"

OF ANDY WARHOL

One thing I've always liked to do is hear what people think of each other—you learn just as much about the person who's talking as about the person who's getting dished. It's called gossip, of course, and it's an obsession of mine. So one afternoon as we stretched Marilyns [Warhol's canvases of the screen idol], when Mark remarked that he thought Gerard was very "complicated," I was in like a flash and asked him just what he meant by that.

"Well," he said, "he doesn't want anyone else to be as close to you as he is. He told me once, 'When it's one-to-one with Andy, it's very easy, but when you're in a group, Andy creates competition between people so he can watch problems being played out. He loves to see people fighting and getting jealous of each other, and he encourages people to gossip about each other.'"

"What did he mean?" I asked him.

"Well, say, like we are right now." Mark smiled. "Here I'm gossiping about him to you, and then at some point you'll get him to tell you exactly what he thinks of me."

"Oh, really?" I said.

"Yes. And I suppose he also meant that, for example, when we leave here tonight, you'll be going on somewhere, but you'll never say who else is invited—you'll just contrive in an elegant fashion to make sure the people you don't want to be there aren't . . . And you'll do it all without saying a word, or by saying something very oblique—some people will realize they have to fall away, and some people will just know they can come along."

"Oh, really?" I said, letting the subject drop—I mean, you can't gossip about yourself.[1]

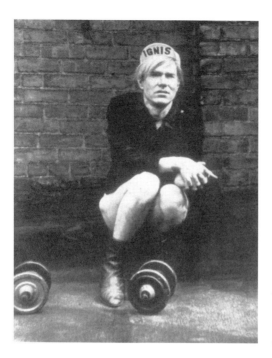

Figure 29. Photograph of
Andy Warhol in the film
Joan of Arc by Piero
Heliczer, 1966. Gerard
Malanga Collection.

This quotation is from Andy Warhol's retrospective account of the "Warhol sixties" contained in his 1980 book *POPism*. That Warhol expresses such an explicit taste for gossip is hardly surprising. The trivialities of gossipy conversation have been seen by many commentators to play an important, if not central, role in Warhol's life and work. From the conversational tittle-tattle trailed between "A" and "B" in his *Philosophy* of 1975, to the gossipy interest in the lives of Hollywood stars and celebrities suggested by his *Lizes* and his *Jackies* of the midsixties, Warhol has frequently been viewed as an artist who, perhaps more than any other before or since, has embraced the pleasures of everyday chatter at various levels of his public output. In a recent academic study, for example, the art historian Reva Wolf has analyzed the ways in which Warhol's work, from his paintings through to his photography and film, can be seen as taking part in a playful dialogue with members of New York's small communities of avant-garde artists and poets.[2] Seen in this way, the meanings of Warhol's oeuvre — at least its originating impetuses and initially intended effects — have been traced back to the interpersonal fripperies of the artist's immediate social circle(s). Christopher Isherwood too, in celebrating the conversational pleasures and wisdom to be gleaned from Warhol's published writings, has said (of *POPism*

itself) that it is "as absorbing as the best telephone gossip, funny yet full of insights."[3]

One of these insights, communicated in the lengthy quotation just cited, is into the subject of gossip itself. Warhol writes that the most interesting thing about gossip, at least for him, is the way in which it betrays information about the person gossiping—even as they "dish" the dirt about someone else. What the gossip has to say, how he/she says it, perhaps even what the person tellingly omits: all are delicious in revealing the foibles and insecurities of those who spend their time chattering about others. As the now mythic image of a voyeuristic Andy Warhol might encourage us to believe, this would make of gossip an ideal communicative practice by means of which the artist could get others to reveal themselves and their vulnerabilities, preferably unselfconsciously, in the name of Art. The scene of gossipy interaction, then, between, at least in this instance, Warhol's English aide Mark Lancaster and the artist's close poet-consort Gerard Malanga, we might imagine as being passively overheard by the same latter-day Baudelairan flaneur who gazed upon the varied and gregarious social types passing in front of his underground camera in the 1960s. Thus Andy's interest in gossip—his obsession even—demonstrates the degree to which his people-watching extended to much more than a purely visual investment in others, incorporating also the knowledge to be gained of others from gossip's informal linguistic economy.

Warhol offers up one further insight into gossip, which, he seems to suggest, is its (usually) unspoken rule: the fact that you simply can't gossip about yourself. To some degree Warhol abides by this in the conversation he recounts with Lancaster by dropping silent when it falls to him to speak about himself. This is not to suggest, however, that Warhol remains untouched as a subject of conversation, but rather to draw our attention to the ways in which his peculiar brand of persona building is founded upon *getting others to do the talking for him* (which, of course, puts him in marked contrast to Larry Rivers, as discussed in the previous chapter). Rereading the recounted words of Lancaster and Malanga in the interests of learning something about them, I am struck by how little, if anything, they tell us of the bodies which speak them, save perhaps that they are astute commentators on Warhol. Indeed it appears to me that the person who is reflected most in their words is *Warhol himself*; it is the artist, or at least a certain construction of him, that is revealed by the reported gossip of his Factory aides. Both of them testify to Warhol's reputation as artist-manager, and in particular to his image as the king (or queen) of party going and social manipulation.[4] For example,

Lancaster testifies to the ways in which Warhol's refusal to speak about himself directly, and his general recourse to a minimalist verbal economy — his near monosyllabic utterances — makes him a successful social figure. It is Warhol's *silence*, Lancaster suggests, which enables Warhol to direct those around him, to manipulate them as he pleases, without resorting to more conventional, vocal means of control.

Thus what emerges from the pages of *POPism* is an understanding of an artist whose interest in gossip, though seemingly focused on what others reveal about themselves in gossiping, is at least in part a clever postmodern way of getting others to speak about *himself*. Warhol had not spent many years enamored of Hollywood for nothing. He knew that the lifeblood of the celebrity image was in gossipy publicity, and that publicity thrived on mystery, especially on the absence of official statements about the private lives of individual stars.[5] Thus, Warhol, in the manner of the stereotypical passive aggressive, gets others to gossip about him; he mobilizes their desire and curiosity in order to create his "own" image while paradoxically refusing all overt forms of control over it.[6] It is in this way that he makes the construction of his artist-celebrity persona, as Simon Watney has observed, the focus of his aesthetic practice, offering, in a quasi-Foucauldian manner, the work of the self in place of the work of art.[7]

This much is probably familiar to most readers. But what, perhaps, is less familiar, and what forms my subject in this chapter, is how this strategic deployment of the talk of others might be taken as rooted in Warhol's experiences of being conversed about in the bohemian world of late 1950s and early 1960s New York. Moreover, what I want to contend is that it is Warhol's experiences of being subjected to malicious art-world gossip about his "private" life, and in particular his homosexuality, which pave the way for the construction of the now familiar Warholian persona of postmodern lore. I will explore how, in the late fifties and early sixties, such talk served to belittle Warhol by marking him out as a "sissy," a then widely recognized and socially abjected gay male type and how, in turn, it conspired to keep him securely locked out of the institutions of fine art. Seeing "himself" in such homophobic pronouncements of art-world gossip, I want to suggest, forms the template for the development of his more media-savvy persona starting from around 1962, the date of his first one-person show in New York at the Stable Gallery.[8] For it is at around this time, I argue, that Warhol makes a decidedly *queer* move by embracing and renegotiating his alienated and effete image as a defining strategy of his postmodern persona building.

I shall also consider that as he does so, a concurrent transformation comes

to be effected in the discourse surrounding Warhol, particularly as his new personality, so to speak, ceases to solicit the kind of abusive and homophobic comment that had hitherto so readily attached itself to the artist and his work. I shall analyze the inauguration of a new regime of art critical talk, which serves to establish Warhol as the now-familiar postmodern "dandy" whose sexuality—where it is mentioned at all—is seen to be asexual or, at best, voyeuristic in character. As a number of recent queer art historians and critics have argued, Warhol's ascent to prominence as a postmodern artist was accompanied by what is now widely regarded as a closeted discursive array of art and film criticism. The editors of *Pop Out: Queer Warhol* have written, "with few exceptions, most considerations of Warhol . . . have aggressively elided issues around sexuality . . . to usher his oeuvre to the world of high art."[9] The work collected in *Pop Out*, and in other recent volumes, has striven to redress such historical blindness and critical heterosexism, with a view to restoring to Warhol and his work the queer meanings and affects which accrue to him in the various contexts in which he lived and worked.[10] But rather than repeat this work here, what I do instead in this chapter is inquire into the exact conditions which gave rise to this discursive closet in the first place; to ask how it becomes possible for critics to so easily disavow a knowledge of the artist's queerness which had hitherto been so aggressively asserted by cruel social parlance and, in remaining faithful to the Warholian line on gossip, to explore what such critical approaches betray, not only of Warhol but also of those who were speaking and writing about him in the early to midsixties.

In tracing a shift, then, from a widespread homophobic denunciation of Warhol as a sissy pre-1962 to his critical celebration as an (asexual) dandy post-1962, I will tell my own story: that of the "inning" of Andy Warhol. Moving from an Andy "outed" as an effete gay man to one pushed back in to the closet; from one kept out of the art world to one finally admitted in to the circuits of art-world sociability and critical legitimacy, I will, in what follows, reverse the narrative flow of the customary coming-out story. Rather than focusing on outing Warhol in the manner of recent gay or queer art history, I shall attend instead to how he comes to be inned. This will necessarily lead me to consider the role played by the petty jealousies and snide comments which accrue to Warhol's person and persona in making him into a successful fine artist, as well as exploring how the development of a critically sanctioned "Warhol" comes to rest on a selective forgetting, or marginalizing, of the insights to be gleaned from such everyday bohemian talk.

Andy Warhol was eminently successful as a commercial artist in the 1950s. He worked for various companies, including the shoe manufacturer I. Miller, for whom he undertook a lucrative job as chief illustrator for their high-profile advertising campaigns in the midfifties. And yet, even if success was a job in New York, as one of Warhol's early projects suggested, the young Andy was not content with his achievement in this field alone. He also wanted to be taken seriously as a fine artist and to become part of New York's avant-garde world of artists, writers, and poets. As has been well documented elsewhere, Warhol made various attempts to make it as a fine artist in the 1950s, including an exhibition of some drawings based on Truman Capote's writings at the Hugo Gallery in 1952 and a show of "boy" drawings at the Bodley Gallery in 1956.[11] Unfortunately for Warhol, however, both exhibitions attracted little press attention, and that which they did receive was largely hostile and dismissive. A brief critical notice in the *Art Digest*, for example, characterized the work in his 1952 show as "fragile impressions."[12] "The work has an air of preciosity, of carefully studied perversity," the review went on, "boys, tomboys and butterflies are drawn in pale outline with magenta or violet splashed here and there — rather arbitrarily it seems. At its best it is an art that depends upon the delicate tour de force, the communication of intangibles and ambivalent feelings."

This critical assessment sets the tone for most of the responses to Warhol and his art into the late 1950s and early 1960s. Warhol, it seems, was just not good enough, or perhaps unacceptable in some kind of way, to be considered a serious candidate for the profession of fine artist. The fact that he was widely known as a commercial artist would have placed him beyond the consideration of the then dominant culture of abstract expressionist art, which valued the "authenticity" of autonomous creative acts over and above those yoked to the realization of capitalist profit. Set against this backdrop, any attempt by Warhol to be taken seriously as an artist was seen to be at best driven by the desire and false consciousness of the dilettante. The novelist Truman Capote recalls that even after the publication of an article in *Life* magazine on Warhol's *non*commercial shoe drawings, "I never had the idea he wanted to be painter or an artist . . . I thought he was one of those people who are 'interested in the arts.' As far as I knew he was a window decorator . . . Let's say a window decorator type."[13] This was perhaps already suggested by the article itself, which described him to a mass-circulation public as a

"commercial artist" who sketched "imaginary footwear ornamented with candy-box decorations as a hobby" (*W* 142). The characterization of Warhol's noncommercial work here as the product of some lower-class fey hobby served to position it as a kind of "fag" art, and Warhol himself as swishy queen whose artistic pretensions just couldn't be taken seriously.[14] This is an explicitly "homosexualized" construction of Warhol which dominates in the 1950s, both in relation to his work and his social persona, and was instrumental in making Warhol an unsuitable candidate for the artist-subject position well into the early 1960s.

Kenneth Silver, in a groundbreaking essay of 1993, argues that it was precisely such a recognition of Warhol's homosexuality, as signified through his association with the supposedly effeminate world of commercial art, as well as through his avowedly effete deportment, which made him difficult to accept in the 1950s art world.[15] Warhol *was* a window dresser in the mid-fifties and put together displays for Bonwit Teller and Tiffany's. This made it difficult, Silver argues, for his would-be artist compatriots, including gay ones such as Jasper Johns and Robert Rauschenberg, to take him seriously as an artist. Even though the Pop artist James Rosenquist, as well as Johns and Rauschenberg themselves, had also worked dressing windows, it was something that most artists tried to distance themselves from upon becoming successful as artists.[16] Warhol, on the other hand, was *famous* for his commercial work and did not appear to be doing it "just to survive."[17] Thus Warhol appeared to be identified with window decorating in a way that other artists did not and, moreover, with a profession which was readily identifiable as a sissy occupation.

This played poorly in the masculinized contexts of the 1950s art world, and therefore it was an identity which most artists tried to disassociate themselves from at all costs. As the radical documentary filmmaker Emile De Antonio has recalled: "the commercial art world was a small gay world and once Rauschenberg and Johns were in [the Leo Castelli Gallery] their lives started to change. They were already not liking to know gay guys who were in fashion, because the mystique of the great artist was already on them" (*W* 148). Warhol, however, couldn't seem to shake off this identity, even despite his pretensions to be an artist. This goes someway, Silver argues, toward explaining why Warhol's attempts to make social connections with his fellow artists, even the gay ones, were met with rejection.

Silver quotes a conversation recounted in *POPism* in which Warhol recalls asking De Antonio about why Johns and Rauschenberg rebuffed him socially. According to Warhol, De Antonio replied, "Okay Andy, if you really

Plate 1. Larry Rivers, *Washington Crossing the Delaware* (1953) Oil, graphite, and charcoal on linen, 6′ 11⅝″ × 9′ 3⅝″ (212.4 × 283.5 cm). The Museum of Modern Art, New York. Given anonymously. © Larry Rivers/VAGA, New York/DACS, London 2001.

Plate 2. Larry Rivers, *The Studio*, oil on canvas, 1956. The John R. Van Derlip Fund, the Minneapolis Institute of Arts. © Larry Rivers/VAGA, New York/DACS, London 2001.

Plate 3. Larry Rivers, *The Greatest Homosexual*, oil, collage, pencil, and colored pencil on canvas, 1964. Hirshhorn Museum and Sculpture Garden, Smithsonian Institution, Gift of Joseph H. Hirshhorn, 1966. © Larry Rivers/ VAGA, New York/DACS, London 2001.

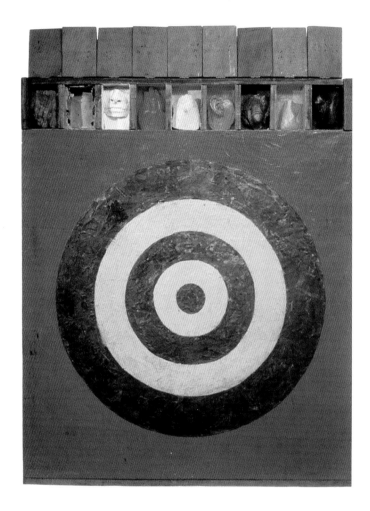

Plate 4. Jasper Johns, *Target with Plaster Casts*, encaustic and collage on canvas with objects, 1955. Collection David Geffen, Los Angeles. © Jasper Johns/VAGA, New York/DACS, London 2001.

want to hear it straight, I'll lay it out for you. You're too swish and that upsets them" (*P* 11–12). Warhol reports that this revelation "hurt a lot" and relates the rest of the conversation thus, responding to Antonio by saying:

> "I know plenty of painters who are more swish than me." And De said, "Yes, Andy, there are others who are more swish — and less talented — and still others who are less swish and just as talented, but the *major painters* try to look straight: you play up the swish — it's like an armor with you." There was nothing I could say to that. It was all too true. So I decided I just wasn't going to care, because those were all things that I didn't want to change anyway, that I didn't think I *should* want to change . . . Other people could change their attitudes but not me — I knew I was right. And as for the "swish" thing, I'd always had a lot of fun with that — just watching the expressions on people's faces. You'd have to have seen the way all the Abstract Expressionist painters carried themselves and the kinds of images they cultivated, to understand how shocked people were to see a painter coming on swish. I certainly wasn't a butch kind of guy by nature, but I must admit, I went out of my way to play up the other extreme. (*P* 12)

As Silver argues, this exchange clues us in to just how distressing Warhol's effeminacy, his "swishness," was for Johns and Rauschenberg. It made Warhol an "obvious" homosexual; it made his homosexuality too readily legible upon his body for him to be admitted into the social circles of successful artists. Given the importance that Johns and Rauschenberg placed on closeting their own sexuality in the world of fine art, to be seen publicly associating with Warhol would be to risk guilt by association: that they too would come to be viewed as suspect homosexuals and that this would have consequences — whether real or imagined — for their critical and economic success as artists.

What is significant here, in the context of this book, is that it is precisely through a piece of gossip exchanged over dinner at the restaurant "21" that Warhol comes to have all of this confirmed to him. Andy enjoyed talking to "De" about the art around town (on this particular occasion they chatted about recent New York exhibitions by Claes Oldenburg, Jim Dine, and Tom Wesselman), particularly because the filmmaker knew so many of the artists personally. But just for once, at least according to Warhol's own recollection in *POPism*, Andy broke gossip's unwritten law and asked De for some news about himself. "Why didn't they ('Jasper' and 'Bob') like me?" he wanted to know. The fact that he is wounded by De's answer, that the news

of the rejections from his fellow gay artists comes as a body blow to him, serves to highlight the performative power of gossip to injure and shame its subjects. Perhaps it is the revelation that he has been the subject of such judgmental forms of conversation *without his being present* which upsets Warhol as much as it might be finding out about their reasons for excluding him from their social circle. Warhol was used to not being spoken *to* in the New York art world ("everytime I saw [Jasper and Bob], they cut me dead") but, in the conversation with De, he discovers that he is also being spoken *about*. This registered affectively in Warhol's body ("I was embarrassed," he writes) and may have served to reinforce his isolation and fuel his anxieties about how he was being seen by others. In discovering the degree to which he was the subject of "malicious" conversation by those he both respected and craved recognition from as friends and peers, Warhol was ultimately wounded by De's words. "I'd naturally hoped to get off easier than this," he writes. "When you ask a question like that, you always hope the person will convince you that you're just paranoid." But in hearing De's unflinching account of Johns's and Rauschenberg's reasons for being socially aloof, Warhol was initially stunned into silence. "I didn't know what to say," he writes. "There was nothing I could say to that. It was all too true" (*P* 11–12).

This stunned, almost mute, Warhol at the dinner table at "21," I would like to suggest, clues us in to how his mature artistic persona of the 1960s could be viewed as constructed through just such an injurious scene of gossip and homosexuality. Warhol recounts his conversation with De in some detail in the opening chapter of *POPism*, which suggests that Warhol himself might have viewed this as some kind of primal scene out of which he emerges as the properly "Warholian" prince of pop in the 1960s. After being hurt by his chat with De, he writes of his decision *not to care*, which presages the self-construction of the cool and detached Warhol in the early 1960s. Part of this construction, as we shall see, consisted of things that he "didn't want to change," including his swishness, which he went out of his way "to play up." This parading of effeminacy, I want to suggest, can be understood as a typically queer move not only insofar, as Kenneth Silver argues, that it is one which parades its gender "inappropriateness," but also because it replays an injurious interpellation the better to recast it and wrestle back some degree of agency over and through it.[18] This is one move, I shall argue, in which the injurious speech of others comes to be recited not through new acts of speech per se on Warhol's part but rather through what we have come

to recognize as the typically Warholian "speech-act" of silence alongside the artist's particular bodily and sartorial performances.

This I shall return to later, but for now it shall suffice to say that such injurious interpellations were Warhol's lot in the late fifties and early sixties. Frank O'Hara was also, in Warhol's own words, "so meeeean" to him upon a visit to his studio in 1959.[19] According to John Giorno, O'Hara ridiculed Warhol's work by calling it "chi chi," and he refused to let the artist draw his feet, even though he was later to allow Johns to cast his foot for the erotically suggestive *Memory Piece (Frank O'Hara)* of 1961 (395). Gerard Malanga speculates that the uneasy relationship between O'Hara and Warhol could perhaps be explained by Warhol's sissiness being too much for the poet's taste.[20] It wasn't until October 1965 that O'Hara eventually began to appreciate Warhol and his pop works in more positive terms.[21] What becomes apparent, then, is that in the late 1950s and early 1960s, Warhol was marginalized by the social circles of his would-be artist-peers. His effeminacy was incompatible with that of the avant-gardists of Greenwich Village — he remained too undeniably gay and working class to be accepted within bohemian society.

This exclusion was maintained, if not, indeed, effected, by the sometimes-venomous things said about him in art-world parlance. According to Victor Bockris, this description of Warhol by New York socialite Frederick Eberstadt summed up how Warhol was seen by the majority of the one hundred or so people who dominated the New York art world at the beginning of the 1960s:

> You couldn't miss him, a skinny creep with a silver wig. His appearance was far more conspicuous than it would be today . . . He was this weird cooley little faggot with his impossible wig and his jeans and his sneakers and he was sitting there telling me that he wanted to be as famous as the Queen of England! Didn't he know that he was a creep? In fact he was the most colossal creep I had ever seen in my life. I thought that Andy was lucky that anybody would talk to him. (*W* 161–162)

A "weird cooley little faggot." This is an interesting expression of an assured, densely coded, and phobic denunciation of Warhol's economic, racial, and sexual otherness. The word *cooley*, usually a derogatory racist term for an immigrant Indian or Chinese laborer, is invoked here in referencing Warhol's East European roots and his working-class origins in industrial Pittsburgh. This, in association with the homophobic determination of *faggot*,

Figure 30. Truman Capote, 1947. Photo © Jerry Cooke/Getty Images.

pays heed to Warhol's ready legibility at this time as abject queer other: a body spoken about but rarely, if ever, spoken to.

Thus Warhol's early desire to be an artist along the lines of his early fifties hero, the dandyesque Truman Capote, was bound to fail (fig. 30). As Bob Colacello has written, in the 1950s Warhol "very much wanted to be what Capote was then: provocative, celebrated, taken seriously by the critics, asked out socially by the right people, the brilliantly witty homosexual who titillated the ladies who lunch."[22] He aspired to be that quasi-Wildean figure, one which might enable him to be both gay and a serious artist while also enjoying a kind of celebrity status in high-society circles. But, as Patrick S. Smith puts it, "the sensibility of a celebrity, like that of a dandy, is a cult of the self that is dependent upon society," and what is clear from what I have been arguing thus far is that Warhol simply could not generate the neces-

sary social lifeblood to make himself over into such a successful, dandified celebrity.[23] As Capote himself recalls of Warhol in the midfifties, he "seemed one of those helpless people that you just know nothing's ever going to happen to . . . Just a hopeless born loser, the loneliest, most friendless person I'd ever seen in my life" (*W* 101).

THE BIRTH OF ANDY WARHOL

Social and psychological injury has already been widely acknowledged as a significant determinant in the development of Warhol's artistic personality in the early sixties. For instance, Bradford R. Collins has written of the profound subjective transformation that Warhol undergoes in professionally making himself over from the "commercial illustrator" of the 1950s to the "Pop artist" of the 1960s.[24] The key feature of the personality which emerges from this transformation, Collins argues, is a "cold," distanced, and detached subject which we now readily identify as definitively Warholian. Rather than projecting himself outward into the social world of (gay) artists in New York bohemia, Warhol projected himself instead onto the image of the commodity. "His identification with unfeeling things," Collins writes— products of American mass culture from Campbell's Soup to news reports of car crashes—"was part of his effort to deaden the sensitive self" (51). This was a sensitive self that, as we have seen, was battered by the violent denunciations and rejections of homophobic society in the 1950s. Warhol's answer to his abjected personal and social condition was to stop caring, his reasoning being that "you can only be hurt if you care a lot" (51). As Jonathan Flatley argues, Warhol's turn to such "unfeeling" products of mass culture can therefore be seen as a reaction to his "shamed" status as a swishy gay man in 1950s America.[25] On this understanding, Warhol's pop way of approaching mass culture doubles as a gay identification with the supposedly leveling powers of the commodity, universalizing both himself and his abjected desire in that civic figure of modern capitalism: the consumer. As Warhol himself tellingly remarks, "you can be watching TV and see Coca-Cola, and you know the president drinks Coke, Liz Taylor drinks Coke, and just think, you can drink Coke, too . . . All the Cokes are the same and all the Cokes are good" (118). In this way, then, Flatley argues for a reading of Warhol's work as a form of gay survival in a homophobic world, symbolically articulating an empowered image of the homosexual citizen precisely through a renewed construction of himself as a kind of postmodern flaneur.

I am sympathetic with such accounts, especially insofar as they take the production of Warhol to be a kind of artistic response to a hurtful and injurious social scene. However, rather than focusing here on Warhol's subsequent turn to the "unfeeling" realm of the commodity, I wish to explore how Warhol's response may be understood as a queer reiteration of hurtful and shaming acts of naming—notably of Warhol as *abject swish*—and, further, one which has unexpected consequences for the structures of public recognition through which Warhol comes to be known into the 1960s. Fundamentally, and as we have already seen from Warhol's words in *POPism*, Warhol comes to accept the image that others have of him as homosexual swish ("It was all too true"), but decides that he is no longer going to accept the normative judgment and shame that habitually accompanies it. In deciding not to care, Warhol accepts the identities of commercial artist and of swishy gay man as his own, while distancing himself from the toxic affects ascribed to them by homophobic artistic culture. In this way, Warhol predates the politics of queer resignification, practiced by activists and theorized by writers such as Judith Butler in the 1990s, by some thirty years or so.[26] He works with an injurious act of naming, and forges himself through a struggle over that naming's possible meanings and affects.

This is particularly true of the way Warhol chooses to inhabit his identity as swish from this point on. It is through partially accepting the injurious sexual interpellations of his artist-peers, I am suggesting, that Warhol transforms himself into a Pop artist. That is, Warhol does not attempt to significantly tone down the signifiers of his gayness in order to win acceptance within the art world. On the contrary, he hyperbolizes them as part of his newly created artistic persona. As we have seen, his swishness was something that he "didn't want to change," so much so that, in the early 1960s, he made a definite decision to draw attention to it. Bockris sees this as just one aspect of Warhol's persona building which was effected through the deliberate theatricalization of his various "weaknesses": "He had, for example, bought some new silver-blond wigs which he wore uncombed and just slightly askew. He had also started to change the way he spoke, mumbling monosyllabic, often incoherent replies to any questions. And he had exaggerated everything else in his repertoire, like his slightly swish dancer's walk and his limp wrists (*W* 157)." Warhol thus deliberately creates himself as freakish, queer other. The exaggeration of his awkward, sissy-boy appearance could be construed as an attempt on Warhol's part to take control over his public persona and to "make a virtue of his vulnerability," as John Richardson puts it, forestalling or neutralizing any possible taunts (*W* 157).

This was a brave move to make at this historical moment because even the homophile organizations fighting for lesbian and gay rights tended to favor an assimilationist politics in which conservative forms of outward appearance, including conventionally gendered identities, were respected. Indeed, in an edition of the *Mattachine Review* in October 1958, whose cover bears the legend "Does he [the homosexual swish] deserve the scorn that society heaps upon him?" it is Warhol's distinctly theatricalized effeminacy that is singled out as justly deserving of ridicule and contempt.[27] The article makes a distinction between effeminate men who are naturally so and as such should be respected, and the affected gay, "who is offensive in his conduct." "Earmarks of the 'affected' individual," it goes on, "are inflection of voice, mincing steps, and broken wrists." Could it not describe Warhol more exactly? Whereas the effeminate gay merely indicates a "temperament," the article finally concludes, "affectedness indicates neurosis" (6).

In the light of all this, one might suspect Warhol, in writing retrospectively in 1980, of putting a more progressive gloss on his early queer artistic persona. One might, for instance, see his display of excessively effeminate gestures — his limp wrists, his dancer's walk, his "shyness" as a speaking subject — as a hyperbolized performance of *shame*, of his "neurotic" condition as a homosexual swish. This is what John Richardson effectively goes on to suggest by saying that "Nobody could ever 'send him up.' He had already done so himself" (*W* 157). This is to see Warhol's queer performance as a kind of self-deprecating *comedy*. I do not wish to either write such meanings in or out at this stage in order to produce a more or less progressive, proud kind of Warholian political subject.[28] Rather, I want to see how this strategy of resignification first comes to play itself out in Warhol's first big break in New York: a one-person exhibition at Eleanor Ward's Stable Gallery in November 1962. Only then do I want to turn my attention to the meanings and affects of Warhol resignificatory strategy which cannot, in any case, be simply assessed by attending to Warhol's (imputed) intentionality alone but will necessarily involve a consideration of its *effects* within the contexts of artistic and critical reception in the 1960s.

Certainly, it was after the Stable Gallery show that Warhol begins to "make it" as an artist, and that his recognizably Warholian persona comes into view. It is interesting to note, therefore, that dominating the exhibition were two *Dance Diagram* canvases laid out end to end on the gallery floor. I find these works intriguing insofar as they suggest a mass cultural reworking of Jackson Pollock's drip painting. Rosalind Krauss makes this point in her book *The Optical Unconscious*, drawing out how Warhol's work serves to re-

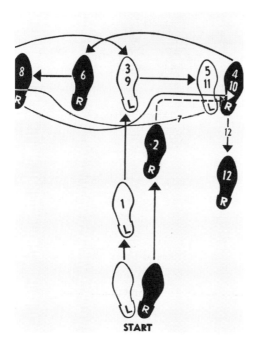

Figure 31. Andy Warhol, *Dance Diagram*, synthetic polymer paint on canvas, 1962. The Andy Warhol Museum, Pittsburgh, Founding Collection. © the Andy Warhol Foundation for the Visual Arts, Inc./ARS, NY, and DACS, London 2004.

call the horizontality of Pollock's painting process, and of Pollock's presence as he stands on and over them during their production.[29] This is a horizontality, Krauss argues, which remains sublimated in the vertical exhibition of Pollock's canvases on the wall but, in Warhol's reworking, is brought "down" not only by the literal placing of his canvases on the gallery floor, but also by *culturally* recasting Pollock's "high" existential painterly actions as the uncertain maneuvers of the dance beginner, as he/she attempts to engage in the "low" practice of learning dance steps mapped out by diagrams in "how-to" magazines.

But what Krauss fails to note is what such diagrams suggest about the *identity* of the artist who made them. Of course, as Krauss writes, "the tacky image" which the *Dance Diagram* conjures up is that of the "middle aged rake trying to learn the rumba from the Arthur Murray instructor" (275) (fig. 31). But, if Pollock's paintings were primarily about indexing the artist's bodily presence in the theater of the painting's production, Warhol's *Dance* canvases might therefore be seen to be significant in how they conjure Warhol's body; not as he wrestles with the traumas and anxieties of the authentic abstract expressionist act, but rather as he swirls and swishes across the surface of the canvas/ballroom floor, his head full of mass cultural fanta-

sies of Fred Astaire and Gene Kelly (or, knowing Warhol, more likely Ginger Rogers). That is, Warhol invites his Stable Gallery audience to associate him with the figure of the dancer, and moreover with the amateur dance *student*, in a bid to stage his artistic identity in the world of avant-garde art.

Of course, such an invocation of the artist's body would have been riven in 1962 with sexual connotations. As I have already noted in chapter 1, throughout the 1950s and early 1960s, the dancer—along with certain other professional figures such as actors, hairdressers, and window dressers—were readily suggestive of male homosexuality. Indeed, as Donald Webster Cory suggests in 1953, the body of the dancer is often taken to be morphologically close, if not almost indistinguishable, from that of the male homosexual. Effeminate, and therefore "obvious," gay men, he notes, are often "believed to be 'sensitive' or 'artistic' types . . . And are said to remind the observer of actors or dancers."[30] This homosexual suggestiveness of the male dancer's body is also borne out, as we have already seen, by Victor Bockris's reference to Warhol's "slightly swish dancer's walk and his limp wrists."

As it happens, Warhol was no stranger to dance and dancers either. He had been a member of a dance club when he was at the Carnegie Institute of Technology in 1948, and even though it is reported that "Andy . . . appeared awkward and uncoordinated" in relation to the other dancers in the club, he was nevertheless accepted as a full member—despite the rules being that club membership was open only to "every *woman* registered at Carnegie" (fig. 32).[31] A college photograph dating from this period represents Warhol as honorary female and presumptive queer, underlining the degree to which dance has frequently been associated with women and male effeminacy. Similarly, there are photographs from 1950 which show Warhol (at the far right) and his then dancer apartment mates from uptown New York clearly acting up for the camera, striking expressive and exaggeratedly theatrical poses (fig. 33). In presenting himself as dancer through *Dance Diagram*, therefore, Warhol would have been self-consciously mining some of his earlier forays into the world of dance and its real and imagined homosexuality.[32]

Given all of this, it is not difficult to imagine Warhol being readily seen as a dancer type in the 1950s and early 1960s. Even if Warhol's personal history was not common knowledge within the art world, one can imagine that Warhol's effeminate deportment would have likely been viewed as redolent of the theatricalized (queer) body of the male dancer. Stephen Bruce, a friend of Warhol's in the fifties, for one, remembers Warhol's manner as "danc-

ing."[33] What is so remarkable, then, about *Dance Diagram* is that it *courts* this identification precisely as part of the substance of its avant-garde gambit to carve out an identity for Warhol as a viable New York artist.[34] He effectively *invites others to view him as queer stereotype.* It is precisely by performing his body as that of the queerly invested body of the dancer that Warhol, at least in part, attempts to make himself over into an avant-garde artist. In some respects, one might say that via *Dance Diagram* Warhol metaphorically steps into Pollock's shoes, and in the process he replaces the action painter's solemn "dance" around his prone canvas with the mincing, clumsy footwork of the Hollywood obsessed sissy-boy.

But if Warhol can be seen to have recited the homophobic interpellations which may have been visited upon him, how might such a recitation have played in the contexts of the 1960s art world? How, exactly, did Warhol's queer gambit pay off?

Figure 32. "Andy Warhol and the Modern Dance Club," Carnegie Institute of Technology, c. 1948. Archives of the Andy Warhol Museum, Pittsburgh. Courtesy of the Andy Warhol Museum, Pittsburgh.

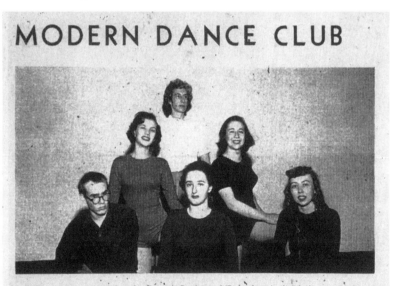

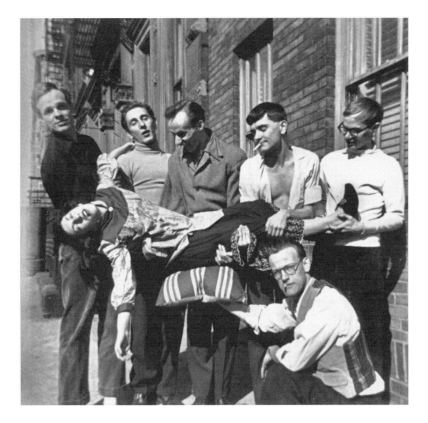

Figure 33. *103 St. Gang*, 1950. Archives of the Andy Warhol Museum, Pittsburgh. Photograph by Leila Davies Singeles. Courtesy of the Andy Warhol Museum, Pittsburgh.

THE "INNING" OF ANDY WARHOL

Before I get to this, I need to signal the degree to which my account thus far of Warhol's transformation from commercial to Pop artist differs from others proffered within art historical literature. Insofar as I have been suggesting that Warhol finally enters the art world by means of a bold, queer performance of his artistic body, I appear to be suggesting something different from that put forward by scholars such as Caroline Jones who argue instead that Warhol's entry into the art world around 1962 is coincident with a "closeting" of the artist and his work.[35] From the absence in his pop work of any obvious homoerotic iconography (one characteristic, of course, of his 1950s "fag" art), through to the general "silence" about homosexuality

in Warhol's world(s) in the 1960s, Jones argues that Warhol entered a closet of sexual meaning which he was only forced out of when Valerie Solanas shot him in 1968. Jones's analysis is important here since I too want to consider a closeting — or an inning — of Warhol which is effected in the early sixties, and in which Warhol's silence plays a key role. However, it is also, I want to suggest — and this is where I depart from Jones — a closeting which takes place in the face of what might be construed as obvious, even *excessive* markers of Warhol's gay identity.

Jones is largely unconcerned about *who* is responsible for doing the closeting: "whether . . . these closets were constructed by Warhol himself or erected by an enforcing culture is less important than that they served to periodize the Art from what had gone before" (256). This is because Jones is concerned with mapping out an aesthetic of silence in Warhol's work, one which she takes to enable both Warhol and art criticism alike to evacuate homosexuality from discourse. True, to some degree, one might argue that Warhol actively went out of his way to efface the legibility of homosexuality from his artistic persona, even going so far as appearing regularly in public from 1962 onward with various beautiful women, including Ruth Kligman and later Edie Sedgwick (fig. 34).[36] But to what degree such women were deployed as "beards" in performing Warhol's "heterosexuality" — in the manner more customary of Hollywood society — and to what degree they were social manifestations of Warhol's camp identification with feminine glamour raises a moot interpretative point. How might we read Warhol's public coupling with Kligman and Sedgwick, et al. as intentioned and sexually meaningful acts — as closeting move or queer performance? And how might they have been (variously) understood by those who witnessed such acts in the 1960s?

To raise such an issue is to immediately entangle oneself in the hermeneutic multiplicity of the performance of Warhol in the 1960s — both as he was read then and as we read him now — and it leads me to question Jones's construction of Warhol's closet. Jones's sophisticated reading draws on the work of Eve Kosofsky Sedgwick in figuring the "the closet-in-view" in Warhol's work, in particular in figuring how homosexuality might be positioned as the significantly *unsaid* in Warhol's life and work, significant precisely because of the absence of any signifiers of it. But this is of little use in addressing those signifiers in Warhol's life and work which appear, both in certain contexts in the 1960s and to my contemporary interpretative gaze, as decidedly queer.[37] How, in the light of this analysis, might we approach the "obviously" gay portraits of Elizabeth Taylor, Jackie Kennedy, Marilyn Monroe —

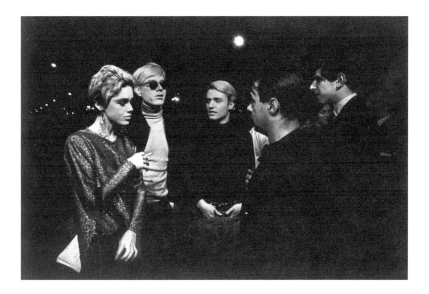

Figure 34. Edie Sedgwick, Andy Warhol, Gerard Malanga, and others, c. 1965. Photo by Nat Finkelstein. Courtesy of Nat Finkelstein.

all icons of camp identification — with which Warhol made his name (fig. 35)? And what of Warhol's avowed pleasures of "playing up" his swishness, an obvious marker of homosexuality at the time? Jones in her analysis of silence is blind to those ostensibly queer speech-acts which constitute "Warhol" as an author function in the 1960s. The closeting move that I want to consider in the remainder of this chapter is, therefore, one that is conducted less on the terms of a queerness made invisible, evacuated from the field of vision, and rather one conducted more in the face of its "flaming" *visibility*.

We can begin to appreciate the character of this closeting move by attending to the changed meanings attributed to Warhol's persona once he becomes a successful artist. In September 1962 Warhol attended a Labor Day weekend party. Bert Greene, somebody Andy had worked with before in the theater, recalls: "We were all waiting for him to arrive, because he was the one among us who had achieved a certain level of fame. He came with an entourage of very good-looking boys, I don't want to say 'call-boys,' but expensive boys and certainly like acquisitions. He had more authority, an air of hauteur. He didn't seem so little-boy fey" (*W* 178). This I take to be significant because it clues us in to a wholesale shift in the meanings of Warhol's effeminacy. Warhol has been transformed, almost overnight, from an obvious fairy

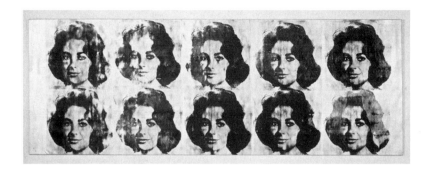

Figure 35. Andy Warhol, *Ten Lizes*, silkscreen ink on synthetic polymer paint on canvas, 1963. Centre Georges Pompidou–MNAM–CCI, Paris. © The Andy Warhol Foundation for the Visual Arts, Inc./ARS, NY, and DACS, London 2004. Photo © CNAC/MNAM.

("he didn't seem so little-boy fey") to a kind of Wildean aristocrat, complete with "expensive boys" in attendance, like "acquisitions." Interestingly here, Warhol has undergone a thoroughgoing class and sexual transformation, at least in the eyes of Greene. He now possesses "authority" and an "air of hauteur." In addition, there is nothing seedy or disreputable about him (they are not "call-boys" on his arm). Such a public appearance with beautiful boys, was, despite my comments above about Warhol's appearances with Sedgwick and other women, to continue as a feature of Warhol's Factory period. Indeed, Warhol was often photographed with his principal Factory assistant, Gerard Malanga, appearing perhaps as "Wilde" to Malanga's "Alfred Douglas." This might be seen to usher in a shift from one construction of Warhol to another; from what we might designate "Warhol-Swish" to "Warhol-dandy."[38]

This transformation from working-class fairy to upper-strata dandy is further effected in the critical attention paid to Warhol's persona from 1962 on. Warhol's effeminacy, one of the most obvious signs of his gayness pre-1962, is recoded as a marker of his asexual or nonsexual selfhood in the wake of his success and visibility within the art world. Alan Solomon perhaps speaks for most commentators in the early 1960s in his description of Warhol's appearance at a gallery opening in 1962: "dark had fallen, but he wore green sunglasses in an old-fashioned plastic frame. His hair was white, his nose rather prominent. He said very little; his voice was fragile, gentle, totally submissive, in fact, almost inaudible. I didn't know what to make of him; he was a wholly unfamiliar type" (fig. 36).[39] Describing Warhol as a

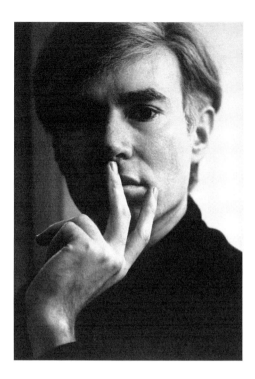

Figure 36. Andy Warhol, 1968. Photo © Malcolm Kirk/Getty Images.

"wholly unfamiliar type," then, Solomon interpretatively frames him in the context of a strange "artistic" otherness, his descriptive cataloguing of Warhol's appearance testament to the artist's inscrutable, hermeneutic opacity. His appearance and deportment are left as quasi-enigmatic, allowed to speak for themselves ("But what do they say?" we can almost hear Solomon ask). Similarly, the *New York Herald Tribune* published this little profile of Andy at the Factory: "He is very relaxed, almost sagging. His mouth is sullen. His hand is loose as you shake it. He is skinny, and he has an anemic look about him" (*W* 256). What's interesting here is that Warhol's persona is merely described; no certain or fixed meanings are ascribed to it.[40] This is a far cry from Eberstadt's violent and assured denunciation of Warhol as that "weird cooley little faggot."

All of this goes to demonstrate, as Eve Sedgwick argues in her 1991 book, *The Epistemology of the Closet*, that we cannot guarantee that all prospective acts of homosexual disclosure will necessarily result in the subject being outed.[41] For even as Warhol stages his gay identity through the theatricalized performance of his effete body, this identity fails to be recognized as such within what I am suggesting is a new discursive regime which comes to attend the artist's body starting in the early sixties. Indeed Warhol, much

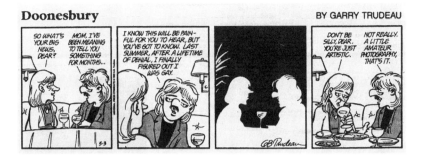

Figure 37. Doonesbury cartoon, 1994. Courtesy of Atlantic Syndication.

like the gay character in a 1994 Doonesbury cartoon strip, might be taken as being *inned* at precisely the moment of his coming out into the New York art world of the sixties (fig. 37). In Gary Trudeau's comic narrative, a gay man finally plucks up the courage to tell his mother (who else?) the "big news" he has been meaning to tell her for months. But after the revelation — apart from an initial, pregnant moment of silence — the mother quickly recontains and disavows the knowledge proffered by his brave act: "Don't be silly, dear. You're just artistic," she says. And in colluding with his mother's will to dismiss the significance and import of his gay declaration, he quickly follows up: "Not really. A little amateur photography, that's it."

What I'm suggesting here then is that Warhol, though undertaking a transgressive queer bodily performance — which we might take as a speech-act akin to the cartoon character's performative declaration — finds the queer import of that performance, the knowledge of (his) homosexuality, effaced from discourse in the structures of recognition which come to in scribe and name his body in the 1960s. It is the witnesses to Warhol's bodily speech-act — his immediate social peers, journalists, art critics — who come to effectively disavow the sexual significance of his peculiar form of self-presentation and to reframe it as important in some quite different order of identity and meaning. Of course, I would not want to deny, in keeping with Caroline Jones's argument, that Warhol himself, like Trudeau's gay character, would have been likely complicit — at least to some degree — in perpetuating this closeted discursive frame which allowed him to *act* gay without being recognized as such within social and critical parlance.

However, what I think is important here is the way in which Warhol's silence about his artistic persona — his reticence to speak about himself, his

mumbling, often incoherent, replies to questions—effectively *forces* his critics to reassess their perhaps more customary homophobic reflexes to his performance of the homosexual swish. The question I think Warhol's performance posed to his critics in 1962 was something of the order of the following: How might one approach the body of the swish in terms other than those of abuse and derision, especially given that such a body was now being presented as that of an emergent and newly successful artist? And this would have been an especially recalcitrant question given the lack of any overt performance of shame, or other interpretative clue delivered by the artist himself. Thus Warhol serves to shift attention away from his body, and its hitherto undeniable suggestion of homosexuality, to the hermeneutic deliberations of those who would claim to know him.

Returning to the statements about gossip with which we began, Warhol's artistic performance thus suggests that we learn less of *him* from all that is spoken and written about him and rather more about *those who do the speaking and writing*. In keeping with the myth of Warhol as cultural mirror, then, we can see how he turns our attention to the ways in which others name him, whether abusively in gossipy references to his homosexuality or, as increasingly is the case in the 1960s, through a less explicitly sexualized celebration of his artistic persona.[42] In short I am interested here in the productivity of Warhol's *performative* silence, one which has a transformative effect on those who would comment about him, and on the (homophobic) structures of interpretation and evaluation.[43] It is the shift to such apparently desexualized forms of address to Warhol—and the structures of disavowal which inform them—to which I finally turn in this chapter.

WILDE IN REVERSE

The tendency of many commentators at this time to simply resort to a description of Warhol's appearance might be seen as an effect of his dandyish pose, to see all there is to "know" about him at the level of surface appearance. This, of course, could be seen to be in keeping with Warhol's now famous saying: "if you want to know all about Andy Warhol, just look at the surface of my films and paintings and me, and there I am. There's nothing behind it."[44] However, this statement wasn't made until 1967, until *after* Warhol became established as the king of artifice and superficiality. I want to suggest that it was less through Warhol's pronouncements that he came to establish himself as a dandyesque figure in the early 1960s. Rather, it was

through the discursive transformation wrought upon Warhol's body by the talk of others in the New York art world as they came, belatedly perhaps, to take the artist and his work seriously and appreciatively.

One of the reasons Warhol came to be accepted in the art world was that he came backed by Henry Geldzahler, then a young curator at the Metropolitan Museum of Art. As Billy Name recalls, Henry "was the word" and "if Henry went to an art opening, everyone went."[45] Geldzahler's advocacy of Warhol, backed by the authority of the museum, caused people to reassess their more dismissive attitudes toward Andy and forced them to struggle for a new language through which they might speak more appreciatively of the artist and his work. As they did so, art critics and other commentators on Warhol effected a transformation of Warhol's public persona inversely related to that visited upon Oscar Wilde in the nineteenth century. As numerous Wilde scholars have argued, Wilde's public image was transformed by the mechanism of the trials in 1895 from that of a lauded, cultural sophisticate to the abject personification of criminalized homosexuality.[46] Warhol, on the other hand, undergoes a kind of Wildean transformation in reverse. Initially marked by the art-world gossips as an obvious queen, Warhol's public persona is refigured after 1962 as perhaps *the* archetypal postmodern dandy, one which pertains ironically to the image of Wilde before "the fall," before the trial — a figure cleansed of any obvious homosexual meaning or identity. Warhol's homosexuality, though arguably still *hyper*visible throughout the 1960s, came to be figured within interpretative frameworks which expunged his queerness from the field of cultural recognition. The degree that Warhol's swishness goes unremarked as a sign of homosexuality in the art world at this time only goes to underscore Lee Edelman's argument in his book *Homographesis* that, under the right conditions, homophobic culture can pass over even the most seemingly obvious homo-manifestations in silence.[47]

And these conditions had only been recently established. My reference to Wilde is not merely a fanciful critical comparison, for a report published in *Time* magazine in August 1965 has the following to say: "Oscar Wilde once noted that the way to get into the best society is to amuse or shock. That theory may have worked in Victorian London, particularly for witty, shocking Oscar Wilde. But it never went over in New York . . . In recent years, however, New York has gone Wilde, and the newest darlings on its social circuit are artists and artisans who ten years ago were talked about but seldom talked to . . . At the moment, the magic names are Andy and Edie."[48]

Interesting here is the recognition of Warhol's transformation as the subject of *talk*: the shift from being "talked about but seldom talked to" toward a figure who, as one of the "newest darlings" on the social circuit, is desired as someone to be talked *to*. That New York had "gone Wilde," and that Warhol (along with his "superstars") had come to epitomize this Wildean moment, should be understood in the context of the specific meanings attributable to Wilde in America in the early 1960s.

Wilde was undergoing somewhat of a rehabilitation with the screening of two British films, *Oscar Wilde* and *The Trials of Oscar Wilde*, in New York in 1960. Both films, but especially the latter, with Peter Finch in the starring role, were greeted with critical suspicion. Bosley Crowther, a *New York Times* columnist, devoted three separate pieces to discussing the films, claiming that they appealed largely to an interest in "the mystery of sexual abnormalities."[49] In a piece tellingly entitled "Wilde Absolved," Crowther argues that *The Trials of Oscar Wilde* was "impressive" in every way except, that is, for its insistence that "Mr. Wilde was a man of pronounced masculine impulse and generosity . . . that his relations with young Lord Alfred Douglas were on a high spiritual plane, and his friendships were inspired by his middle-aged love of youth."[50] "You wonder if this is a fairly true account, if Mr. Wilde was as noble and heroic as he is made to appear," Crowther goes on, "and if he was, what was he doing with those cheap and shady young men? It looks to us if they are trying to whitewash a most unpleasant case, which is one of the more notorious and less ennobling in literary history" (26).

Thus Crowther responds to what we might call, using rather more contemporary terminology, a filmic "degaying" of Wilde, the better to reinvest him (and by implication his homosexuality) with a degree of legitimacy and respectability hitherto unattributable to Wilde's character — at least, that is, since the event of the Wilde trials which besmirched his name in the first place. "The incongruity in both pictures," Crowther writes, "is the sympathy extended to what was plainly a sordid and repulsive affair. It almost looks as if they are attempting to justify Oscar Wilde without having the nerve to come out bluntly and justify his abnormality."[51] Here Crowther goes to the heart of my argument vis-à-vis Warhol. For if Wilde was being degayed at this time, if he was being inned by popular representations of him in the cinema, then the Wildean dandy became cleansed (once again) of homosexual meaning just at the time of Warhol's appearance on the 1960s art scene. This meant that it was no longer imperative to frame Warhol's "curious way of being" in the context of an abject homosexuality. It was now

possible to reposition it within a culturally available, degayed genealogy of the dandy, one which effected a legitimation of Warhol as an artist "without having the nerve to come out bluntly and justify his abnormality."

This degaying of Wilde, and by extension Warhol, is developed in Susan Sontag's "Notes on Camp" published in *Partisan Review* in 1964. As I have already suggested in chapter 3, Sontag's article was, at least in part, responsible for degaying camp at the moment of its emergence into mainstream culture. However, it is not only camp that is degayed by the "Notes" but also Wilde, to whom Sontag dedicates her text. Wilde's aphorisms punctuate Sontag's analysis at regular intervals indicating the degree to which Wilde himself might be taken as the metatext of her reading of camp and its histories. "Camp," she argues in a famous formulation, "is the answer to the problem: how to be a dandy in the age of mass culture."[52] Wilde is the "transitional" figure who makes all of this possible, who drags the dandy's traditional investments in aristocratic culture and "good taste" kicking and screaming into modern mass society:

> The man who, when he first came to London sported a velvet beret, lace shirts, velveteen knee-breeches and black silk stockings, could never depart too far in his life from the pleasures of the old-style dandy; this conservatism is reflected in *The Picture of Dorian Gray*. But many of his attitudes suggest something more modern. It was Wilde who formulated an important element of the camp sensibility—the equivalence of all objects—when he announced his intention of "living up" to his blue-and-white china, or declared that a doorknob could be as admirable as a painting. When he emphasized the importance of the necktie, the boutonniere, the chair, Wilde was anticipating the democratic *esprit* of Camp. (528)

It is not difficult to imagine how such a "democratic *esprit*" could have been seen in Warhol's attachment to "unfeeling things" in his pop works of the early 1960s, nor how Sontag's culturally and critically rehabilitated Wilde could be read as providing a genealogy of modern dandyism into which Warhol and his newly created artistic persona might easily have been slotted. Indeed, it is just such a degayed discursive invocation of the dandy—as a figure concerned with making life into a work of art; as a passive, detached persona predisposed to an appreciation of the superficial and the inconsequential—which comes to be deployed in providing Warhol with a critical and historical legitimacy in discourses of art in the 1960s and beyond.

The emergence of such constructions of the dandy paves the way for

art history and criticism to finally canonize Warhol in the early 1970s in a Wildean guise. Mary Josephson writes that "just as Wilde's epigrams were repeated by his contemporaries in drawing rooms, Warhol's are retold in the gossip column, the drawing room of the masses . . . Like Wilde, Warhol has a quality that has not, to my knowledge, been much remarked on — a dignity that, whatever may rage below the surface, is maintained with mild and steely gentleness."[53] And Max Kozloff, in the same year, remarks: "Like Oscar Wilde, he can say that he puts his talent into his art, but his genius into his life."[54] Perhaps the most canonizing gesture is undertaken by Stephen Koch, who, in his 1973 book *Stargazer*, situates Warhol in a historical lineage of dandyism reaching back further than Wilde, to Baudelaire and the founding moments of European modernism. Through his various pronouncements such as "I want to be plastic" and "I want to be a machine," Koch argues, Warhol was expressing his desire to transform himself into an object and thus can be understood as the "greatest living inheritor of that creature of style [the dandy] Baudelaire so flawlessly described."[55] Thus Josephson, Kozloff, and Koch alike deploy a construction of Warhol as dandy as a determining condition of Warhol's entry into the canon.

Koch, however, is *un*like some of his critical forebears since he *does* reference homosexuality, at least that of Warhol's "world" if not that of Warhol himself ("Warhol's world is decidedly homosexual," he writes). However, this is only in order to dismiss it in favor of a discussion of Warhol's narcissism. In doing so, Koch's book presages the gradual emergence of Warhol's homosexuality in discourse throughout the 1970s, but one that is still figured through the representational and sexual ambivalence of the dandy, the same ambivalence which, in the 1960s, had been responsible for his inning at the hand of critical discourse. Well into the 1970s, when Warhol became almost synonymous with the decadence of Manhattan nightlife at Studio 54 (my choice of words already signaling a Wildean interpretative frame), the figure of the dandy, and its attendant significatory ambivalence, was again called upon to articulate (Warhol's) homosexuality. This it did while simultaneously effecting its disappearance into the performance of a particular kind of artistic life, thereby figuring a homosexuality decidedly other to itself. "His Wildean life with its parties and hints of perversity, his fondness for the fib and the put-on, his 'underground' movies with their nudity and unexpected couplings, aroused media attention," writes Paul Gardner in *Artnews* in 1980, serving to articulate how a Warholian homosexuality, as a self-styled public and transgressive spectacle, emerges only as and through its simultaneous evaporation into the artistic invocation of

a "Wildean life."[56] This confers upon Warhol's gay identity, then, a profound instability as it both emerges and disappears in the semiotic field of dandyism.

It is this instability of meaning within discourses of dandyism, the shuttling of identities between the sexual and the artistic which, I have been arguing, provides the occasion for Warhol's inning in the 1960s. This inning provides the discursive condition, I have been suggesting, which enables Warhol to become successful as an artist. The emergence of degayed constructions of dandyism furnishes art criticism with a means of addressing Warhol's effete persona without having to construe it as an abject marker of his homosexuality. Greene, Solomon, and others in the 1960s approach Warhol's bodily deportment as the performance of a postmodern, specifically "artistic" form of dandyism. This construction is one which effectively disavows the knowledges of the artist's sexuality which had been hitherto entertained in New York bohemia as malicious gossip. This was despite Warhol's hyperbolized performance as a homosexual swish and goes to show how, even in the face of such a bold enactment of queer identity, the etiquette of serious art critical discourse required a less flagrant address to the artist's sexual identity than that proffered within the circuits of informal conversation. Ironically, it seems, by playing up to people's private and denigratory fictions of him, Warhol served to produce a public persona which generated a closeted discursive regime around it, shutting people's mouths and displacing from so-called official recognition any direct mention of his homosexuality.

However, even if the dandy had been desexualized in the early 1960s, its history still haunted each dandyish pose; and every act of naming such a pose invoked the spectral presence of a male homosexuality which refused to stabilize as an identity or its absence. Perhaps, in this way, the construction of Warhol-dandy engendered the discursive maintenance of an open secret about Warhol's homosexuality in the cultural contexts of the 1960s. It offered to the professional art explainers and New York socialites a way of approaching and legitimizing the artist's apparent queerness without naming it *as such*, without having to finally say that this is what Warhol *was* or what his public persona *meant*. Dandyism provided an interpretative screen through which a knowledge of Warhol's queerness could be avowed, but one entertained only *in*, and *as*, a process of its simultaneous disavowal. This was the discursive form which knowledge of Warhol's sexuality took in the early 1960s, one largely constrained from achieving the status of an avowed truth — of the meaning of Warhol's body, or the body of his art.

All of this allows Warhol to emerge into the 1960s New York art world as the self-styled *purveyor* of gossip rather, as had been the case earlier, than a high-profile *object* of it. The circulation of the Warhol-Dandy construction enabled him to perform his homosexual identity, even hyperbolize it, as an expression of his artistic selfhood, while deflecting homophobic hostility by appearing "otherwise." Thus his coming out into the art world—if we can characterize his swishy performance as a kind of declaratory homosexual speech-act—is one which both produced and effaced gay identity in the visual and interpretative field. In the context of a culture in which homosexuality was kept alive through a discursive dynamic of avowal and disavowal, the construction of Warhol-dandy, then, emerged to secure Warhol a place in art history, one which the art-world gossips of the 1950s and early 1960s—and their more declaratory homophobic pronunciations—had conspired to rob him of at the earliest opportunity.

CHAPTER 5

BODIES OF EVIDENCE:

QUEERING DISCLOSURE IN THE ART

OF JASPER JOHNS

In January 1958 Jasper Johns had his first one-person show at the Leo Castelli Gallery in New York. It was a huge critical and commercial success. By the end of the show, all but two of the works on exhibition had been sold. As early as the first Saturday in the exhibition run, Alfred H. Barr Jr., then director of collections at the Museum of Modern Art in New York, paid a visit to Castelli's with a view to acquiring some of Johns's work for the museum. He thought Johns's art was evidence of a "new spirit" in American painting and, together with his associate Dorothy Miller, he selected four works for purchase: *Green Target*, *White Numbers*, *Flag*, and *Target with Four Faces*.[1] In the event, only three works were bought by the museum. *Flag* was referred to the museum's board of trustees, which decided that it would be an unwise purchase and dropped it for fear of offending patriotic sensibilities. In a roundabout way, however, the painting was still secured for the museum. Barr was able to persuade Philip Johnson, one of the trustees, to purchase it privately. The painting finally entered the museum's collection in 1973 as a gift honoring Barr on his retirement.[2]

But *Flag* was not the only problematic painting that Barr considered for the museum on this visit. Barr also wished to buy *Target with Plaster Casts* (color plate 4) but found it an equally, if not more difficult, proposition to consider as an addition to the museum's collection. Barr was concerned about what the museum trustees might think of one of the painted plaster body parts contained in the row of compartments along the top edge of the painting. As Calvin Tomkins tells it: "Barr really wanted to buy the larger *Target with Plaster Casts*, but he was nervous about the museum trustees'

reaction to the green-painted plaster cast of a penis in one of the wooden boxes on top. Would it be all right, he asked Castelli, to keep the lid to that particular box closed? Castelli said they would have to ask the artist, who just happened to be in the back room. Johns came out, listened to Barr's request, and said that it would be all right to keep the lid closed some of the time but not all the time. Barr decided to take *Target with Four Faces* instead."[3]

What Barr "really wanted," according to Tomkins, was *Target with Plaster Casts*, but he couldn't buy it without first agreeing to an important adjustment to its future conditions of exhibition: namely, that the green plaster cast of the penis would have its compartment lid permanently closed. Without such a change, it seems, Barr would not even countenance putting the painting before the museum for consideration (as he felt able to do with *Flag*, despite his anxieties about its patriotic meaning). Johns's refusal of Barr's conditions of purchase, his insistence on the lid to the penis cast being at least *sometimes* open, would have ensured a degree of mutability to the painting's appearance that proved unacceptable to Barr. In sticking to this version of his authorial desire, Johns left Barr with no other choice than to purchase the less contentious *Target with Four Faces* instead.

Barr's decision not to buy *Target with Plaster Casts* was later ratified by the museum's committee, which deemed the painting unacceptable "because certain graphic details would prevent its exhibition" (*F* 221, n. 58). The painting found no other takers, despite being one of the most referred-to pieces in the show. Out of the eighteen paintings exhibited, it was one of only two left unsold at the exhibition's end. The other, *White Flag*, Johns chose to keep for himself. It was therefore left to Leo Castelli, who wanted a Johns piece for his private collection, to finally buy *Target with Plaster Casts*. Although proving subsequently to be a wise and significant investment, at the time Castelli may have bought it more as a mark of thanks and support to an artist whose inaugural show had proved otherwise to be such a tremendous commercial success. Castelli quipped that he ended up with *Target with Plaster Casts*, "penis and all" (*F* 221, n. 58).

Thus *Target with Plaster Casts* differed from the other works in Johns's 1958 show because it was the subject of an irresolvable tension between the authority of artist and museum.[4] Unlike *Flag*, which was purchased circuitously, Johns's and Barr's incommensurate conditions of sale contrived to prevent the purchase of *Target* altogether and ensured its effective absence from the walls of MOMA for some years to come.[5] What strikes me in all of this is the significance accorded to the visibility or otherwise of a single painted

plaster cast of a penis. Why should the cast have been the most salient and contentious feature of a work comprising other related body fragments and a painted target? Why should the acquisition of the painting, and its concomitant institutional legitimation by the museum, depend on attitudes toward this one particular fragment as opposed to the painting as a whole? What was the peculiar affective condition of the penis cast at this time, and what might *Target with Plaster Casts* as a whole have represented to Barr, to Johns, and to others who might have seen it at Castelli's?

These questions provoke my curiosity because relatively little scholarly attention has been paid to them thus far, leaving the decision *not* to buy this particular artwork underexamined and unexplained. Art historians *have* considered the difficulties surrounding the purchase of *Flag*, relating the anxiety of the museum's acquisitions committee to the patriotic sensibilities inflamed by McCarthyism in the early 1950s. For instance, in his book *Figuring Jasper Johns*, Fred Orton undertakes an extensive analysis of the ambiguity of the painting's patriotic meaning, which, he argues, made it too troublesome a work to receive public recognition from a major art institution at that time. The difficulties surrounding *Target*, however, have thus far received comparably little attention. Orton himself is generally elliptical in considering the problems presented by this painting, especially in comparison with the sheer volume of research and analysis marshaled in his writing on *Flag*.[6]

This resultant "gap" in the historical record forms the point of departure for this chapter, and it provides me with the lure for my interpretative desire. I am curious to know what it was, exactly, which remained unspoken and yet powerful enough to render this painting unfit for purchase and exhibition. In addressing this issue I embark, on one level, on a fairly straightforwardly art historical enterprise to trace the possible meanings and affects which may have accrued to the painting in the cultural contexts of the late 1950s. But, as I hope will become clear, what I am also interested in exploring is how the archival procedures of art history, dependent as they are upon marshaling certain forms of evidence in reading iconographic meaning, are brought sharply to their limits as we come to speculate about *Target*'s queer meanings and affects. This is because the queerness that I am at pains to explore here resides in a set of meanings and identifications which circulate around, but fail to stabilize as, the interpretative "truth" of *Target*'s peculiar visuality. It is these meanings which I wish to pay heed to, and proliferate, here—both in, and *as*, I write.

In this way, the subject of this chapter is not solely the historical one

of tracing the meanings that might accrue to a work by Jasper Johns, but also the historiographical question of how we might bear witness to the queer effects of such meanings on interpretative discourse. In paying heed to the unruliness of queer meanings as they circulate within unsanctioned discourses that purportedly depend on less rigorous standards of evidence and corroboration, I explicitly and performatively stage the shaping power of my own curiosity and desire on my sexual inquiries.[7] By self-consciously tracing and enacting my continuing fascination with Johns's painting, or more narrowly one "part" of it, I hope to trouble the "disclosing" of sexual truths within art history's normatively constative mode of address. Needless to say, it does not trouble *me*, nor would it surprise anyone that knows me, to think that I have fixated upon a cock (or at least a cast of one) for my final chapter. But it *does* vex my approach to art history in apprehending how *Target with Plaster Casts*, "penis and all," might have appeared as phobic object in 1958. This is because, despite the amassing of much art historical argumentation, there appears to be yet more to say, still more questions to be answered — leading me to a lip-smacking embrace of the conjectural, if not "idle," determination of stories which might purportedly account for the painting's fate.

OBSCENE PARTS

Target with Plaster Casts, painted in 1955, consists of a large target painted in encaustic lined along the top edge by a row of nine wooden compartments, each with its own hinged lid. From left to right, most of the boxes contain painted plaster casts of fragments of the human body: part of a right foot (painted purple); the lower portion of a face (white); a hand with little finger missing (red); a breast and nipple (pink); an ear (orange); a penis (green); and a heel (yellow). The interiors of each box are painted the same color as their respective body parts. The contents of the two remaining boxes differ slightly from the rest. One box, its interior painted blue, appears empty except for what appears to be a rough, and uneven, residue of glue around its edges. Another, instead of a body cast, contains a painted black bone which some commentators have likened to the appearance of female genitals (*F* 47). Critical commentary has conventionally viewed the painting as comprising two key elements: target on the one hand, plaster body parts on the other. In doing so, it has variously attempted to read the relations between these two components as the subject or meaning of the work. Indeed, it is

through the variously construed aporetic or contradictory play of "target" against "casts" that critics have come to identify what we now recognize as a typically Johnsian play of meaning.

Richard Francis, for example, in his 1984 monograph remarks on the play of affect, from the "emotional quality" of the casts to the "cool" of the target, as being typical of the way in which Johns's art works to both suggest and deny personal or emotional meaning.[8] This play of an emotive "hot" against an impersonal "cool" is typical of the way in which Johns's art has been read as putting into play ontological differences, and it is the reason it often refuses conventional distinctions of meaning and value applied to it by art historians and critics. However, though in retrospect it can be seen to engender this typically Johnsian hermeneutic effect, in the late 1950s and early 1960s it was taken by some critics to be exceptional among Johns's early oeuvre precisely in the degree to which it *failed* to achieve such results. This failure had a lot to do with the particular affective condition ascribed to the body parts, one which worked to overshadow any play of meaning between them and the target.

One such critic, Robert Rosenblum, clues us in to the ways in which the "hot" determination of the plaster casts might have been responsible for this. Writing in a review of the Castelli show in *Arts Magazine* in January 1958, he refers to the painting in a brief, though telling, comment as comprising a "peep show." "The target," he writes, "offers a comparably dazzling theme and variations (to the flag), in one case offering a peep show which even imposes a moral decision upon the observer."[9] In writing thus, Rosenblum signals what I take to be the deleterious affect of the painting, specifically of the body parts, which marked it out as different from the rest of Johns's artistic corpus at the time. This single line of criticism is highly significant, being exceptional among critical responses in the late 1950s and early 1960s in referring more or less explicitly to the troublesome nature of the painting's *erotic* character. Other critics, such as Leo Steinberg, *do* refer to the problematic affective condition of *Target*'s body parts, but do so in respect of their unwelcome morbidity rather than by dint of any erotic allure or meaning.[10]

Perhaps referring less to the painted target, and more to the plaster casts in the hinged compartments, Rosenblum's characterization of Johns's painting alludes to the way in which the painting presents the viewer with a fetishized spectacle of body parts, to be revealed or concealed as in an erotic peep show. The play between the veiling and the unveiling of the body, between the parts of the body which are hidden by clothing and those which are ex-

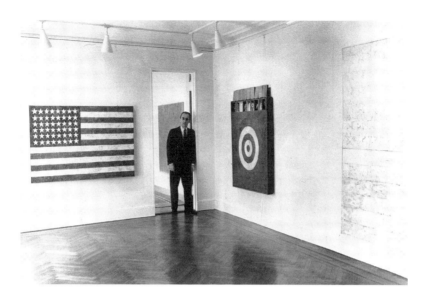

Figure 38. Installation shot of Jasper Johns's exhibition at the Leo Castelli Gallery, New York, 1958. Photo by Rudolph Burckhardt © ARS, NY, and DACS, London 2004.

posed to vision, is what Linda Williams, following David James, identifies as a defining feature of the modern striptease, and therefore of the modern peep show. "The striptease consists," she writes, "of a continual oscillation between exposure and concealment — the satisfaction of seeing all and the frustration of having that sight cut off in a 'premature climax'" is what constitutes the pleasurable dynamic of the peep show's erotic spectacle.[11]

Target's compartment lids, we might assume, were instrumental in effecting a similar pornographic viewing for the painting's spectators in 1958. Although these wooden lids can be closed, the painting has, to my knowledge, always been exhibited with them open. A photograph of *Target* in situ at the Castelli exhibition confirms this, showing all the interiors of the painting's boxes on view (fig. 38).[12] Nevertheless, the idea that the lids may be open *or* closed, that the body casts *could* be closed off and hidden from view, might have been highly significant in determining how and what they were seen *as* in 1958. Body casts in closable boxes might have been read as something that could be, or, with more moral force, *should* have been hidden from view. Reading the casts in this way would have made any gaze upon them an illicit or furtive activity, a covert and voyeuristic "peep" at them.

Rosenblum sums up his *Arts* review by writing that: "Johns' work, like

all genuinely new art, assaults and enlivens the mind and eye with the ex-
hilaration of discovery."[13] Certainly the "exhilaration of discovery" would
make sense in terms of what *Target*-as-peep show scandalously reveals to the
eye. But also "assaults" and "enlivens": these words echo meaningfully in the
semiotic orbit of *Target*'s initial moment of exhibition, particularly insofar
as they might be construed in terms of a legal discourse of obscenity. In so
doing, they might be taken as alerting us to the *obscene* status of the paint-
ing's bodily display, especially as construed within the cultural contexts of
the late 1950s.

Debates about obscene literature and imagery were highly public and
contentious at this time. Highly publicized trials concerning D. H. Law-
rence's *Lady Chatterly's Lover*, Henry Miller's *Tropic of Cancer*, and John Cle-
land's *Memoirs of a Woman of Pleasure* were only the tip of a large legal
iceberg involved in the complex reappraisal of definitions of obscenity. In
addition to such landmark trials, many cases were heard against so-called
pulp novels, including titles such as *Campus Mistress* and *Orgy Club*, and
"serious" journals and institutions concerned with sexuality such as *One*
magazine and the Kinsey Institute.[14]

But if concerns about obscenity were in the air in the late 1950s, then
the law around obscene representation, and specifically obscene male body
parts, was *particularly* vivid at the time of Johns's Castelli show in Janu-
ary 1958. In the summer of 1957 Lawrence Ferlinghetti, proprietor of the
beat generation's City Lights bookstore in San Francisco, was tried, along
with Shigeyoshi Murao, a clerk at the store, for printing, publishing, and
selling an allegedly obscene text: Alan Ginsberg's *Howl and Other Poems*.[15]
The trial was widely publicized. According to Michael Schumacher, Gins-
berg's biographer, it had "a national audience" and "representatives from
major newspapers and magazines attended and reported to readerships rep-
resenting the spectrum of social and literary ideologies."[16] *Life* magazine
dedicated a full four-page pictorial article to the trial and the work of some
of the beat poets, including Ginsberg, Ferlinghetti, Kenneth Rexroth, Gerd
Stern, and Michael McClure.[17] The trial had a number of hearings and finally
concluded in October 1957, when the defendants were acquitted of all
charges. *Howl* was in its fourth printing by the end of the trial, and count-
less mimeographed versions were being circulated throughout the United
States.

The case against *Howl* would therefore have been likely to impact upon
the meaning of Johns's art in early 1958. For not only was the trial highly
publicized and only a few months ended, it was a case which centered around

whether or not particular references to body parts could be taken as obscene in themselves. The words concerned were largely vernacular terms, particularly genital references such as *balls*, *ass*, and *cock*. The prosecution contended that *Howl* was an obscene speech act because of the inclusion of lines such as "with dreams, with drugs, with waking nightmares, alcohol and cock and endless balls."[18] They argued that Ginsberg's use of the words *cock* and *balls* in such lines was designed to appeal to an erotic or prurient interest and were therefore obscene in themselves. The defense, on the other hand, argued that the poem had to be taken as a whole and that, as such, it demonstrated "redeeming social significance." They argued that it was a "howl of protest" against the dehumanizing logic of contemporary Western society and that it therefore had significant literary merit and social importance.

The prosecution eventually lost the case after putting forward some particularly disastrous witnesses, and all charges against Ferlinghetti were dropped. In his summing up, Judge Clayton Horn found the coarse and vulgar language in *Howl* not to be obscene in character, because it was not seen to be primarily "erotic or aphrodisiac in character."[19] Its use of swearwords and anatomical references was not intended, he ruled, to appeal to prurient tastes, at least not primarily, and the poem was therefore cleared of all charges.

As Schumacher reminds us, "in retrospect, given today's standards, the trial appears to be almost fatuous, but in 1957, many precedents were yet to be set. *Playboy* magazine was only a few years old, and Hugh Hefner was still battling obscenity charges for publishing photographs that, by today's standards, were tame."[20] Michael Crichton notes, in a similar way, how the fears surrounding Johns's *Target* appear almost fatuous to the contemporary observer.[21] However, given this climate, what was particularly striking about the *Howl* ruling was that graphic and sexually explicit references to homosexuality were cleared of obscene charges. This is not to say, however, that the trial in any way affirmed homosexuality. Rather, it had the effect of overturning the idea that the representation of homosexuality was necessarily obscene in and of itself. Witnesses for the defense helped clear the poem of obscenity by stating that its references to homosexual sex acts were clearly designed to express Ginsberg's vision of a corrupt society rather than to be sexually arousing. "The essence of the poem," one of the defense witnesses said, "is the impression of a world in which all sexuality is confused and corrupted. These words indicate a corrupt sexual act. Therefore, they are part of the essence of the picture which the author is trying to give us of modern life as a state of hell."[22]

Howl appeared to have a knock-on effect, relaxing the application of obscenity law to representations of sexuality in the months following the October ruling. A November 1957 decision, reported in *Newsweek* in January 1958, found that materials ordered by researchers at the Kinsey Institute were not obscene, since they were not intended to appeal to the "prurient interest" of the "average person." Federal District Judge Edmund L. Palmieri of New York is quoted as saying that "the Kinsey researchers were not average people . . . and their interest in the material sent from Europe and the Orient was scientific, not sexual." "In effect," *Newsweek* goes on, "the government agreed that obscenity lies in the eyes of the beholder."[23] And in the same month as Johns's Castelli show opened to its public, the U.S. Supreme Court finally ruled in favor of *One* magazine, overturning a number of previous findings against it that its representations of homosexuality were "obscene, lewd, lascivious and filthy."[24]

So obscenity law, particularly as applied to vulgar language and representations of body parts and homosexual acts, appeared to be relaxing. But if *Howl* had been cleared of obscenity in October 1957, and other representations of homosexuality were also being cleared by the courts in the same month as Barr entered the Castelli show, then why did Barr still refuse the acquisition of *Target* "penis and all" for the Museum of Modern Art? Was it because plaster casts of human body parts, and particularly male genitalia, when displayed as part of a work of art had more erotic charge than words referring to the same within a poem? Barr appears unable to do for Johns's painting what Judge Horn does for *Howl* and take its more "vulgar" moments within the context of a nonobscene or "redeemable" whole. Perhaps Barr, in considering the work as a whole, in considering target and casts together, couldn't derive any convincing social or aesthetic framework of value which might displace the troublesome visibility of the penis cast. The lack of any apparent relation between target and casts may well have stymied any attempt at constructing a rational explanation for their juxtaposition, thereby remaindering them as strange and unyielding to exegetical discourse. This would have proved problematic for any would-be public defendant of Johns's art in establishing the nature of its so-to-speak redeemable enterprise, in the law courts or otherwise.

Further, without recourse to such a defensible framework of interpretation, Barr may have been left with no option but to suspect the leer of the lascivious in *Target*. Did he perhaps suspect Johns's pornographic intentionality in producing the painting, especially given the artist's insistence on the

visibility of the penis cast as an integral part of the work? Did he think the penis cast, and therefore the work as a whole, *obscene*?

Alfred entered the gallery expectantly. He was hoping to see something new and exciting.

The warmth of the gallery interior immediately enlivened his chilled body. There were many unusual works hanging on the walls, which certainly marked a departure from what he now found customary in the work of most abstract artists. The works showed bold iconic designs of flags, targets, and numbers. Alfred found himself curiously drawn to one particular, encrusted painting of a target with a row of plaster casts of human body parts arranged in a row at its uppermost edge. Alfred felt strangely uneasy, sensing he was being shown something that perhaps he shouldn't see.

His eye scanned the arrangement of body fragments, but one in particular seemed to unleash something in him. He looked away, at the other works in the show, but each time he returned his gaze, he found himself transported to the brink of ecstasy. He felt uneasy about his compulsion to look, but nevertheless found himself mesmerized by this part, unveiled before his eyes: a single, green painted cast of a penis. Though he felt drawn to it, he wasn't sure he could share the intensity of his feeling with Dorothy, his assistant.

She was at his side. Alfred wondered what she was thinking. He really wanted to tell her how he felt, but perhaps she just wouldn't understand. He knew there was something here pushing at the edge of respectability. What might she think of him?

He stumbled to try to find the words, but, in the end, he simply decided to keep it to himself.

Instead he decided to go ahead and buy the painting, there and then. It tickled him to think of the faces of the committee members back at the museum, imagining how shocked they would be. "How will they deal with this one?" he mused mischievously.

THE PROBLEMATIC PENIS

Rosenblum's reference to *Target* as a peep show is richly suggestive of the painting's erotic meaning and opens up a reading which anticipates, to some degree, the later, more art historical understanding of it as surrealist-

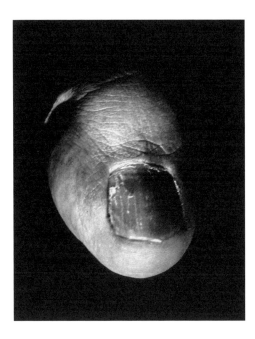

Figure 39. Jacques-André
Boiffard, *Le Gros Orteil*, 1929.
Centre Georges Pompidou–
MNAM–CCI, Paris. Photo ©
CNAC/MNAM/Dist RMN.

inspired *corps morcelés* (cut up bodies). Art historians have variously writ-
ten about *Target*'s surrealist determination by drawing attention to the
uncanny strangeness of its compartmentalized objects.[25] Thus, they have
suggested connections between Johns's work and surrealist photo-objects
such as Jacques-André Boiffard's *Le Gros Orteil*, 1929 (fig. 39), or the body
parts in René Magritte's *The One Night Museum*, 1927. Such a comparison
has the effect of foregrounding Johns's plaster casts as uncanny and fetishistic
dream objects — uncanny because familiar signifiers of the body are stripped
of their conventional signifieds through fragmentation and juxtaposition,
and fetishistic because they thereby become the objects of an obsessional
and desirous gaze.

Thus Rosenblum's "low" reading of *Target*'s eroticism is matched by art
history's "high" reading of it in the 1980s and 1990s. These related, though
different, readings of the painting's erotic meaning are underpinned by the
presence of the genital body part(s), without which the erotic charge might
have been somewhat lessened. Richard Francis refers to the genital body
parts as "'private' in the conventional definition" and all of the parts as "pri-
vate in this context."[26] Insofar as "private" glosses the sexual here, Francis
underscores *Target* as being evocative of erotic secrets of some sort. This is
significant, I think, and goes some way toward explaining the censorious at-
tention paid to the penis cast by Barr and MOMA. But the singular attention

paid to this cast over and above the other parts, in particular the "female" part, should lead us to think about its problematic status as residing in something more than its presumed vulgarity as eroticized genital display.

The fact that the penis cast, and not the "vaginal" bone, is singled out by Barr as the object of censorship leads me to suspect that what was problematic about the former in 1958 was the visibility accorded to a *male* body part and, furthermore, one positioned as the object of an eroticizing gaze. Its problematic affect, I want to suggest, was largely a consequence of its marking of male sex in the field of erotic vision rather than merely the possible offense it might have caused to *Target*'s more prudish viewers. The iconic marking of the vagina would likely have proved equally troublesome for such viewers, but it was, I contend, less problematic overall given that it was patriarchal convention for the female body to appear as object of the gaze. What interests me here, then, is the troublesome nature of the penis cast for masculine *heteroerotic* forms of spectatorship, such as those of Rosenblum and others, who sought to find, or indeed *found*, in *Target* a conventional erotic scene, whether as low peep show or high surrealist object.

This transgressive incursion of the male body into such conventional frames of masculine desire means Johns's painting has the troubling effect of instilling a potentially *homo*erotic gaze within the phantasmatic scene of heterosexual interpellation itself. This attempt at constructing a homoerotic representation through the architectures of straight interpellation might be taken as echoing the representations of male bodies elsewhere in 1950s culture, particularly those carried within the physique photography of, for example, Bob Mizer or Bruce of Los Angeles. This returns us to the low registers of *Target*'s meaning, though this time to the pocket-sized titles of 1950s muscle magazines such as *Physique Pictorial*, *Tomorrow's Man*, and *Vim*. Such publications were popular among gay men at this time, since they offered a homoerotic variation on the straight physique magazine. They developed the format of the "serious" muscle magazines of the 1940s, such as *Your Physique*, by gradually reducing the amount of textual advice on how to develop the male body through physical exercise. This was in favor of a photo-based magazine given over to a largely visual appreciation of the toned male torso.

The gaze of physique photography's male consumers on its near-naked images of men was legitimized in the only way possible in the 1950s, by an appeal to homosocial forms of attention.[27] As the fall 1957 issue of *Physique Pictorial* claimed, its readership was largely made up of artists, naturalists, bodybuilders, gym owners, and trainers.[28] Thus, the magazine suggested, its

male readership was largely interested in images of other men for distinctly "honorable" and expressly noneroric reasons. *Physique Pictorial*, though later to become more explicit and gay-affirmative, was at this time, along with its stablemates, concerned to construct its spectatorship along these lines in order to escape the legal force of the censor.[29] And it did so, at least avowedly, by both discursive and visual means—by directing the viewer's gaze by means of minimal "straight" biographies and comments about its models ("Notice the firm maturity in Lynn's face here compared to his earlier pictures") as well as by (barely) sublimating homoeroticism within the many classical and athletic poses and accoutrements which were a stock-in-trade of the physique genre (fig. 40).[30]

But even though *Target* might be seen to share a historical structure of homoerotic representation, articulated through the established icons of straight male identification, there was one way in which Johns's work departed from such imagery: by visibly *showing* the penis. Physique representations worked on the basis of suggesting or inferring the male member, usually by lighting and pose, but always stopped short of *revealing* it (fig. 41). The penis was always hidden behind a posing pouch or some other accoutrements of the photographic mise-en-scène. It was not until 1965 that the drapes came off in short-lived titles, such as *Butch*, *Tiger*, and *Rugged*. Readers of *Physique Pictorial* had to wait four more years still for the posing pouch to finally disappear from its pages. Interestingly, in this context, *Target* appears as a fairly groundbreaking work, "unveiling" the penis well before it became a common and acceptable feature of homoerotic representation in the mid-to-late 1960s.

This meant that, though it shared with the muscle magazines a closeted solicitation of the homoerotic gaze, the work also went one step further, anticipating the explicit representations of gay pornography in the late 1960s and early 1970s. Such "explicitness" (the word already ushers us into the realm of the pornographic) would undoubtedly have made the visible display of Johns's penis cast as exciting and attractive to some consumers in 1958 as it appeared offensive and troublesome to others.

> Andy loved the idea of a cock in a work of art. After all, it was his favorite subject. He really loved the thrill he got when looking at the men in the physique magazines. Imagining what was underneath those posing pouches just turned him wild with desire. It was one of his favorite pastimes. Of course, they might have looked straight to some, but Andy just loved how all those butch guys came on so suggestively and knowingly to camera.

Figure 40. *Physique Pictorial*, 1957. Reproduced by permission of the Athletic Model Guild.

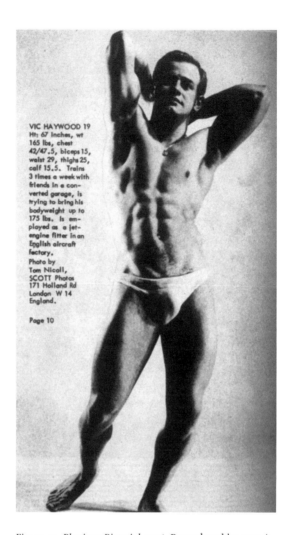

VIC HAYWOOD 19
Ht: 67 inches, wt
165 lbs, chest
42/47.5, biceps 15,
waist 29, thighs 25,
calf 15.5. Trains
3 times a week with
friends in a con-
verted garage, is
trying to bring his
bodyweight up to
175 lbs. Is em-
ployed as a jet-
engine fitter in an
English aircraft
factory.
Photo by
Tom Nicoll,
SCOTT Photos
171 Holland Rd
London W 14
England.

Page 10

Figure 41. *Physique Pictorial*, 1956. Reproduced by permission of the Athletic Model Guild.

But Jasper had gone further even than these magazines. He'd done exactly what Andy dreamed of. Not only had he made it as an artist, and made it big, he had also managed to make a stir with a work including a life size, 3-D cock in it! Not only was Jasper stunningly handsome, but there was his cock, completely unveiled for all to see! Andy just knew it was his. How about that for daring self-exposure! He couldn't believe that the best Jasper's critics could come up with was to call him unpatriotic because of his painting of the American flag.

"Gee," he thought, "Why was nobody saying anything about the cock in his work?"

A SUBJECT OUT OF CONTROL

So far in this chapter, I have reflected on the meanings and affects that might have accrued to one particular "part" of Johns's painting. But what about the meanings of the "whole," either as suggested by the juxtaposition of target with casts, or by the body fragments taken as some kind of totality?

In the first extended piece of critical writing on the artist's work, Leo Steinberg writes in 1962 that Johns's art often frustrated critical attempts to fix its meaning, particularly when approached as an expression of the artist's feeling or emotions.[31] The elements in a typical Johns work, he writes, "lie side by side like flint pebbles. Rubbed together they would spark a flame, and that is their meaning perhaps. But Johns does not claim to have ever heard of the invention of fire. He just finds and places the pebbles" (19). In this way, Steinberg foregrounds Johns's broadly nonexpressive strategy to enable the chance production of meaning, working against conventional models of intentional and authorial "message." This strategy is in sympathy with the work of composer John Cage and is borne out by *Target with Plaster Casts*, Steinberg argues, insofar as there is a play between the "wholeness" of the target and the "parts" of the body casts — "the subject remains the bull's eye in its wholeness for which the anatomical fragments provide the emphatic contrast" (37).

However, this play of meaning is taken to be overshadowed by what Steinberg calls Johns's "miscalculation" with the casts:

> Apparently the artist wanted to know whether he could use life casts of the body and no more read them for meaning than he read the linage in the pasted newspaper fragments below. He was exploring a possibility

to its limits; and I think he miscalculated. Not in that he failed to make a picture that works, but in that the attitude of detachment required to make it work on his terms is too specialized, too rare, too pitilessly unsentimental, to acquit the work of morbidity. When affective human elements are conspicuously used, and yet not as subjects, their derogation becomes a subject that's got out of control. (37)

Johns's artistic gambit, his attempt to present the affective bodily parts in a way that would relieve them of their usual and obvious affect, fails since their power is just too strong. Even though the body parts are not used "as subjects," Steinberg argues, even though they are not intentionally imbued with any "human" meaning, they still have a significant affect *as* a subject. That is, *Target*'s spectacle of a "body in bits" is just too productive of morbid affect—it is too suggestive of a scene of corporeal mutilation to allow for any distancing or detachment to take place. In this way, the body parts comprise a "subject out of control," failing to remain within the terms of his Cagean (non)intention.

This interesting notion of a "subject out of control" goes to the heart of my writerly address to *Target* and its prospective meanings and affects in these pages. I am keen to put into play those figments which exceed interpretative frames, as well as those affects which fall outside, and trouble, the artistic intentionality informing the work's production. Such unruly phantasms, as they animate the painting's rude visibility, are precisely what would have made it troublesome in 1958, and are the very medium through which the painting's queerness can be appreciated.

One such phantasm can be approached if we consider for a moment the body that is conjured up by the totality of *Target*'s plaster fragments. Even if the work as a whole—target with casts—fails to add up to a typically Johnsian whole, then what of the individual body parts when taken together? Fred Orton suggests that they cannot be made to easily coalesce into a representation of a single gendered body, given the uncertain or neutral gendering of most (if not all) of the pieces on view. Perhaps then, Orton goes on, we might approach the wholeness that they evoke as *imaginary*. "Taken together," Orton writes, "the casts cannot be understood synecdochically. Together they cannot represent a whole—unless the whole they turn us towards is an imagined one that is neither male nor female but both male and female. There is really no body represented by the sum of these parts" (*F* 48).

But if this reference to the painting as a kind of dream object returns us to the surrealist inflection of *Target* explored earlier in this chapter, it does

so while also marking it with a difference. For *Target*'s imaginary body or nonbody is unlike that, for example, of Magritte's *The Eternally Obvious* (1930), where—even despite the fragmentation of bodily figure—the object of desire remains wholly "woman" (fig. 42). Each fragment of representational surface adds up to a normative anatomical and semiotic whole. *Target*, on the other hand, evokes a figure frozen out of cultural inscription by the heterosexist gender binaries of 1950s culture—one which, in being neither male nor female, and yet both, is hardly recognizable as a "body" at all. It is indistinct, its contours impossible to delineate, its materiality impossible to visualize. It does not have any readily discernible features by which we might know it, by which we might mark it and make it legible within visual representation. And yet, for all this, it is a body that is powerfully affecting as an *imaginary* construct within 1950s culture. Orton's words, again, are highly illuminating in this regard. Given that there is no "satisfactory whole that can be seen as represented in and by the sum of the body parts," he argues, *Target* is both "unwholesome" and "unhealthy."[32] Here art historical discourse, in acknowledging *Target*'s refusal of a satisfactory, as it were, interpretative closure, provokes a metaphorical invocation of the painting's body as *abject*; as both "unwholesome" and "unhealthy." Drawing here on the languages of morality and medicine, Orton styles this body as corrupting, harmful, and sickly—a set of connotations which immediately return us to the abject definitions of homosexuality characteristic of homophobic discourse in the 1950s. Thus, as *Target*'s body parts fail to be interpretatively resolved into a whole, it can be seen to evoke a chimerical construction of a queer body—*queer* precisely because it haunts and contests the "one-ness" of normative gendered embodiment.[33]

Indeed, we might surmise that it was precisely the readiness of *Target* to suggest unruly queer connotations which led Johns to defer from making the same "miscalculation" again with body casts, at least until the early 1960s.[34] Art historians have variously written about *Target* as being unusual among Johns's early oeuvre in operating in a quasi-confessional manner, "almost inescapably evok[ing] the artist himself" (*F* 50). This might be taken in almost literal terms as Johns's "exposing himself" by dint of an indexical sign of his genitalia. But it might also be understood as a form of self-disclosure brought about by attending to the body parts *as sexual subject*. For even if Johns "didn't want [his] work to be an exposure of [his] feelings," even if he wanted to work "in such a way that . . . [he] could say that it's not . . . [him]," the danger presented by *Target* was that it could be taken as a work too readily offering up clues about his gay identity.[35]

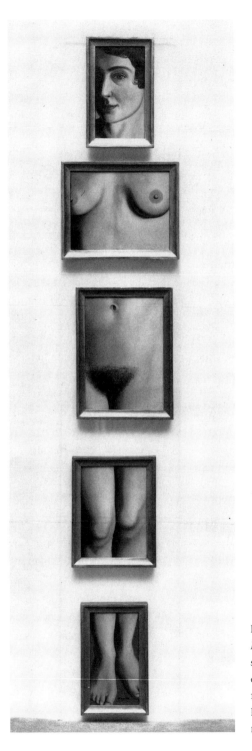

Figure 42. René Magritte, *The Eternally Obvious*, oil on five separately stretched and framed canvases mounted on Plexiglas, 1930. The Menil Collection, Houston. © ADAGP, Paris, and DACS, London 2001.

Reading the limited amount of literature on Johns's own views on the painting, it seems he was both aware of, and annoyed by, the censorious attitudes visited upon it. We have already considered Johns's negative response to Barr's request to effectively "closet" the painting's sexual meanings by keeping the body parts, and particularly the penis cast, shut away from view. In an earlier incident at the Jewish Museum, Johns appears similarly perturbed, if not downright angry, in discovering that his painting has been literally shut away within a cupboard. In an interview from 1991, Johns recalls one of the organizers of the exhibition alerting both the artist and the art historian Meyer Schapiro — who was advising on the selection of artwork for the show — to the whereabouts of *Target*: "Oh Dr Schapiro," an unidentified man is reported to have said, "there is another painting of Jasper Johns and there just wasn't enough room for it in here, so we have it in another space." Johns recalls that both he and Schapiro were then ushered through into

a huge space with thousands of paintings! We walked through a hall or something, and opened a broom closet, and it was my *Target with Plaster Casts*.

I was livid; I didn't know what to do, and I was also very polite . . . I went back in and said something to Bob (Rauschenberg): "I'm getting out of here . . . I'm furious!" Then this man came in and said, "Jasper, Meyer Schapiro likes that painting of yours very much, and thinks it ought to be in the exhibition. But my colleagues tell me that if it's in the show, I will lose my job. Now would it be all right with you if we close some of the compartments?" There were plaster casts, and one of them was a penis. "And wouldn't that add to the mystery of the piece?" I said, "Perhaps it would, but mystery is not something of any particular interest to me. If I had wanted to add mystery to the piece, perhaps I would have already done it . . . I think you should send my work back to the studio." I left, went home, and started writing a letter [of complaint].[36]

This rare insight into Johns's fiery temperament is at odds with the artist's generally cool and cerebral public image, and it perhaps suggests that Johns was highly sensitive to the public reaction to this particular painting. But even if Johns appears to have been adamant that the painting be viewed as he had originally intended, and not shut away or closeted, it appears that this insistence might have been compromised by a more sober assessment of the dangers of self-revelation presented by it.

In turning away from making the kind of bodily arrangement which char-

acterizes *Target* well into the 1960s, we might also surmise that Johns had come to the same conclusions as Leo Steinberg about it being a "miscalculation" — but on slightly different terms. Perhaps, yes, he thought it comprised "a subject out of control," but one that was not simply too affective, but too *queerly* affective for the homophobic climate of the fifties art world. Perhaps it was too risky in giving too much credence to the gossips who had already begun circulating stories about Johns's homosexuality in the wake of his success. As Rauschenberg has subsequently recalled, his sexual relationship with Johns soon became the subject of art-world gossip: "What had been tender and sensitive became gossip. It was sort of new to the art world that the two most well-known, up and coming studs were affectionately involved."[37] Perhaps, then, given the amount of barely concealed hostility toward this particular painting, and toward homosexuality more generally, Johns came to be quickly aware of the ways in which it would have perpetuated talk about him and his close companion, which could only have threatened his public image, and tainted the meaning and value of his art. Such talk, by dint of its informality and relative privacy, he could not hope to have any command over: it would truly be *out of his control.*

> Jasper was slightly worried. When Leo came around the corner he looked excited, but there was also a slight furrowing of his brow which suggested something wasn't quite right. "The museum wants to buy your painting but wants to shut away the genitals." Jasper was slightly perturbed by the request. He had wondered himself if he'd gone too far with the penis, if the wellspring of his desire had betrayed him a little more than he would have preferred. What was he to do? He certainly wanted the boost to his standing that a museum acquisition would bring, but could he compromise his integrity in order to get it? And could he risk the self-exposure that his painting might bring about if it became the subject of controversy? Did he really want his secrets to become known? Too many people already were whispering about him and Bob.
>
> Perhaps it was best to just play it cool and hold out for the best. "Tell him that they can cover them some of the time, but not all of the time."
>
> Jasper hadn't suspected anything like this happening. "That's probably just as much as I can get away with right now," he thought. He wiped his brow nervously and tried hard to concentrate on other matters, but the thought of being found out still lingered with him, registering as a twist or two in his gut.

This presumptively wary approach to the gossipy meanings of his art is evidenced by the mature artist's attempts to curtail the interpretative efforts of present-day queer scholarship. In making the decision to withhold permission to reproduce his work in Jill Johnston's 1996 book *Privileged Information*, we might see Johns again, in his later years, demonstrating his disapproval of interpretative approaches to his work which purport to uncover its sexual secrets, which might make public its private meanings and references.[38] Johnston's book typifies the work of a generation of post-Stonewall art historians who have worked hard at cracking the codes of Johns's obliquely autobiographical art in order to access its gay meanings.[39] In characterizing his coded representations as evidence of a "closeted" aesthetic, Johnston engages in a kind of history writing which "outs" its biographical gay subject as the significant referent lurking behind Johns's mysterious and often abstruse iconography. In doing so, Johnston and other gay scholars have been seen by some and, particularly one imagines, by Johns himself, as engaging in a prying mode of investigative activity. Indeed, as I have already noted in the introduction to this book, such approaches have often been seen as an invasion of the artist's privacy, even though the artworks in question belong very much to public-sphere culture.

As I approach *Target* here in these pages, I find myself drawn along by a similar curiosity about the queer meanings of Johns's oeuvre. But even so, I am at the same time brought sharply against the limitations of such established forms of gay reading. Johnston avails herself of "privileged," insider information provided by members of Johns's intimate circle — of friends, artist-colleagues, and lovers — which she then puts to use in elaborating the queer significance of his art. In approaching *Target* here, I find such avenues of information relatively closed. Many of the people who might cast light on the painting's problematic allure are now dead (including Alfred Barr, Dorothy Miller, Leo Castelli). Others who are alive — such as Rauschenberg and Johns himself — are unavailable for comment, while others still, who frequently speak to scholars about the queerness of Johns's oeuvre, were simply not around at the time of the Castelli show, and therefore have little or no insights to offer on the matter at hand.[40]

Neither can I simply appeal to the "fact" of Johns's gay identity as key to unlocking his painting's queer meaning. This is because the meanings that I trace here are not, or not solely, the artist's intended ones and cannot—

by dint of some investigative footwork—be latterly "disclosed" within interpretative discourse. I am interested, more broadly, in what *Target* might have meant to *others* as much as to Johns himself and am thus not interested in a purely biographical reading. What I have attempted to do here, then, working toward the limitations of such established (gay) art historical procedures, is to put into play some possible meanings which might animate the painting's import while keeping the precise determination of its troublesome affect open to question. Moreover, I have played out *Target*'s meanings in this manner in order to *allegorize* a queer interpretative perspective which proceeds by the production of readings which must, of necessity, remain susceptible to what D. A. Miller has called an "abiding deniability." This is a reading practice which has been the subject of this chapter, and indeed this book: a form of queer comprehension/incomprehension which trades less upon so-called facts, and more upon the nonnormative forms of an explicitly phantasmatic "evidence." Thus as I approach the close of this chapter, I find that I have come around to queering the very idea, as well as the practice, of sexual disclosure. As I have attempted to "unveil" *Target*'s queer meanings within hermeneutic discourse, I have—by dint of the relative lack of "hard" evidence—been thrown back on the phantasmatic dimensions of disclosure itself—of disclosing as interpretative *performance*.

As such, it should be clear that the promise of disclosure—and of the sexual truths it supposedly communicates—is being taken here as a particular *styling* of information transmission, one couched in terms of transmission *as revelation*. This "revelation," however, is never absolute, even when it appears to be so. This much becomes clear as we return to *Target*'s lidded body parts once more. In considering them as peep show, I have already reflected on how they might be taken as soliciting a pleasurable form of spectatorship which resides in maintaining the *play*, rather than the satisfaction, of the desire to see hidden body parts. My point is simply that—as I approach it here—the painting is solicitous of the play of *hermeneutic*, as well as erotic desire. For even with all its lids open—with everything shown, with all its body parts seemingly exposed to vision—one of the painting's wooden compartments remains mysterious to me.

This is because the contents of the blue box, to the right of the foot and to the left of the face, appear to be missing. And I say "missing" here rather than "empty" because there is a rough and uneven substance (glue?) which lines the edges of the compartment, perhaps indicating a plaster cast ripped from its position. That this edging is itself painted blue suggests that the artist intended it to appear this way, and that the piece hasn't been subse-

quently ripped out or fallen from its position accidentally. This makes the compartment all the more intriguing, making it a deliberate marking of an "absence" in the painting's visual field. But what might this missing signifier be? What, if anything, might Johns have wanted to signal by this marking of a significant absence? And how might we read it now? Unlike the casts in the other compartments, this absence has not, to my knowledge, been analyzed within discourses of art criticism or art history.[41]

Simply put, I fancy that *Target*'s significant bodily absence might be understood in the context a veiled evocation of the *anus*. This is a fanciful identification on my part which echoes other similar anal projections in late-fifties U.S. culture. The readers of Allen Ginsberg's *Howl*, for instance, were similarly encouraged to read into the gaps left by the explicit omissions in the initial published version of the poem. Certain references to anatomical body parts and other "obscene" words were excised from the text, and represented only by dots signaling their absence. This was a strategy adopted by Ginsberg and his publishers to avoid censorship, and, belatedly, it worked when, during the *Howl* trial, Judge Clayton Horn ruled that any interpretation of the missing words by the prosecution was ruled as inadmissible. The line "Who let themselves be [six dots] in the . . . [three dots] by saintly motorcyclists and screamed with joy" was allowed to live within the law even though quite obviously a reference to anal sex.[42] Thus the reach of the law only extended to that which was denoted within the text. Any construction that might have been put upon it, any attempt to "fill in" the vacant spaces, was dismissed by the court as mere speculation. The law, at least in respect of the homoeroticism of *Howl*, was therefore only interested in that which was legible as cultural *text*. The realm of the interpretative imaginary, and its plural and oscillating field of identifications, was consigned to the realm of the culturally unreal, to that which was not "really there" and therefore unavailable to be legislated against.

This meant that anal erotic and other perverse identifications could be interpellated within culture, with a relative degree of immunity from censorship, by representations which refused to *mark* such meanings within a representational "real" but nevertheless solicited them at the level of interpretative possibility. This was true of many of the covers, for example, of *One* magazine, which, by the late 1950s, began to deploy a particular representation of the male body which could be read as anally eroticized and, therefore, queer by its homosexual readership, while appearing relatively free of "obscene" meanings to the censorious authorities. For instance, the cover image of the October 1959 issue positions the viewer as an unobserved voyeur of

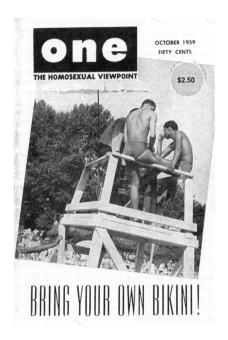

Figure 43. "Bring Your Own Bikini!" Front cover of *One* magazine, October 1959. Courtesy of ONE Institute and Archives, Los Angeles.

the male body, unobserved because the bodies are turned away from us, viewed *from behind* (fig. 43). In this way, the spectator is interpellated into "The Homosexual Viewpoint" (the subtitle of the magazine) in terms of a scopic position which adopts the male buttocks as the site of a homoerotic investment. That the cleft of the buttocks on the central male figure is made particularly visible by the crease of his swimwear — his right buttock hanging over the edge of his wooden perch — serves to signal the anatomical and psychic proximity of the (visible) buttocks to that phantasmatically privileged site of gay male pleasure and identity — the anus. Thus, even though not represented within the field of vision, it is the anus, connoted through metonymic association, which forms the locus of an imaginary homoerotics of the male body.

If this makes me less "cockeyed," and rather more anally oriented, in my reading of Johns's *Target*, it nevertheless keeps it within the realm of an explicitly phantasmatic animation of the painting's "body." I could, like some other commentators, have discussed the anal character of *Target* by focusing my attention instead on reading the painting's target as anal *figure*.[43] Such a reading tends to suggest that what is "really" represented by the target is an anus, and that once disclosed within the context of a gay reading practice, Johns's *Target* will *look* "gay," its anal erotic sexuality made manifest as

Figure 44. Robert Mapplethorpe, *Marty Gibson*, photograph, 1982. © The Robert Mapplethorpe Foundation. Courtesy Art + Commerce Anthology.

visual truth.[44] Nowhere more so can we see this at work than in a previously unpublished photograph of Marty Gibson taken by Robert Mapplethorpe in 1982 (fig. 44). This we might take as a denotative, pornographic unveiling of Johns's closeted representational schema. Here Johns's encaustic target is replaced by an explicit photographic representation of a man's anus, framed by the buttocks and made perfectly visible by the play of light over the radial puckering of skin around the sphincter. Compositionally, the image recalls Johns's *Target*, with its division into a smaller wooden upper section, subdivided by the gaps between the struts of the fence, and the lower, larger section dominated by the representation of the model's backside.

However, I am claiming no such "revelatory" meanings here. In fact, I am deliberately staging my anal identifications, as well as the multifarious other readings and identifications which I have set out here, as figments of (my) queer projection which don't necessarily uncover or finally unveil any "hidden" thing. What I have achieved by all this is nothing more, which is also to say nothing *less*, than an explicitly performative analogue in my critical

writing of, for example, what *Target* might have meant, at both a conscious and unconscious level, to Alfred Barr, to Johns, and to others in 1958. Although such meanings are in no way "recovered" within my writing (I have not psychoanalyzed Barr, Johns, or anyone else for that matter), I intend what I have written to nevertheless bear witness to the "resistant beckoning" of *Target* which provided the "lure" for this writing in the first place.[45] Certain forms of evidence have been mobilized in my reading—debates about obscenity, art critical perceptions, contemporaneous forms of homoerotic imagery—all of which might have been mobilized, in a more habitual manner, within a constative discourse of the art historically "true." But what I have hopefully achieved here, in supplementing such forms of evidence with more overt speculation, is to have dragged art-history's interpretative protocol into the realms of *explicitly* phantasmatic projection. Although not exactly baseless, I hope that such a self-conscious staging of interpretative projection for you, dear reader, has helped to foreground the processes of phantasmatic identification as important to a queer epistemological project: one which finds value in the perversion of authorized protocols of truthful disclosure.

FLIRTING WITH AN ENDING

"Every conclusive decision brings flirtation to an end." — Georg Simmel[1]

In opening this book I wrote about flirting with the dangers of not being taken seriously in adopting gossip as my subject. These dangers, of course, are those of not being listened to, of being belittled for speaking without authority, and — reminding us of the differing communities and orders of discourse which are taken to be appropriate therein — of appearing to speak in the wrong manner to the wrong people. As I now come to write a few "afterwords," I hope that this book will serve at least as example of how such a flirtation, rather than being a marginal concern for the queer historian's professional vanity, might instead be embraced as a significant aspect in itself of doing queer work. Flirting with historical protocol, rather than courting the respect of the academic establishment by doing history "properly," might usefully delineate how queer work can *of necessity* disengage us, or realign us in an odd relation to, the communities of "serious" academic discussion. What *Between You and Me* hopefully illustrates is that in betraying history, so to speak, in not being "true" to it — by speaking and writing improperly in its name — one might come to glimpse the possibilities of thinking history otherwise, of thinking it *queerly*.

Indeed it may be that flirting could be considered as a kind of queer methodology in its own right.[2] Adam Phillips in his book *On Flirtation* has suggested that even though flirtation is often taken as the "maligned double of things done properly" — as the unserious and inappropriate act of desire which eschews lasting commitment and love — it might, when viewed from

an alternative vantage point, be taken simply as "a *different* kind of relation, another way of going about things" (my italics). Phillips goes on: "Flirting may not be a poor way of doing something better (of being faithful, of being committed, etc.) but a different way of doing something else."[3] In this book I have been interested in this "different way of doing something else." I have not been overly invested in the so-called proper ways of doing things — whether in adopting only proper sexuality as the subject of my inquiry, or in abiding by established rules for the production of historical knowledge per se. This is because what I have been writing about — gossip — bears a definitional relationship to *im*propriety, comprised as it is of communicative acts and forms of information that are anything but committed to bourgeois discursive codes and academic standards of verification. If what I have written here plays fast and loose with the writing of history "proper," then so much the better to address my queer subject *as such.*

Flirtation may be taken as offering a specifically queer methodology because of its particular relationship to "the serious." Phillips writes again: "The fact that people tend to flirt only with serious things — madness, disaster, other people — and the fact that flirting is a pleasure, makes it a relationship, a way of doing things, worth considering" (xvii). Just as queer sexuality is routinely derided as nonserious in its brush with a valorized heterosexuality (whether in being viewed as a phase or as false or unreal copy of proper sexuality), so too flirtation is all too often represented as failing to measure up to that with which it playfully toys (fidelity, dedication, etc.). And yet, viewed more positively, both queerness and flirtation might be deemed to offer up an eroticized, pleasurable "way of doing things" that, at the least, is "worth considering" — even if it amounts to nothing more than aberrant trivial behavior to the sober and seriously committed. *Between You and Me* revels in this flirtatious queerness — both in terms of subject and method. From the trivialities of the work of Rivers, O'Hara, and Warhol, to my embrace of the pleasures of sensationalized narrative within archival discourse, the book willfully attends to and embodies camp's playful address to "the serious" as queer critical method.

But this is already to make it too high-minded. In tying up this book with these last few words, I don't want to latterly betray my subject by making it the matter of a "serious," theoretical conclusion.[4] My point has been to largely avoid theorizing and pinning down gossip, and to defer from making it a respectable subject or new methodology of academic inquiry (though I may have flirted with the dangers of all these things). It would be so easy to betray gossip in this manner. Instead, my desire is to remain true to it by

ending the book without too much closure, perhaps even without too much of an ending (my turn to the language of fidelity here paradoxically suggesting my desire to be "faithful" to gossip at the very least). Flirtation, above all, Phillips writes, allows us to "sustain the life of desire" and, insofar as it does, to "put in disarray our sense of an ending" (xvii, xviii–xix). To try to wrap things up in some formal conclusion would therefore fly in the face of gossip's flirtatious informational economy, which resides precisely in its lack of definitiveness. So I'll content myself for now by signaling the existence of many other stories about the art and artists considered in this book which fall well beyond this book's "ken" — some juicy and scurrilous, some less so; some undiscovered or still yet to be told. And the queer methodology that I have only briefly alighted upon in these closing words may, or may not, be the beginning of something — some new practice of queer (art) history, of queer studies. But that's flirtation for you: one never knows for sure whether it's the beginning of something or not, or where — if indeed anywhere — it's going to go.

{ NOTES }

INTRODUCTION

1 "Winston Leyland interviews John Giorno," in Leyland, *Gay Sunshine Interviews*, 1:131–162. All the following citations from this source will be abbreviated as *G* and appear in the text.

2 John Giorno, "Vitamin G."

3 Perhaps foremost among those studies which have attempted to reclaim gossip as socially productive is Goodman and Ben-Ze'ev, *Good Gossip*. See also Salamensky, *Talk, Talk, Talk*, and Spacks, *Gossip*, for related perspectives from the fields of cultural studies and literary studies respectively. Additional studies from the social sciences and social history include Bergmann, *Discreet Indiscretions: The Social Organisation of Gossip*; Dunbar, *Grooming, Gossip and the Evolution of Language*; Rosnow and Fine, *Rumor and Gossip*; and Tebbutt, *Women's Talk?*

4 This does not mean, however, that my book will be free from its own campiness. Indeed, as we shall see, parts of the book deliberately set out to address the question of what it might mean to let loose the spirit of camp in the art historical archive.

5 Even though in May 2004 a Boston-based district judge threw out a case claiming defamation for being wrongly identified as gay, it is still unclear whether other judges in other states—particularly those with anti–same-sex sodomy laws—would conclude in such a liberal fashion with similar cases. For more on this see Jay Blotcher, "*Gay* Libelous no more?" on the *Advocate*'s Web site, visited on November 5, 2004, printout on file with author. For a summary of the issues facing art historians wishing to write about homosexuality in art history, see Martin Duberman, "Is There Room for Privacy on the Canvas?"

6 This is perhaps most evident in gay scholars' *own* worries about how others

perceive them. Richard Meyer writes about the concerns which have haunted his work as a historian of homosexuality and American art: "I have wondered —and sometimes worried—about the discomfort my work might arouse in various audiences. I have worried that teachers, colleagues, students, readers, even family members would not consider my work fully professional, that, on some level, all it would signify to them would be sex, and, more especially, gay male sex . . . In this sense, the respectability of my own practice as an art historian has been an ongoing—if, until now, unspoken—concern." *Outlaw Representation*, 277.

7 See Katz, "The Art of Code," 189-206; Meyer, "Warhol's Clones," 93-122; Silver, "Modes of Disclosure," 179-203; and Weinberg, "It's in the Can," 40-56.

8 "The fact that something has been said groundlessly, and then gets passed along in further retelling, amounts to perverting the act of disclosing." Cited in Salamensky, "Dangerous Talk: Phenomenology, Performativity, Cultural Crisis," in *Talk, Talk, Talk*, 26. Heidegger's disdain for gossip, or *Gerede*, is analyzed extensively by Salamensky and, more briefly, by Spacks, *Gossip*, 16-20.

9 Rosnow and Fine, *Rumor and Gossip*, 11.

10 Ehrenstein, *Open Secret*, 11.

11 Salamensky, "Dangerous Talk," 26-28.

12 Rogoff, "Gossip as Testimony," 58-65.

13 I follow Rogoff in her broadly psychoanalytic and deconstructive understanding of the phantasmatic meanings of sexuality. My preference for spelling *phantasy* with a "ph" throughout this book is a deliberate attempt to signal gossip's narratives as figments of interpretive and sexual *desire*. In refusing to see gossip as mere *fantasy*—opposed to true reality as simple illusion—I instead want to tease out what Rogoff calls gossip's "unruly contamination" of evidential discourse (Rogoff, "Gossip as Testimony," 58). Here Rogoff draws on the writings of Jacques Derrida in adopting a deconstructive approach to epistemology—which I also develop here—indicating how gossip might help unveil positivistic "truth" itself as phantasmatic construct.

14 I am, of course, drawing upon Jacques Derrida's work on supplementary logic here. See ". . . That Dangerous Supplement . . . ," in *Of Grammatology*, 141-164.

15 Rosnow and Fine, *Rumor and Gossip*, 83.

16 The phrase "hermeneutics of suspicion" I have borrowed from Edelman, *Homographesis*, 7, who, in turn, takes it from Paul Ricoeur. For a discussion of suspicion and paranoia in contemporary critical work. See Eve Kosofsky Sedgwick, *Touching Feeling: Affect, Pedagogy, Performativity* (Durham: Duke University Press), 123-151.

17 David Ehrenstein writes that the era of the scandal magazines ran from the early 1950s to roughly 1964, which also happily coincides with the period of my present study. *Confidential*, perhaps the most famous of these journals, ran briefly from 1952 to 1957, while others such as *Whisper* continued publication until the early 1960s. For more on these titles and specific details about their treatment of homosexuality, see Ehrenstein, *Open Secret*, 89-105.

18 In June 2001 the London *Guardian* reported on an American study which claimed that, on average, men gossiped more than women. The *Guardian*'s report does not give us any indication of the sexual orientation of the men and women surveyed, but it is presumptively heterosexist in its references to "self-promoting" and "chest-beating" males. Given the report's findings, however, there is a delicious irony in the *Guardian*'s decision to carry its story on the paper's "Women's" page. So maybe women are more interested in gossip after all! Tim Dowling, "Pssssssst . . . ," *Guardian*, 18 June 2001, G2 tabloid section, 9.

19 I often use the term *abject* and its derivatives in this book. At times I use it in the simple everyday sense to mean dejected or contemptible, though I also — particularly in chapters 1 and 4 — use it as a theoretical concept to signal the processes of social and psychic violence operative in the maintenance of sexual and gender identity. See Julia Kristeva, *Powers of Horror: An Essay on Abjection* (New York: Columbia University Press, 1982).

20 Both Joe Brainard and Ray Johnson deployed, albeit in very different ways, interpersonal modes of address in their art practices of the 1960s. Of the two, Brainard was the one most closely associated with Frank O'Hara's circle, producing a number of campy and humorous collages in collaboration with him in the early sixties. Ray Johnson, on the other hand, developed intimate correspondence with other artists into an art form, and he founded the New York Correspondance [*sic*] School around 1963. Although neither, strictly speaking, peddled gossip as art, it is fair to say that along with Rivers and New York school poets such as O'Hara, John Ashbery, and Jimmie Schuyler, they effected a radical and sustained turn to the intimate exchanges of (queer) New York as the basis of their practice as artists and poets. For more on these artists, see Constance M. Lewallen, *Joe Brainard: A Retrospective* (New York: Granary Books, 2001); José Esteban Muñoz, "Utopia's Seating Chart: Ray Johnson, Jill Johnston, and Queer Intermedia as System," in Butt, *After Criticism*, 101–116; and Donna De Salvo and Catherine Gudis (eds.), *Ray Johnson: Correspondences* (New York: Flammarion, 1999).

21 "A" and "B" refer to the two conversationalists upon which the *Philosophy* is based: Andy Warhol and Brigid Polk, a member of Warhol's entourage in the 1960s and early 1970s. Equally, however, Warhol sees "A" and "B" in a typically identity-effacing manner as structural positions in a communicative exchange: "B is anybody who helps me kill time. B is anybody and I'm nobody. B and I." Warhol, *Philosophy*, 5.

22 In a fascinating essay, Ann Gibson argues that gay men could often pass as straight in the patriarchal contexts of the 1950s art world — and therefore enjoy the privileges of being male — while women *as women* were often socially and critically marginalized. By the same token, however, she argues that for some lesbian artists, who were often seen stereotypically as being "more like men," this world provided a space in which it was possible to be accepted as a lesbian and be taken seriously as an artist — much more so than other heterosexual women and effete gay men. "Men in dresses were funny," Gibson writes.

"Women in pants were real artists." "Lesbian Identity and the Politics of Representation in Betty Parson's Gallery," in Davis, *Gay and Lesbian Studies in Art History*, 252.

23 As James H. Jones writes, even though Kinsey's report on female sexual behavior was greeted by a large degree of press coverage, "the response to this volume was milder than the reaction that had greeted the male volume. As one reviewer noted, the female volume 'caused fewer violent convulsions among the defenders of our morals than his earlier book about the male.'" *Alfred C. Kinsey*, 707.

24 This move was also responsible for galvanizing certain New York artists and poets into being more political about the homophobic operations of city and state authorities. For Frank O'Hara's outraged response and subsequent actions, see Gooch, *City Poet*, 423–425.

25 Doty, "Growth of Overt Homosexuality in City Provokes Wide Concern," 1, 32.

26 Helmer, "New York's 'Middle-class' Homosexuals," 85–92; "Homosexuality in America," 66–80; and "The Homosexual in America," 40–41.

27 For a discussion of the explicitness of Warhol's filmic representations of homosexuality, see Thomas Waugh, "Cockteaser," in Doyle, Flatley, and Muñoz, *Pop Out*, 51–77.

28 Indeed, as Edelman demonstrates in his subtle reading of *Life*'s 1964 article "Homosexuality in America," even as the popular press was concerned to present the "obvious" visible codings of homosexuality in the format of a photo article, it also recognized the degree to which homosexuals had the capacity to pass unremarked in the "straight" world. See his "Tearooms and Sympathy, or, The Epistemology of the Water Closet," in *Homographesis*, 148–170.

29 Both George Chauncey and Henry Urbach also date the emergence of the closet as a figure of homosexuality in the early to mid-1960s. See Chauncey, *Gay New York*, 6; and Urbach, "Closets, Clothes, disClosure," 254.

30 The main exception is chapter 4, in which I use the idea of the closet, and its narrative structures, to explore the shifts in the meanings attributable to Andy Warhol's persona in the early 1960s.

31 The titles of studies such as Andrea Weiss and Greta Schiller, *Before Stonewall*, and Peter M. Nardi, David Saunders, and Judd Marmor, *Growing up before Stonewall*, readily demonstrate the determining position of Stonewall in narrating postwar gay and lesbian history in America. I am indebted to Chauncey's comments in formulating the interpretative and historical framing of this book otherwise; see his *Gay New York*, 1–8.

32 Indeed, as Patricia Meyer Spacks has argued, biographies can be seen to engage their readers in a similar intimate manner to the way that one is addressed in a conversational exchange. See Spacks, *Gossip*, 92–120.

33 Diana Fuss provides a useful gloss on the distinction between public identity

and private identification by arguing that every identity is, in fact, simply "an identification come to light." *Identification Papers*, 2.

34 Derrida, *Archive Fever*.

35 Salamensky, "Dangerous Talk," 25.

36 This phrase is Mary Edsall's and Catherine Johnson's. Cited in Rebecca Schneider, "Performance Remains," *Performance Research*, 101.

37 J. Hillis Miller, for instance, sees performatives as epistemologically empty: "Human performatives . . . can never be the object of an epistemological act . . . [but] are always from beginning to end baseless positings." Cited in Timothy Gould, "The Unhappy Performative," in Parker and Sedgwick, *Performativity and Performance*, 25. Salamensky is more in agreement with myself on this issue when she writes, "performative discourse may also convey information; [just as] informative discourse may . . . perform," in "Dangerous Talk," 19.

38 Timothy Gould writes of how Austin views the very distinction between performative and constative utterances as aporetic: "His goal was not to substitute performance and its various effects for truth and its various consequences. His strategy was rather to drag the fetish of the true and the false into the same swamp of assessment and judgement in which we find the dimension of happiness and unhappiness that afflicts our performative utterances." "The Unhappy Performative," in Parker and Sedgwick, *Performativity and Performance*, 23.

39 The science-fiction writer and queer theorist Samuel R. Delany has written, "It is often hard for those of us who are historians of texts and documents to realize that there are many things that are directly important for understanding hard-edged events of history, that have simply never made it into texts or documents . . . And this is particularly true of almost all areas of sex." "Aversion/Perversion/Diversion," 29–30.

40 For related studies which explore the transformation of art historical method in relation to performativity, see Butt, *After Criticism*; and Amelia Jones and Andrew Stephenson (eds.), *Performing the Body / Performing the Text* (London: Routledge, 1999).

41 Judith Butler, *Bodies That Matter: On the Discursive Limits of "Sex,"* 13.

CHAPTER 1. THE AMERICAN ARTIST AND SUSPICION

1 Benton, "What's Holding Back American Art?" 9–11, 38.

2 This internationalism was that associated with the growing power of international corporations after the war rather than with any workerist or communist international. See Fred Orton, "Footnote One: The Idea of the Cold War," in Fred Orton and Griselda Pollock, *Avant-Gardes and Partisans Reviewed* (Manchester: Manchester University Press, 1996), 205–218, for a particularly useful account of the triumph of business liberalism underpinning the so-called triumph of American modernist painting. See also Serge Guilbaut, *How New*

York Stole the Idea of Modern Art (London: University of Chicago Press, 1983), 174–178, for a discussion of how "Americanism" in postwar art came to be synonymous with internationalism.

3 Benton, "What's Holding Back American Art?" 10.

4 Ibid.

5 See Vito Russo, *The Celluloid Closet* (London: Harper and Row, 1987), 3–59, for a useful account of mass representations of the "sissy-boy" in Hollywood cinema at this time. The term was also used extensively before the war too. See Chauncey, *Gay New York*, for an excellent history of queer denominations pre-1950.

6 Having said this, however, such constructions of an art world overrun with homosexuals reoccurred in American art in the early 1990s. For more details, see Steven C. Dubin, *Arresting Images: Impolitic Art and Uncivil Actions* (London: Routledge, 1992).

7 James Thrall Soby, "A Reply to Mr. Benton," *Saturday Review of Literature*, 15 December 1951, 11.

8 Soby is the author of, among others, *After Picasso* (New York: Dodd, Mead and Company, 1935); *Tchelitchew* (New York: Museum of Modern Art, 1942); *Georges Rouault* (New York: Museum of Modern Art, 1945); and *Twentieth Century Italian Art* (New York: Museum of Modern Art, 1949). He had been made associate director of MOMA in 1943.

9 For two of the best accounts to date of the indeterminacy of homosexual meaning in 1950s and 1960s American culture, see Miller, "Anal Rope," 119–141; and Lee Edelman, "Tearooms and Sympathy; or, The Epistemology of the Water Closet," in *Homographesis*, 148–170.

10 Benton, *An Artist in America*, 261–269. Originally published in New York by the Robert M. McBride company in 1937. A second revised edition was published by Kansas City Press and Twayne Publishers in New York in 1951. All the following citations from this source will be abbreviated as *A* and appear in the text.

11 "Developed during his stint in the teens with the early motion picture industry, Benton's reliance on type cast figures—male and female, black and white, rural and urban—assured greater audience accessibility for his pictures . . . Benton distilled (observational fact) into archetypal anecdotes, much as Hollywood filmmakers did, to mesh with contemporary perceptions of real life. Exaggerating physical traits and other identifying elements, Benton made character recognition an easy task for his viewer." Doss, *Benton, Pollock, and the Politics of Modernism*, 123.

12 We might also see the work of Benton's contemporary, Paul Cadmus, as part of such an economy with its similar, though perhaps less phobic, visual typology of sexuality in American society. As Jonathan Weinberg has pointed out, Cadmus's paintings, like Benton's, are attentive to the coding of social and sexual difference, including representations of 1930s urban gay types. See Jonathan Weinberg, "Cruising with Paul Cadmus," *Art in America*, vol. 80,

no. 11, November 1992, 102–109; his *Speaking for Vice: Homosexuality in the Art of Charles Demuth, Marsden Hartley, and the First American Avant-Garde* (New Haven, Conn.: Yale University Press, 1993), 32–41; and Meyer, *Outlaw Representation*, 33–93.

13 Benton, "What's Holding Back American Art?" 10.

14 I use the terms *gay* and *straight* here without any particular regard for their historical currency in 1950s discourse. Such terms were common within the homosexual lingo of the period, but far less so in mainstream language. Benton, in particular, would more likely use *homosexual*, *sissy*, and *fairy* for gay, and *ordinary* or *normal* for straight. For more on sexual denominations in the postwar world, see Cory, *The Homosexual in America*, xiv.

15 Kinsey, Pomeroy, and Martin, *Sexual Behavior in the Human Male*. All the following citations from this source will be abbreviated as *S* and appear in the text.

16 Cited in "How Men Behave," 66.

17 *Saturday Review of Literature*, vol. 31, 10 April 1948, 21.

18 J. Jones, *Alfred C. Kinsey*, 570.

19 Cited in Kinsey, Pomeroy, and Martin, *Sexual Behavior in the Human Male*, 651.

20 Cited in Wickware, "Report on Kinsey," 98.

21 "Kinsey Speaks Out," 27; "The Talk of the Town: Notes and Comment," *The New Yorker*, 27 March 1948, 19.

22 Unless, of course, we insist on the possible gay coding of Kinsey's red tie here. The homosexual significance of the red tie is discussed in Weinberg, *Speaking for Vice*, 32–42.

23 See Ehrenreich, *The Hearts of Men*, 14–28.

24 See Norman Podhoretz, "The Know-Nothing Bohemians," 305–318, and Bernard Wolfe, "Angry at What?," 316–322.

25 Partially reprinted in Cory, *The Homosexual in America*, 269–280; and in Martin Duberman, *About Time*, 181–185.

26 The numbers of gay men fired year by year from their employment in the State Department were 1950, 54; 1951, 119; 1952, 134; 1953 (January to July only), 74. These figures are reprinted in *One* magazine, vol. 1 no. 7, July 1953. See also D'Emilio, *Sexual Politics, Sexual Communities*, 41–49, and his "The Homosexual Menace," 226–240, for more details.

27 D'Emilio, *Sexual Politics, Sexual Communities*, 42.

28 Cited in D'Emilio, "The Homosexual Menace," 228.

29 Whitfield, *The Culture of the Cold War*, 44.

30 Indeed, it is highly likely that Benton would have glimpsed in the homophobic political climate of 1951 a new and propitious context for him to resume the customary gay bashing more common to his pronouncements of the 1930s. Benton, as a chauvinistic populist, would have found much in McCarthyism's popular and prejudicial agenda to identify with. Its attacks upon elites of all kinds, especially intellectual ones, in the name of a heavily masculinized con-

struction of the American patriotic body, may well have bolstered Benton into resuming his misogynistic and homophobic attacks on the institutions of American art.

31 This is borne out in Schlesinger's *The Vital Center*, which is now widely regarded as a key text of postwar American internationalist liberalism. Schlesinger describes Communism here as "something secret, sweaty and furtive like nothing so much, in the phrase of one wise observer of modern Russia, as homosexuals in a boys' school." Cited in Whitfield, *The Culture of the Cold War*, 43.

32 Reprinted in Duberman, *About Time*, 220–223.

33 Norse, *Memoirs of a Bastard Angel*, 77.

34 Vidal, *Palimpsest*, 103–104.

35 Tomkins, *Off the Wall*, 260.

36 Rosenberg, "The Art Establishment," 46.

37 "The Homosexual in America," 40–41.

38 Tomkins, *Off the Wall*, 260.

39 Rosnow and Fine, *Rumor and Gossip*, 50–62.

40 This is variously instanced by C. Jones, *Machine in the Studio*, 38–39; Leja, *Reframing Abstract Expressionism*, 254–256; and Barber, "T-shirts, Masculinity and Abstract Expressionism." See also Pollock, "Killing Men and Dying Women," 219–294, for a useful account of gender binaries in 1950s American culture as they pertain to the gendering of the artist and artistic activity.

41 See also Anne M. Wagner, "Lee Krasner as L. K.," *Representations*, no. 25, winter 1989, 42–57, for a related analysis to Jones's.

42 Leja, *Reframing Abstract Expressionism*, 255.

43 A related argument has already been made, though more in relation to the "feminization" of the American male in postwar U.S. culture, by A. Jones, in her *Body Art*, 77–86. Both feminization and homosexualization were closely related as threats to dominant constructions of American masculinity in 1950s culture, the one usually implying the other.

44 Katz, "The Art of Code," 192.

45 Butler, *Bodies That Matter*, 111. Butler only refers to "normative" heterosexuality as being constructed in this way because, she writes, "it is not always or necessarily the case that heterosexuality be rooted in such a full-scale repudiation and rejection of homosexuality." This is borne out by my analysis in chapter 3 of Larry Rivers's distinctly *non*normative heterosexuality, which is fashioned out of an *embrace* of queer identification.

46 "The abjection of homosexuality can take place only through an identification with that abjection, an identification that must be disavowed, an identification that one fears to make only because one has already made it, an identification that institutes that abjection and sustains it." Ibid., 112.

47 For more on the homophobic responses of the abstract expressionists, see chapter 3 in this volume.

48 Leja, *Reframing Abstract Expressionism*, 255.

49 Edelman, *Homographesis*, 7.

50 John Gruen, interview with the author, New York, 26 February 2001.

51 Benton, *An Artist in America*, 266.

52 Perchuk writes of how Pollock becomes angered after being filmed at work by Hans Namuth in 1950. In particular it is the sudden realization of the *performative* condition of his artistic masculinity which upsets Pollock most: "In the process of shooting the movie, Pollock became self-conscious that the tremendous strain was not directed toward producing authenticity but a masquerade. He saw himself as a performer, and all the elements of his working method — the horizontality of the picture surface, the display that produced the drips, pours, and puddles, the presence that allowed him to be in the painting — became histrionics." Andrew Perchuk, "Pollock and Postwar Masculinity," 42.

CHAPTER 2. IDOL GOSSIP

1 Cory, *The Homosexual in America: A Subjective Approach*. All the following citations from this source will be abbreviated as *H* and appear in the text.

2 Edmund Bergler's work typifies psychiatry's pathologizing attitude toward homosexuality in the 1950s with book titles such as *Neurotic Counterfeit-Sex* telling you about as much as you need to know about the kind of analysis contained between its covers. See also Irving Beiber et al., *Homosexuality: A Psychoanalytical Study* (New York: Basic Books, 1962), for a similar, slightly later, treatment of the subject; and for a useful oral history of gay men and psychiatry in the United States, see Peter M. Nardi, David Sanders, and Judd Marmor, *Growing up before Stonewall* (London: Routledge, 1994), 35–45. In the then forty-eight states of the United States, laws on sodomy, crimes against nature, buggery, disorderly conduct, solicitation, prostitution, and corruption of minors made homosexuality a substantially criminal occupation. Extracts from the legal statutes covering the criminality of homosexuality at this time are printed in Cory, *The Homosexual in America*, 281–292. Finally, in addition to the homophobic definitions meted out by psychiatry and law, Western Christian theology added its own traditional homophobia. As John D'Emilio notes, one biblical scholar who undertook a reevaluation of Christian attitudes toward homosexuality in the 1950s closed his book with the thirteenth century because he failed to note any significant alteration in the tradition since that time. For this, and a broader overview of the abject definition of homosexuality in midcentury America, see D'Emilio, *Sexual Politics, Sexual Communities*, 9–22.

3 One only has to read Seymour Kleinberg's and Martin Duberman's retrospective accounts of growing up gay in the 1950s to be apprised of the degree to which homophobic definitions were internalized by many American men at the time. See Kleinberg, *Alienated Affections*, and Martin Duberman, *Cures: A Gay Man's Odyssey* (New York, Plume, 1991).

4 The Mattachine Society which was established in Los Angeles in 1950. For

excellent histories, see D'Emilio, *Sexual Politics, Sexual Communities*, 57–91, and Stuart Timmons, *The Trouble with Harry Hay: Founder of the Modern Gay Movement* (Boston: Alyson, 1990), 139–171.

5 *One* magazine was first published in January 1953. It was not, however, the official organ of the Mattachine Society; this mantle was assumed by the *Mattachine Newsletter* and the *Mattachine Review*. Cory published regularly in *One* throughout the 1950s and early 1960s: "Donald Webster Cory," 2–11; "Can Homosexuals Be Recognized?" *One*, 7–11; "Toward a Rational Approach to Homosexuality," *One*, vol. 10, no. 3, March 1962, 5–11; and "From the First to the Second Cory Report," *One*, vol. 11, no. 10, October 1963, 5–8.

6 By the 1960s, however, Cory's standing within the homophile community was beginning to wane. He increasingly professed the view that gay men were disturbed and needed to be cured, and he refused to take issue with the medical model of homosexuality alongside other activists. See D'Emilio, *Sexual Politics, Sexual Communities*, 167, for more details.

7 Lyn Pedersen (pseud. James L. Kepner Jr.), "The Importance of Being Different," 4. Pedersen's call to assert homosexual difference was part of a debate among gay activists in the midfifties around this issue. He took issue with those in the homophile community who stressed the homosexual's *similarity*, and who therefore staked everything on political and social assimilation to the straight mainstream. Instead Pedersen was typically Coryesque in stressing the "minoritarian" case: the need to recognize — and politically defend — the difference of gay people.

8 The power of such nonspecialist talk, and its pertinence to matters of homosexuality, is evidenced by Cory's own book, which drew its authority less from any scientific analysis and rather more from its expressly personal approach. Subtitling the book "A Subjective Approach," Cory bravely signaled that his book's arguments were derived from the sexual and social experiences of its expressly queer author, readily referring to himself as an "acknowledged homosexual." Cory, *The Homosexual in America*, xiii. Although this bravery was perhaps tempered by the pseudonymous nature of the book's authorship (Cory later revealed his birth name, Edward Sagarin, in the 1960s), the book clearly distanced itself from the more scientific and "objective" perspectives which were more common to the study of sexuality, and particularly to studies of male homosexuality, including Kinsey's 1948 book. This might have signaled to some the dubious foundation of the book's arguments, but it also serves, I think, to suggest the value of the knowledge derived from Cory's own experience as a gay man, as well as from the anecdote and observations he collects from other (gay) men. The book therefore stakes out an alternative authority for its "findings" as a sympathetic "insider" account of being homosexual in American society at this time.

9 See George Chauncey, *Gay New York*, 228–244, for a rich account of the Village in the 1920s.

10 Gide, *Corydon*.

11 *The Mattachine Review*, first published in 1955, was the cultural organ of the Mattachine Society, and generally reflected the views of the society's leadership, while *One* magazine, initially published in 1953, was not formally linked with the society and was often critical of its views.

12 The *Review* was generally more desirous of convincing presumptively straight "experts" and academics of the justness of the homosexual cause, whereas *One* had more of an eye on the everyday (gay) reader, tending to carry more "opinion" pieces, poetry, and fictional narratives.

13 *One* reported the outcome of a roundtable discussion at the One Institute, the Los Angeles–based educational center for the study of homosexuality, in 1958. It revealed that most of the participants felt "at least an unusually large percentage of homosexuals possessed special artistic talents." "Homosexual vs. Heterosexual Living," *One*, vol. 6, no. 3, March 1958, 9.

14 Freud, *Leonardo da Vinci: A Memory of His Childhood* (London: Random House, 1947). The 1957 translation was by Alan Tyson and was published in New York and London.

15 Kupper, "Immortal Beethoven," 8.

16 A. E. Smith, "The Curious Controversy over Whitman's Sexuality," 6–25.

17 Russell and McIntire, "In Paths Untrodden," 13.

18 Gilbert Cant, an associate editor of *Time*, cited in "Lyn Pedersen" (pseud.), "Do Homosexuals Hide behind Great Men?" 4–6.

19 Mailer, "The Homosexual Villain," 12.

20 Ellis, "Art and Sex," 15.

21 In addition to the articles already cited above, see Palmieri, "Leonardo the Forerunner," 76–83.

22 Chauncey, *Gay New York*, 285.

23 Kupper, "Immortal Beethoven," 8.

24 "The Art of Michelangelo," *Fizeek Art Quarterly*, no. 3, June 1962, 3–5.

25 As Alan Miller notes, the readership of physique magazines often appreciated the closeted veneer of the magazine's intentions: "homophile publications such as *One* and *Mattachine Review* were available in the '50s and '60s but were usually considered too political or too obvious (and of course not racy enough) for most gay readers. Even when blatantly erotic, physique magazines were excused (one is not sure how successfully) as works for those interested in bodybuilding, art or nudism—anything to avoid labels being applied to the purchasers." "Beefcake with No Labels Attached," *The Body Politic*, no. 90, January/February 1983, retitled as "Beefcake before Blueboy," Web page visited 5 November 2004, printout on file with author.

26 The queer coding of Michelangelo's *David* is also deployed in Basil Dearden's exploration of homosexual blackmail in his 1961 film *Victim*. At one point in the film, the camera lingers on a reproduction of *David* in the blackmailer's flat, clueing the spectator in to the possible sexual orientation of its occupant.

27 "Winston Leyland interviews Lou Harrison," in Leyland (ed.), *Gay Sunshine Interviews*, 1:180.

28 For more on Warhol's desire for, and identification with, Truman Capote, see chapter 4.

29 "George Whitmore interviews Tennessee Williams," in Leyland, *Gay Sunshine Interviews*, 1:315.

30 Kleinberg, *Alienated Affections*, 33.

31 Cohen and Dyer, "The Politics of Gay Culture," 176.

32 See Muñoz, *Disidentifications*, 195–200.

33 Winston Leyland, "Ned Rorem: An Interview," *Gay Sunshine*, summer 1974, 6.

34 *Painters Painting* (directed by Emile De Antonio), Turin Film Corporation, 1972.

35 Rorem, *The Paris and New York Diaries of Ned Rorem, 1951–1961*, 225.

36 The works from the 1940s and 1950s, cited by Smith, are G. W. Allen's *Walt Whitman Handbook* (1946), and his biography, *The Solitary Singer* (1955); Fredson Bowers's book *Whitman's Manuscripts* (1955); as well as articles by Malcolm Cowley in *The New Republic* (1946), and by Frances Oakes in *The Walt Whitman Newsletter* (1956).

37 Miller, "Anal Rope," 124.

38 Silver, "Modes of Disclosure," 184–185. See also Johnston, *Jasper Johns*, 164–178, for a related analysis.

39 Eve Kosofsky Sedgwick, *Between Men: English Literature and Male Homosocial Desire* (London: Columbia University Press, 1985), 206.

40 Russell and McIntire, "In Paths Untrodden," 13.

41 Fred Orton, *Figuring Jasper Johns*, 118–124.

42 Kleinberg, *Alienated Affections*, 28.

43 See Russell and McIntire, "In Paths Untrodden," and Smith, "The Curious Controversy over Whitman's Sexuality."

CHAPTER 3. THE GIFT OF THE GAB: LARRY RIVERS

1 Glueck, "Rivers Paints Himself into the Canvas," 34–35, 78–83. All the following citations from this source will be abbreviated as *R* and appear in the text.

2 Rivers changed his name from Yitzroch Grossberg, first to an anglicized "Irving" Grossberg, and finally to Larry Rivers on the occasion of a concert played by his bebop band in the 1940s.

3 Moreover, in referring to him as a "hard-core picaresque," Glueck indicates that Rivers's personality is suggestive of literary as well as cinematic mythologies. Glueck, "Rivers Paints Himself into the Canvas," 35.

4 Sam Hunter, *Larry Rivers* (New York: Harry N. Abrams., 1970), 12. All the following citations from this source will be abbreviated as *L* and appear in the text.

5 Gooch, *City Poet*, 231. All the following citations from this source will be abbreviated as *C* and appear in the text. For Larry Rivers's and Frank O'Hara's

own accounts of their first meeting, see John Gruen, *The Party's Over Now*, 141–142.

6 Pollock's comments were published as "My Painting," in *Possibilities*, vol. 1, winter 1947–1948. Reprinted in David Shapiro and Cecile Shapiro (eds.), *Abstract Expressionism: A Critical Record* (Cambridge: Cambridge University Press, 1990), 356–357.

7 For a useful discussion of these lithographs, collectively entitled *Stones*, see Perloff, *Frank O'Hara*, 100–105, and also Ferguson, *In Memory of My Feelings*, 50–59. The bitchy remark "There they are, covered with blood and semen!" was made by John Bernard Myers upon seeing Rivers and O'Hara together at the ballet, and it is incorporated into the third print of the series. Myers was Rivers's dealer at the time, and was infatuated with him. For more on this, see Gruen, *The Party's Over Now*, 134–137.

8 Larry Rivers with Arnold Weinstein, *What Did I Do?* All the following citations from this source will be abbreviated as *W* and appear in the text.

9 "By the time Frank O'Hara took his last trip to Fire Island [in 1966], my curiosity about homosexuals and life and sex among them had diminished. They were my friends, and their exotic and erotic aura continued, but only as a warm glow in my memory." Rivers and Weinstein, *What Did I Do?* 470.

10 Paul Cummings, interview with Larry Rivers, 2 November 1968, Washington, D.C., Archives of American Art/Smithsonian Institution, microfilm no. 3949, 11.

11 Cited in John Gruen, *The Artist Observed*, 29.

12 I use the term *queer* here to refer to both lesbian and gay, since Rivers clearly took both Blaine and O'Hara as important embodiments of what it meant to be an artist. However, as we shall see, by 1950/1951 it was primarily gay *male* society which fascinated and attracted Rivers, largely by dint of its transgressive performance of masculine sexual potency and the bewildering argot of a camp vernacular.

13 Isherwood, *The World in the Evening*, 125.

14 Queer theory has done much to theorize the relations between camp, drag, and performativity. Most notable, of course, is Judith Butler, *Gender Trouble*, esp. 137–139. Butler's notion of drag as that which reveals the imitative structure of gender itself has been applied to camp by Meyer, *The Politics and Poetics of Camp*, and Robertson, *Guilty Pleasures*.

15 Gruen, *The Party's Over Now*, 133.

16 See my "The Greatest Homosexual?" 111–112.

17 See Stimpson, "The Beat Generation and the Trials of Homosexual Liberation," 373–392, for an excellent account of the problematic relationship of some of the straight(er) beats, principally Kerouac and Cassady, to homosexuality and their queer counterparts, Ginsberg and Burroughs. Also, for a portrait of the queer beatnik, see de Ortega Maxey, "The Homosexual and the Beat Generation," 5–9.

18 Cummings, interview with Larry Rivers, 12.

19 "And then there was the '-ola' suffix, used to an excess that didn't necessarily lead to the palace of wisdom, but I picked up on it like everyone else I knew, gay and straight." Rivers and Weinstein, *What Did I Do?* 110.

20 O'Hara and Rivers, "Why I Paint as I Do," 98. All the following citations from this source will be abbreviated as *WH* and appear in the text.

21 Fred Orton, in recent unpublished work, has argued that most of the art world was prodemocrat and viewed the election of Eisenhower in January 1953 with some anxiety. Orton maps in some detail the political climate into which Rivers's painting was pitched. Not only could Rivers's patriotic choice of subject be seen in the context of McCarthyism, but also in the context of Eisenhower becoming the first soldier-president of the United States, the first, that is, since Washington: "Our country was founded by a general, now let's save it with one" was a pro-Eisenhower slogan at the time.

22 "[Leutze] thought that crossing a river on a late December afternoon was just another excuse for a general to assume a heroic, slightly tragic pose . . . What could have inspired him I'll never know. What I saw in the crossing was quite different. I saw the moment as nerve-wracking and uncomfortable. I couldn't picture anyone getting into a chilly river around Christmas time with anything resembling hand-on-chest heroics" (*WH* 98).

23 See Cynthia Morril, "Revamping the Gay Sensibility: Queer Camp and Dyke Noir," in Meyer, *Politics and Poetics*, 114–115.

24 Isherwood, *The World in the Evening*, 125.

25 Andrew Ross, "Uses of Camp," in his *No Respect*, 152.

26 Sam Hunter, interview with Larry Rivers, Sam Hunter Papers concerning Larry Rivers 1950–1969, Washington, D.C., Archives of American Art / Smithsonian Institution, microfilm nos. 630, 673.

27 Isherwood, *The World in the Evening*, 125.

28 "Rivers was 'talent' in the Broadway or Hollywood sense of skill practised to arouse an assortment of feelings." Harold Rosenberg, "Rivers' Commedia dell' Arte," 35.

29 Cummings, interview with Larry Rivers, 12.

30 For the most sophisticated and detailed account of the relationship between Rivers and O'Hara, see Perloff, *Frank O'Hara*, esp. 84–85, 92–96, 99–105. See also Irving Sandler, *The New York School: The Painters and Sculptors of the Fifties* (London: Harper and Row, 1978), 108.

31 "A Memoir by Frank O'Hara," in Hunter, *Larry Rivers*, 51.

32 Cited in Gross, "Poets and Painters in the Theater," 33.

33 For a useful overview of such criticisms, see Bruce Boone, "Gay Language as Political Praxis," 59–92.

34 Feldman, *Frank O'Hara*, 49.

35 For more on this, see H. Smith, *Hyperscapes in the Poetry of Frank O'Hara*, 145.

36 "Personism: A Manifesto," in Allen, *The Collected Poems of Frank O'Hara*, 499.

37 Feldman, *Frank O'Hara*, 52.

38 For some critics, this refusal of a grand poetic manner is taken to evidence superficiality, meaninglessness, or opaqueness, whereas for others, such as Feldman, it is seen as the expression of a feminized construction of male homosexuality. For others still, like Boone, this vernacular styling of O'Hara's poetry is seen to embody an "oppositional" gay language practice. Boone positions the relative "privacy" of meaning and address in O'Hara's work as an effect of the impact of homophobia on gay communication, forcing it to take forms other than that of "official" straight language. If critics can find in O'Hara only superficiality and meaninglessness, then it is because, Boone argues, they are positioned on the "outside" of the camp vernacular, unable to hear its differentially constituted codes of coherence. Boone's argument is germane to my own here, though I highlight the queer *pleasures* offered by camp communication rather than focus more strictly, as Boone does, on reading the alternative subcultural meanings passed over in silence by the "straight" critic.

39 Sandler, *The New York School*, 108.

40 Kaufman, "Rivers," 400.

41 Griffin, "Larry Rivers," 9.

42 Tyler, "The Purple-Patch of Fetichism," 40–43, 52–53.

43 Ibid., 52. Tyler isn't the only commentator to draw upon journalistic analogies in characterizing Rivers's work. Kaufman, again, writes: "art cannot be pure journalism, and Rivers often seems dead set on having it so." Kaufman, "Rivers," 400.

44 Cited in Sandler, *The New York School*, 108.

45 Tyler, "The Purple-Patch of Fetichism," 40.

46 Cited in Glueck, "Rivers Paints Himself into the Canvas," 79.

47 This deflation of moral seriousness has been identified as a key feature of camp by Susan Sontag: "Camp is a solvent of morality. It neutralizes moral indignation, sponsors playfulness." "Notes on Camp," *Partisan Review*, 529. Sontag's text is obviously very important for any discussion of camp, though, for matters of historical specificity, I do not want to consider it until my next chapter, which focuses more properly on the early 1960s. In many ways, Rivers's camp performance—especially as it is undertaken by a "straight" artist—can be seen to lay the ground for Sontag's own mainstreaming of camp in the era of Pop art.

48 Cited in Gooch, *City Poet*, 175.

49 Gruen, *The Party's Over Now*, 140.

50 Hess, "Larry Rivers' History of the Russian Revolution," 58.

51 Kikel, "The Gay Frank O'Hara," 8. See also Kikel's "After Whitman and Auden: Gay Male Sensibility in Poetry since 1945," *Gay Sunshine*, nos. 44/45, 1980, sec. 2, 34–39.

52 Beaver, "Homosexual Signs," 117.

53 Cited in Phyllis Rosenzweig, *Larry Rivers*, 41.

54 See note 47.

55 Richardson, "Dada, Camp, and the Mode Called Pop," 549–558. For a discussion of Richardson's comments, see Butt, "The Greatest Homosexual?" 118–119.

56 John Ashbery, "Larry Rivers Was Dying," *New York Times*, Sunday, 25 August 2002, 28.

CHAPTER 4. THE "INNING" OF ANDY WARHOL

 1 Warhol and Hackett, *POPism*, 73. All the following citations from this source will be abbreviated as *P* and appear in the text.

 2 Wolf marshals the evidence of Warhol's gossiping as proof of his social and artistic interactions with others, which, she argues, runs counter to his image as a passive and impersonal artist. Thus she makes a quasi-humanist argument about Warhol's "deep human presence," which puts her analysis at odds with my own. This is because my aim here is to explore the gossipy determination of Warhol's distinctly *alienated* persona, as well as paying heed more generally to the sexual and interpretative uncertainties which gossip keeps in play. Wolf, on the other hand, tends to use her readings of gossip in Warhol's oeuvre to *secure* a reading of a "real," "human" Warhol behind his more customary postmodern mask. Wolf, *Andy Warhol, Poetry, and Gossip in the 1960s*.

 3 Warhol and Hackett, *POPism*, dust jacket blurb.

 4 For the most comprehensive and intelligent account of Warhol as an artist-manager, see C. Jones, *Machine in the Studio*, 233–263.

 5 For a useful account of how the official silence around individual stars' sex lives works to fuel the gossip industry around them, and thus contributes to the mystery and allure of their public personae, see Diana McLellan, *The Girls: Sappho Goes to Hollywood* (London: Robson, 2000).

 6 This argument, or a variation on it, has been made before by Terry Atkinson in his essay "Warhol's Voice, Beuys's Face, Crow's Writing," 156–179.

 7 Watney, "The Warhol Effect," in Garrels, *The Work of Andy Warhol*, 120–122.

 8 In advance of this New York show in November 1962, however, Warhol had his very first one-person show, Campbell's Soup Cans, in Los Angeles at the Ferus Gallery.

 9 Doyle, Flatley, and Muñoz, *Pop Out*, 1.

10 See also Douglas Crimp, "Getting the Warhol We Deserve: Cultural Studies and Queer Culture." Meyer, "Warhol's Clones," 93–122; Silver, "Modes of Disclosure," 179–203; and Suárez, *Bike Boys, Drag Queens and Superstars*.

11 Trevor Fairbrother provides a useful analysis of the boy drawings in "Tomorrow's Man," 63–73. For another, more recent account of Warhol in the fifties, see Meyer, *Outlaw Representation*, 95–128.

12 J. F., "Irving Sherman, Andy Warhol."

13 Cited in Victor Bockris, *Warhol*, 142. All the following citations from this source will be abbreviated as *W* and appear in the text.

14 Michael Moon refers to Warhol's 1950s work as "fag" art in "Screen Memories, or, Pop Comes from the Outside: Warhol and Queer Childhood," in Doyle, Flatley, and Muñoz, *Pop Out*, 80.

15 Silver, "Modes of Disclosure," 193–202.

16 Rauschenberg and Johns performed window-dressing work under a pseudonym of "Matson-Jones." See Francis and King, *The Warhol Look*, 98–110, and 111–123, for more details on the involvement of Pop artists in window design in the 1950s.

17 As De Antonio is reported as saying to Warhol: "you're a commercial artist, which really bugs them because when *they* do commercial art — windows and other jobs I find them — they do it just 'to survive.' They won't even use their real names. Whereas *you've* won prizes! You're *famous* for it!" Warhol and Hackett, *POPism*, 12.

18 See Silver, "Modes of Disclosure," 194. I am, of course, using the term "interpellation" in the Althusserian sense. See Louis Althusser, "Ideology and Ideological State Apparatuses," in *Essays on Ideology* (London: Verso), 1–60.

19 Cited in Gooch, *City Poet*, 395.

20 When O'Hara visited Warhol's Factory for the first time in 1964, Malanga recalls, "Frank left . . . not very impressed with what Andy was doing . . . There was a weird homosexual climate there at that point. Maybe he felt Andy was too sissified for his tastes." Cited in ibid., 397–398.

21 See ibid., 398–399, for more details on O'Hara's critical acceptance of pop.

22 Colacello, *Holy Terror*, 24.

23 P. Smith, *Andy Warhol's Art and Films*, 12.

24 Collins, "The Metaphysical Nosejob," 47–55.

25 Jonathan Flatley, "Warhol Gives Good Face: Publicity and the Politics of Prosopopoeia," in Doyle, Flatley, and Muñoz, *Pop Out*, 101–133.

26 See Butler, *Bodies That Matter*, 223–242.

27 Wicker, "Effeminacy vs. Affectation," 4–6.

28 In any case, Eve Kosofsky Sedgwick justly argues, pride and shame cannot be extricated from one another in the production of progressive political subjectivity: "the forms taken by shame are not distinct 'toxic' parts of an identity that can be excised; they are instead integral to and residual in the processes by which identity itself is formed." "Queer Performativity: Warhol's Shyness/ Warhol's Whiteness," in Doyle, Flatley, and Muñoz, *Pop Out*, 142.

29 Krauss, *The Optical Unconscious*, 276.

30 Cory, "Can Homosexuals Be Recognized?" 8.

31 Bennard B. Perlman, "The Education of Andy Warhol," in the Andy Warhol Museum, *The Andy Warhol Museum*, 159.

32 It was while living with "a bunch of [gay] dancers" in a two-bedroom apartment in uptown New York in the summer of 1950 that Warhol first came to

explore the realities of "the homosexual underground." See Bockris, *Warhol*, 93–95, for more details.

33 Cited in Koestenbaum, *Andy Warhol*, 36.

34 The phrase "avant-garde gambit" is borrowed from Griselda Pollock, *Avant-Garde Gambits: Gender and the Colour of Art History* (London: Thames and Hudson, 1992).

35 C. Jones, *Machine in the Studio*, 248–263. Meyer also follows Jones's basic argument here in *Outlaw Representation*. For a critical assessment of the latter, see Butt, "Respecting the Outlaw," 170–176.

36 For more details, see Bockris, *Warhol*, 187–190.

37 The campness of Warhol's work was certainly not lost on queer audiences in the 1960s. Victor Bockris quotes the art critic Mario Amaya commenting on Warhol's work in the wake of the Stable Gallery show: "When I got back from London in 1962 people were saying, 'Oh God, guess what Andy's doing now . . . He's a great artist and he's actually conned somebody into giving him a show.' This was a great laugh and everyone thought it was a camp joke, particularly all the faggots." *Warhol*, 184.

38 I have followed Terry Atkinson in naming my two constructions of Warhol here. Atkinson is similarly concerned with analyzing the relations between two constructions of the artist, in his case "Warhol-dandy" and what he calls "Warhol-Catastrophe." See Atkinson, "Warhol's Voice, Beuys's Face, Crow's Writing," 156–179.

39 Solomon, *Andy Warhol*, 1–2.

40 Many commentators similarly contented themselves with simply describing Warhol's appearance. See Nancy Love, "Pop Goes the Easel," *Greater Philadelphia*, vol. 56, no. 11, November 1965, 156; and Hancock, "Soup's On," 16.

41 Sedgwick, *Epistemology of the Closet*, 79, 248.

42 For the most developed account of Warhol as cultural mirror, see Josephson, "Warhol," 40–46.

43 Jonathan Katz relates a useful, and comparable, account of the performative value of silence for a politics of queer resistance—including some passing comment on Warhol—in "Performative Silence and the Politics of Passivity," 97–103.

44 Cited in Whiting, "Andy Warhol," 71.

45 Billy Name, interview with the author, Poughkeepsie, February 2001.

46 See in particular Bartlett, *Who Was That Man?*; and Moe Meyer, "Under the Sign of Wilde: An Archaeology of Posing," in Moe Meyer, *The Politics and Poetics of Camp*, 75–109. Related arguments can be found in Sinfield, *The Wilde Century*; and Cohen, *Talk on the Wilde Side*.

47 "Yet while the cultural enterprise of reading homosexuality must affirm that the homosexual is distinctively and *legibly* marked, it must also recognize that those markings have been, can be, or can pass as, unremarked and unremarkable." Edelman, *Homographesis*, 7.

48 "Edie and Andy," *Time*, 27 August 1965, 32.

49 Crowther, "Screen: Oscar Wilde," 28; "Screen: Wilde Absolved," 26; and "Oscar Happy, Two Films at Once about Mr. Wilde," 1.

50 Crowther, "Wilde Absolved," 26.

51 Crowther, "Oscar Happy," 1.

52 Sontag, "Notes on Camp," 527.

53 Josephson, "Warhol," 42.

54 Kozloff, "Andy Warhol and Ad Reinhardt," 115.

55 Stephen Koch, *Stargazer: Andy Warhol's World and His Films* (London: Calder and Boyars, 1974), 114.

56 Paul Gardner, "Gee, What's Happened to Andy Warhol?" 76.

CHAPTER 5. QUEERING DISCLOSURE AND JASPER JOHNS

1 Cited in Orton, *Figuring Jasper Johns*, 93. All the following citations from this source will be abbreviated as *F* and appear in the text.

2 Perhaps the ending of the Vietnam War in January 1973 had some impact both on the condition of patriotism in American society and the subsequent entry of *Flag* into the museum.

3 Tomkins, *Off the Wall*, 143–144.

4 In a situation that was to anticipate the Barr-Johns dialogue in 1958, *Target with Plaster Casts* had also been excluded from the Artists of the New York School: Second Generation exhibition in 1957 at the Jewish Museum. More on this later in the chapter, in the section "A Subject Out of Control."

5 As far as I am aware, the painting did not finally appear on MOMA's walls until some thirty-eight years later, as part of the 1996 retrospective exhibition of Johns's work. This is according to the provenance record I have acquired from the Leo Castelli Gallery archives in New York; the record runs up to 1993, when the painting was sold to its current owner, David Geffen.

6 See Orton, *Figuring Jasper Johns*, 89–146, for his analysis of *Flag*.

7 I do this in part by writing passages in a style borrowed from two fairly randomly chosen pulp novels: Catherine Mann, *Rumours* (London: Grafton, 1989) and Sara Fitzgerald, *Rumours* (London: Coronet, 1992). Both novels are expressly marketed to a female readership and promise stories of love and scandal in the high societies of Hollywood (Mann) and the legal profession (Fitzgerald). Both are concerned with providing their readers with the pleasures to be gained from sexual knowledge in the form of sensationalized revelations.

8 Francis, *Jasper Johns*, 25. See also Solomon, *Jasper Johns*, 10–11, for a similar account of the contrasting play of targets and casts.

9 Rosenblum, "Jasper Johns," 54.

10 Steinberg, "Jasper Johns," 37.

11 Linda Williams, *Hard Core: Power, Pleasure, and the "Frenzy of the Visible"* (London: Pandora, 1990), 77.

12 Initially, Johns had intended that the viewer engage in a very "physical" and

"active" relationship with the painting, either standing back to view the target or going close to lift or shut the lids. Gallery protocol ensured, however, that active physical participation with the bodies in Johns's art was supplanted by an imaginative encounter, especially as far as opening or closing the lids was concerned.

13 Rosenblum, "Jasper Johns," 55.

14 See Lewis, *Literature, Obscenity and Law*, 185–224, for details on the Lawrence, Miller, and Cleland cases, and 190–196, for a discussion of the cases brought against pulp literature. Further information on the cases against *One* and the Kinsey Institute is to be found in *One* magazine, March 1957, 5–19, and October 1954, 4–6, 12–13, 18–19.

15 For the proceedings of the trial, see Ehrlich, *Howl of the Censor*. Also see Michael Schumacher, *Dharma Lion: A Critical Biography of Allen Ginsberg* (New York: St. Martins Press, 1992), 253–255, 259–264, for critical discussion of the trial and its legal and public effects.

16 Schumacher, *Dharma Lion*, 259.

17 "Big Day for Bards at Bay," 105–108.

18 Ginsberg, *Howl and Other Poems*, 10.

19 Ehrlich, *Howl of the Censor*, 264.

20 Schumacher, *Dharma Lion*, 259.

21 "Alfred Barr would not buy *Flag* from the first show for the Museum of Modern Art, fearing patriotic repercussions; and *Target with Plaster Casts* had been turned down by both the Jewish Museum and the Modern because the casts included genitalia. These were significant points in the late 1950s; they guided people's actions. Today those fears seem quaint, almost endearing." Crichton, *Jasper Johns*, 73–74.

22 Ehrlich, *Howl of the Censor*, 33.

23 "Dirt Defined," 11.

24 For details on the previous findings, see *One*, March 1957, 5–19.

25 For art historical accounts which frame *Target's* body casts in relation to surrealism, see Roberta Bernstein, "Seeing a Thing Can Sometimes Trigger the Mind to Make Another Thing," in Varnedoe, *Jasper Johns*, 47–49; Kenneth Silver, "Modes of Disclosure," 188, 190; and Orton, *Figuring Jasper Johns*, 49–50.

26 Francis, *Jasper Johns*, 24.

27 For a useful account of the normative legitimization of the male gaze upon representations of the male body, and particularly the containment of the homoerotic, see Michael Hatt, "The Male Body in Another Frame: Thomas Eakins' 'The Swimming Hole' as a Homoerotic Image," *Journal of Philosophy and the Visual Arts: The Body* (London: Academy, 1993), 8–21.

28 *Physique Pictorial*, vol. 7, no. 3, fall 1957, 7, reprinted in *The Complete Reprint of Physique Pictorial*, vol. 1, *1951–1964* (London: Taschen, 1997).

29 See Hooven, *Beefcake*, 54, 58, for details.

30 *Physique Pictorial*, vol. 7, no. 3, fall 1957, 7.

31 Leo Steinberg, "Jasper Johns," *Metro*, nos. 4/5, May 1962. Revised and reprinted as "Jasper Johns: The First Seven Years of His Art," 17–54.

32 Fred Orton, "Jasper Johns: The Sculptures," in *Jasper Johns: The Sculptures*, 15.

33 This reference to the "one-ness" which *Target*'s casts "kill" is from N. Calas, cited in Steinberg, "Jasper Johns," 37.

34 Johns was not to utilize fragmented human body casts again until the 1960s, in works such as *According to What* and *Watchman* (both of 1964), and *Passage II* (1966).

35 Vivien Raynor, "Jasper Johns: 'I have attempted to develop my thinking in such a way that the work I've done is not me,'" 22.

36 Jasper Johns interview with Billy Klüver and Julie Martin, in Varnedoe, *Jasper Johns*, 273.

37 Cited in Katz, "The Art of Code," 190.

38 Jill Johnston, *Jasper Johns*, 11. In a note to the reader, the publishers note that they "regret" Johns's decision to refuse permission and that they view it as "an obstacle to the free exchange of ideas, interpretation, and critical response."

39 Others include Silver, "Modes of Disclosure"; Katz, "The Art of Code"; and Dellamora, "Absent Bodies / Absent Subjects," 28–47. Katz has also published "Dismembership," which moves closer to my argument here in its consideration of how *Target* articulates queer forms of knowledge.

40 Both performer Rachel Rosenthal and artist Mark Lancaster have spoken to art historians about Johns and his work. Unfortunately for me, Rosenthal was in Los Angeles at the time of the Castelli show and Lancaster was still in England, not becoming Johns's assistant until the 1970s.

41 Katz and Orton only remark on the "emptiness" of the box, foregoing any analysis of its significance. See Katz, "Dismembership," 175, and Orton, *Figuring Jasper Johns*, 47.

42 See Ehrlich, *Howl of the Censor*, 31–34, for details of the court proceedings concerning the missing words.

43 Jonathan Weinberg, "It's in the Can: Jasper Johns and the Anal Society," *Genders*, no. 1, spring 1988, 40–56. In this article, Weinberg reads anal imagery in Johns's art which sets him apart from my consideration of *Target*'s anal *imaginary*, one that cannot be seen to stabilize at the level of image or icon. He reads the target as an anus on the basis that the word *anus* comes from the Latin word for *ring*, and that it evokes ideas of "attack and penetration" since it is primarily a "hole to aim at" (43). In many ways, this reading echoes Kenneth Silver's, which takes the painting's "body" to be that of the penetrated "gay" body of Saint Sebastian. "Modes of Disclosure," 190. See also Molesworth, "Before Bed," 69–82, for a related account of anality in the work of Robert Rauschenberg.

44 Weinberg wisely cautions, however, against completely conflating Johns's anal imagery with male homosexuality. "It's in the Can," 44.

45 Peggy Phelan, *Mourning Sex*, 4. I should also note that the argument as I de-

velop it here in this chapter was influenced by Phelan's response to Jonathan Katz during the session "Body Politics: Performativity and Postmodernism," chaired by Amelia Jones at the 1997 College Art Association conference in New York.

AFTERWORD

1 Cited in Phillips, *On Flirtation*, xxi.
2 I am deeply indebted to Carol Mavor for suggesting I develop my thoughts on flirtation in this direction here. See her *Becoming*, 16, for more on flirtation as a queer methodology of history.
3 Phillips, *On Flirtation*, xxii.
4 In this sense I am in sympathy with Jane Gallop, who writes in the afterword to her 2002 book *Anecdotal Theory*: "as I imagined writing what would be an impressive theoretical conclusion, something in me resisted moving from anecdote to theory, fixing the anecdotal in a final, abstract, generalizable form" (161).

{ BIBLIOGRAPHY }

Allen, Donald (ed.). *The Collected Poems of Frank O'Hara*. Berkeley: University of California Press, 1995.

Alloway, Lawrence. *Robert Rauschenberg*. Washington, D.C.: Smithsonian Institution, 1976.

Andy Warhol Museum. *The Andy Warhol Museum*. New York: Distributed Art Publishers, 1994.

Ashton, Dore. "Show at the Stable Gallery." *Kunstwerk*, vol. 16, November 1962, 70.

Atkinson, Terry. "Warhol's Voice, Beuys's Face, Crow's Writing." In John Roberts (ed.), *Art Has No History! The Making and Unmaking of Modern Art*. London: Verso, 1994, 156–179.

Atwell, Lee. "In Search of Ned Rorem." *Gay Sunshine*, no. 17, March/April 1973, 5–6.

Austin, J. L. *How to Do Things with Words*. Oxford: Oxford University Press, 1975.

Babuscio, Jack. "Camp and the Gay Sensibility." In Richard Dyer (ed.), *Gays and Film*. London: British Film Institute, 1977, 40–57.

Banes, Sally. *Greenwich Village 1963: Avant-Garde Performance and the Effervescent Body*. Durham, N.C.: Duke University Press, 1993.

Barber, Fionna. "T-Shirts, Masculinity and Abstract Expressionism." Unpublished typescript of paper given at the Associations of Art Historians annual conference, London 1993.

Bartlett, Neil. *Who Was That Man? A Present for Mr. Oscar Wilde*. London: Serpent's Tail, 1988.

Bastian, Heiner. *Andy Warhol Retrospective*. London: Tate Publishing, 2001.

Beaver, Harold. "Homosexual Signs." *Critical Inquiry*, autumn 1981, 99–119.

Benton, Thomas Hart. "What's Holding Back American Art?" *Saturday Review of Literature*, 15 December 1951, 9–11, 38.

———. *An Artist in America* (4th rev. ed.). Columbia: University of Missouri Press, 1983.

Bergin, Paul. "Andy Warhol: The Artist as Machine." *Art Journal*, vol. 16, no. 4, summer 1967, 359–365.

Bergler, Edmund. "Homosexuality and the Kinsey Report," in Charles Berg, A. M. Krich (eds.). *Homosexuality: A Subjective and Objective Investigation*. London: George Allen and Unwin, 1958, 273–300.

Bergmann, Jörg R. *Discreet Indiscretions: The Social Organisation of Gossip*. New York: Aldine De Gruyter, 1993.

Bieber, Irving. *Homosexuality: A Psychoanalytic Study*. New York: Basic Books, 1962.

"Big Day for Bards at Bay." *Life*, vol. 43, no. 11, 9 September 1957, 105–108.

Bockris, Victor. *Warhol*. London: Penguin, 1989.

Boone, Bruce. "Gay Language as Political Praxis: The Poetry of Frank O'Hara." *Social Text*, no. 1, 1979, 59–92.

Bourdon, David. "Andy Warhol." *The Village Voice*, 3 December 1964, 23.

———. *Warhol*. New York: Harry N. Abrams, 1989.

Bronski, Michael. *Culture Clash: The Making of Gay Sensibility*. Boston: South End Press, 1984.

Butler, Judith. *Gender Trouble: Feminism and the Subversion of Identity*. London: Routledge, 1990, esp. 137–139.

———. "Imitation and Gender Insubordination." In Diana Fuss (ed.), *Inside/Out: Lesbian Theories, Gay Theories*. London: Routledge, 1991, 13–31.

———. *Bodies That Matter: On the Discursive Limits of "Sex."* London: Routledge, 1993.

Butt, Gavin. "The Greatest Homosexual? Camp Pleasure and the Performative Body of Larry Rivers." In Amelia Jones and Andrew Stephenson (eds.), *Performing the Body/Performing the Text*. London: Routledge, 1999, 107–126.

———. "Happenings in History, or, the Epistemology of the Memoir." *Oxford Art Journal*, vol. 24, no. 2, 2001, 113–126.

———. "Respecting the Outlaw." *Art History*, vol. 27 no. 1, February 2004, 170–176.

Butt, Gavin (ed.). *After Criticism: New Responses to Art and Performance*. Malden: Blackwell, 2005.

Chauncey, George. *Gay New York: Gender, Urban Culture, and the Making of the Gay Male World 1890–1940*. New York: Basic Books, 1994.

Cohen, Derek, and Richard Dyer. "The Politics of Gay Culture." In Gay Left Collective (ed.), *Homosexuality: Power and Politics*. London: Allison and Busby, 1980, 172–186.

Cohen, Ed. *Talk on the Wilde Side*. London: Routledge, 1993.

Colacello, Bob. *Holy Terror: Andy Warhol Close Up*. New York: HarperPerennial, 1990.

Collins, Bradford R. "The Metaphysical Nosejob: The Remaking of Warhola, 1960–1968." *Arts Magazine*, February 1988, 47–55.

Coplans, John. "Early Warhol: The Systematic Evolution of the Impersonal Style." *Artforum*, vol. 8, no. 7, March 1970, 52–59.

Corber, Robert J. *In the Name of National Security: Hitchcock, Homophobia, and the Political Construction of Gender in Postwar America*. Durham and London: Duke University Press, 1993.

Core, Philip. *Camp: The Lie That Tells the Truth*. London: Plexus, 1984.

Corliss, Richard. "Raggedy Andy Warhol." *Commonweal*, 28 July 1967, 469.

Cory, Donald Webster (pseud. Edward Sagarin). *The Homosexual in America: A Subjective Approach*. New York: Greenberg, 1951.

———. "Donald Webster Cory." *One*, vol. 1, no. 2, February 1953, 2–11.

———. "Can Homosexuals Be Recognized?" *One*, vol. 1, no. 9, September 1953, 7–11.

Crichton, Michael. *Jasper Johns*. London: Thames and Hudson, 1977.

Crone, Rainer. *Andy Warhol*. London: Thames and Hudson, 1970.

Crimp, Douglas. "Getting the Warhol We Deserve: Cultural Studies and Queer Culture," *In[] visible Culture: An Electronic Journal for Visual Studies*, no. 1, Web page visited 5 November 2004, printout on file with author.

Crow, Thomas. "Saturday Disasters: Trace and Reference in Early Warhol." In Serge Guilbaut (ed.), *Reconstructing Modernism: Art in New York, Paris, and Montreal 1945–1964*. Cambridge, Mass., and London: MIT Press, 1990, 311–331.

Crowther, Bosley. "Screen: Oscar Wilde," *New York Times*, 21 June 1960, 28.

———. "Screen: Wilde Absolved," *New York Times*, 28 June 1960, 26.

———. "Oscar Happy, Two Films at Once about Mr. Wilde." *New York Times*, 3 July 1960, sec. 2, 1.

Crowther, R. H. "Homosexual Culture." *One Institute Quarterly*, vol. 3, no. 2, spring 1960, 176–182.

Davis, Whitney (ed.). *Gay and Lesbian Studies in Art History*. New York: Harrington Press, 1994.

Delany, Samuel R. "Aversion/Perversion/Diversion." In Monica Dorenkamp and Richard Henke (eds.), *Negotiating Lesbian and Gay Subjects*. London: Routledge, 1995, 7–33.

Dellamora, Richard. "Absent Bodies/Absent Subjects: The Political Unconscious of Postmodernism." In Peter Horne and Reina Lewis (eds.), *Outlooks: Lesbian and Gay Sexualities and Visual Cultures*. London: Routledge, 1996, 28–47.

D'Emilio, John. *Sexual Politics, Sexual Communities: The Making of a Homosexual Minority in the United States, 1940–1970*. Chicago and London: University of Chicago Press, 1983.

———. "The Homosexual Menace: The Politics of Sexuality in Cold War America." In Kathy Peiss and Christina Simmons (eds.), *Passion and Power: Sexuality in History*. Philadelphia: Temple University Press, 1989, 226–240.

de Ortega Maxey, Wallace. "The Homosexual and the Beat Generation." *One*, vol. 7, no. 7, July 1959, 5–9.

Derrida, Jacques. *Archive Fever: A Freudian Impression*. Chicago and London: University of Chicago Press, 1996.

———. *Of Grammatology*. Baltimore: Johns Hopkins University Press, 1974.

Deutsch, Albert. "The Sex Habits of American Men: Some of the Findings of the Kinsey Report." *Harper's Magazine*, vol. 195, December 1947, 490–497.

"Dirt Defined." *Newsweek*, 13 January 1958, 11.

Doss, Erika. *Benton, Pollock, and the Politics of Modernism: From Regionalism to Abstract Expressionism*. Chicago and London: University of Chicago Press, 1991.

Doty, Robert C. "Growth of Overt Homosexuality in City Provokes Wide Concern." *New York Times*, Tuesday 17 December 1963, 1, 32.

Doyle, Jennifer, Jonathan Flatley, and José Esteban Muñoz. *Pop Out: Queer Warhol*. Durham and London: Duke University Press, 1996.

Duberman, Martin. *Black Mountain: An Exploration in Community*. New York: E. P. Dutton, 1972.

———. "Gay in the Fifties," *Salmagundi*, no. 58–59, fall 1982–winter 1983, 42–75.

———. *About Time: Exploring the Gay Past*. New York: Meridian, 1991.

———. *Cures: A Gay Man's Odyssey*. New York: Plume, 1991.

———. "Is There Room for Privacy on the Canvas?" *New York Times*, 7 September 1997, sec. 2, 89.

Dunbar, Robin. *Grooming, Gossip and the Evolution of Language*. London: Faber and Faber, 1996.

Edelman, Lee. *Homographesis: Essays in Gay Literary and Cultural Theory*. London: Routledge, 1994.

"Edie and Andy." *Time*, 27 August 1965, 32–33.

Ehrenreich, Barbara. *The Hearts of Men: American Dreams and the Flight from Commitment*. London: Pluto, 1983.

Ehrenstein, David. "The Filmmaker as Homosexual Hipster: Andy Warhol Contextualised." *Arts Magazine*, summer 1989, 61–64.

———. *Open Secret: Gay Hollywood 1928–1998*. New York: William Morrow, 1998.

Ehrlich, J. W. (ed.). *Howl of the Censor*. San Carlos, Calif.: Nourse Publishing, 1961.

Ellis, Albert. "Art and Sex." *Mattachine Review*, vol. 8, no. 7, July 1962, 4–22.

Fairbrother, Trevor. "Tomorrow's Man." In Donna M. De Salvo (ed.), *Success Is a Job in New York: The Early Art and Business of Andy Warhol*. New York: Grey Art Gallery and Study Center, 1989, 55–74.

Feldman, Alan. *Frank O'Hara*. Boston: Twayne, 1979.

Fenves, Peter. *Chatter: Language and History in Kierkegaard*. Stanford, Calif.: Stanford University Press, 1993.

Ferguson, Russell. *In Memory of My Feelings: Frank O'Hara and American Art*. Berkeley and London: University of California Press, 1999.

"Files on Parade," *Time*, 16 February 1953, 26.

Fitzgerald, Sara. *Rumours*. London: Coronet, 1992.

Foucault, Michel. *The History of Sexuality: An Introduction*. London: Penguin, 1984.

Francis, Mark, and Margery King (eds.). *The Warhol Look: Glamour, Style, Fashion*. London: Bullfinch Press, 1997.

Francis, Richard. *Jasper Johns*. New York: Abbeville Press, 1984.

Freeman, David L. (pseud. Charles Rowland). "The Homosexual Culture." *One*, vol. 1, no. 5, May 1953, 8–11.

———. "Literature and Homosexuality." *One*, vol. 3, no. 1, January 1955, 13–15.

———. "How Much Do We Know about the Homosexual Male?" *One*, vol. 3, no. 11, November 1955, 4–6.

Freud, Sigmund. *Leonardo da Vinci: A Memory of His Childhood*. London: Ark, 1984.

Fuller, Peter. "Jasper Johns interviewed I." *Art Monthly*, no. 18, 1978, 6–12.

Fuss, Diana. *Identification Papers*. London: Routledge, 1995.

Gallop, Jane. *Anecdotal Theory*. Durham, N.C.: Duke University Press, 2002.

Gardner, Paul. "Gee, What's Happened to Andy Warhol?" *Artnews*, vol. 79, no. 9, November 1980, 76.

Garrels, Gary (ed.). *The Work of Andy Warhol*. Seattle: Bay Press, 1989.

Geddes, Donald Porter (ed.). *An Analysis of the Kinsey Reports on Sexual Behaviour in the Human Male and Female*. New York: Mentor, 1954.

Geldzahler, Henry. "Andy Warhol." *Art International*, vol. 3, no. 3, April 1964, 34–35.

Gide, André. *Corydon*. New York: Farrar, Straus and Company, 1950.

Ginsberg, Allen. *Howl and Other Poems*. San Francisco: City Lights, 1956.

Giorno, John. "Vitamin G." *Culture Hero*, January 1970, unpaginated.

———. *You Got to Burn to Shine: New and Selected Writings*. London: Serpent's Tail, 1994.

Glueck, Grace. "Rivers Paints Himself into the Canvas." *New York Times Magazine*, 13 February 1966, 34–35, 78–83.

Gooch, Brad. *City Poet: The Life and Times of Frank O'Hara*. New York: HarperPerennial, 1993.

Goodman, Robert F., and Aaron Ben-Ze'ev. *Good Gossip*. Lawrence: University of Kansas Press, 1994.

Griffin, Howard. "Larry Rivers." *Art News*, vol. 55, December 1956, 9.

Gross, Brenda Suzanne. "Poets and Painters in the Theatre: A Critical Study of the New York Artists Theatre." City University of New York, PhD dissertation, 1989.

Gruen, John. *The Party's Over Now: Reminiscences of the Fifties. New York's Artists, Writers, Musicians, and their Friends*. New York: Viking Press, 1972, 141–142.

———. *The Artist Observed: 28 Interviews with Contemporary Artists*. Chicago: A Cappella Books, 1991, 29.

Guiles, Fred Lawrence. *Loner at the Ball: The Life of Andy Warhol*. London: Bantam Press, 1989.

Hancock, Marianne. "Soup's On." *Arts Magazine*, vol. 39, no. 9, May–June 1965, 16–18.

Harrison, Charles, and Fred Orton. "Jasper Johns: 'Meaning What You See.'" *Art History*, vol. 7, no. 1, March 1984, 76–101.

Harrison, Helen A. *Larry Rivers*. New York: Harper and Row, 1984.

Helmer, William J. "New York's 'Middle-Class' Homosexuals." *Harper's Magazine*, March 1963, 85–92.

Hess, Thomas, B. "Andy Warhol." *Art News*, vol. 63, no. 9, January 1965, 11.

———. "Larry Rivers' History of the Russian Revolution." *Art News*, October 1965, 36–37, 58.

"The Homosexual in America." *Time*, 21 January 1966, 40–41.

"Homosexuality in America." *Life*, 26 June 1964, 66–80.

"Homosexuals: To Punish or Pity?" *Newsweek*, 11 July 1960, 78.

Horne, Peter, and Reina Lewis (eds.). *Outlooks: Lesbian and Gay Sexualities and Visual Cultures*. London: Routledge, 1996.

"How Men Behave." *Time*, vol. 51, January 1948, 66.

Hunter, Sam. *Larry Rivers*. New York: Harry N. Abrams, 1970. Revised as *Larry Rivers*. London: Arthur A. Bartley, 1989.

Isherwood, Christopher. *The World in the Evening*. London: Methuen, 1954.

J. F., "Irving Sherman, Andy Warhol." *Art Digest*, July 1952 (unpaginated).

"Jam Session." *Newsweek*, vol. 65, 26 April 1965, 56.

Jay. "On Being Obvious." *One*, vol. 8, no. 3, March 1960, 17–18.

Johns, Jasper. "Marcel Duchamp (1887 1968)." *Artforum*, November 1968, 6.

Johnston, Jill. *Jasper Johns: Privileged Information*. London: Thames and Hudson, 1996.

Jones, Amelia. *Postmodernism and the En-Gendering of Marcel Duchamp*. London: Cambridge University Press, 1994.

———. *Body Art: Performing the Subject*. Minneapolis: University of Minnesota Press, 1998.

Jones, Caroline A. "Finishing School: John Cage and the Abstract Expressionist Ego." *Critical Inquiry*, vol. 19, summer 1993, 628–665.

———. *Machine in the Studio: Constructing the Postwar American Artist*. Chicago and London: University of Chicago Press, 1996.

Jones, James H. *Alfred C. Kinsey: A Public/Private Life*. New York and London: W. W. Norton.

Josephson, Mary. "Warhol: The Medium as Cultural Artifact." *Art in America*, vol. 59, no. 3, May–June 1971, 40–46.

Katz, Jonathan D. "The Art of Code: Jasper Johns and Robert Rauschenberg." In Whitney Chadwick and Isabelle Courtivron (eds.), *Significant Others: Creativity and Intimate Partnership*. London: Thames and Hudson, 1993, 189–206.

———. "Passive Resistance: On the Success of Queer Artists in Cold War America." *Image*, no. 3, December 1996, 119–142.

———. "Dismembership: Jasper Johns and the Body Politic." In Amelia Jones and Andrew Stephenson (eds.), *Performing the Body / Performing the Text*. London: Routledge, 1999, 170–185.

———. "Performative Silence and the Politics of Passivity." In Henry Rogers and David Burrows (eds.), *Making A Scene: Performing Culture into Politics*. Birmingham: Article Press, 2000, 97–103.

———. "John Cage's Queer Silence or How to Avoid Making Matters Worse." In David W. Bernstein and Christopher Hatch (eds.), *Writings through John Cage's Music, Poetry, and Art*. Chicago and London: University of Chicago Press, 2001, 41–61.

Kaufman, Betty. "Rivers: Boy Painter." *Commonweal*, vol. 84, 24 June 1960, 400–401.

Kikel, Rudy. "The Gay Frank O'Hara." *Gay Sunshine*, no. 35, 1978, 8–9.

Kinsey, Alfred C., Wardell B. Pomeroy, and Clyde E. Martin. *Sexual Behavior in the Human Male*. Philadelphia: W. B. Saunders Company, 1948.

"Kinsey Speaks Out." *Newsweek*, 12 April 1948, 27–28.

Kleinberg, Seymour. *Alienated Affections: Being Gay in America*. New York: Warner Books, 1980.

Koch, Stephen. *Stargazer: Andy Warhol's World and His Films*. London: Calder and Boyars, 1974.

Koestenbaum, Wayne. *Andy Warhol*. London: Weidenfeld and Nicolson, 2001.

Kornbluth, Jesse. *Pre-pop Warhol*. New York: Panache Press, 1988.

———. "Andy Warhol and Ad Reinhardt: The Great Acceptor and the Great Demurrer." *Studio International*, vol. 181, no. 931, March 1971, 113–117.

Krauss, Rosalind E. *The Optical Unconscious*. Cambridge, Mass., and London: MIT Press, 1993.

Kupper, William. "Immortal Beethoven: A Repressed Homosexual?" *One*, vol. 6, no. 6, June 1958, 6–8.

Lancaster, Mark. "Andy Warhol Remembered." *Burlington Magazine*, March 1989, 198–202.

Lehman, David. *The Last Avant-Garde: The Making of the New York School of Poets*. New York: Doubleday, 1998.

Leja, Michael. *Reframing Abstract Expressionism: Subjectivity and Painting in the 1940s*. New Haven, Conn.: Yale University Press, 1993.

Levy, David C. *Larry Rivers: Art and the Artist*. Boston: Bulfinch, 2002.

Lewis, Felice Flanery. *Literature, Obscenity and Law*. London: Feffer and Simons, 1976.

Leyland, Winston (ed.). *Gay Sunshine Interviews*. Vol. 1. San Francisco: Gay Sunshine Press, 1978.

———. *Physique: A Pictorial History of the Athletic Model Guild*. San Francisco: Gay Sunshine Press, 1982.

Lobel, Michael. "Warhol's Closet." *Art Journal*, vol. 55, no. 4, winter 1996, 42–50.

Love, Nancy. "Pop Goes the Easel." *Greater Philadelphia: The Magazine for Executives*, vol. 56, no. 11, November 1965, 155–157.

MacCabe, Colin, with Mark Francis and Peter Wollen. *Who Is Andy Warhol?* London: British Film Institute, 1997.

Machlin, Milt. *The Gossip Wars: An Exposé of the Scandal Era*. London: Star, 1981.

McShine, Kynaston. *Andy Warhol: A Retrospective*. New York: Museum of Modern Art, 1989.

Mailer, Norman. "The Homosexual Villain." *One*, vol. 3, no. 1, January 1955, 8–12.

———. "The White Negro: Superficial Reflections on the Hipster." *Advertisements for Myself*. London: Panther, 1961, 269–289.

Martin, Robert K. *The Homosexual Tradition in American Poetry*. Austin and London: University of Texas Press, 1979.

Meyer, Moe. *The Politics and Poetics of Camp* London: Routledge, 1994.

Meyer, Richard. "Warhol's Clones." In Monica Dorenkamp and Richard Henke (eds.), *Negotiating Lesbian and Gay Subjects*. London: Routledge, 1995, 93–122.

———. *Outlaw Representation: Censorship and Homosexuality in Twentieth-Century American Art*. New York: Oxford University Press, 2002.

Miller, D. A. *The Novel and the Police*. Berkeley: University of California Press, 1988.

———. "Anal Rope." In Diana Fuss (ed.), *Inside/Out: Lesbian Theories, Gay Theories*. London: Routledge, 1991, 119–141.

———. "Sontag's Urbanity." In Henry Abelove, Michèle Aina Barale, and David M. Halperin (eds.), *The Lesbian and Gay Studies Reader*. New York: Routledge, 1993, 212–220.

Miller, Debra. *Billy Name: Stills from the Warhol Films*. New York: Prestel, 1994.

Molesworth, Helen. "Before Bed." *October*, no. 63, winter 1993, 69–82.

Moon, Michael. *A Small Boy and Others: Imitation and Initiation in American Culture from Henry James to Andy Warhol*. Durham, N.C.: Duke University Press, 1998.

Muñoz, José Esteban. *Disidentifications: Queers of Color and the Performance of Politics*. Minneapolis: University of Minnesota Press, 1999.

Nardi, Peter M., David Saunders, and Judd Marmor, *Growing up before Stonewall: Life Stories of Some Gay Men*. London: Routledge, 1994.

Norse, Harold. *Memoirs of a Bastard Angel*. London: Bloomsbury, 1990.

O'Hara, Frank. Interview with Larry Rivers, "Why I Paint as I Do." *Horizon*, vol. 2, no. 1, September/October 1959, 95–101.

———. *Art Chronicles 1954–1966*. New York: George Braziller, 1975.

Orton, Fred. "Present, the Scene of . . . Selves, the Occasion of . . . Ruses." *Block*, no. 13, 1987/1988, 5–19.

———. *Figuring Jasper Johns*. London: Reaktion, 1996.

———. *Jasper Johns: The Sculptures*. Leeds: Henry Moore Institute, 1996.

Osborne, John, and John Deane Potter. "London Theatre Debates Homosexual Problem." *Mattachine Review*, vol. 5, no. 6, June 1959, 20–23.

Palmieri, Mario. "Leonardo the Forerunner." *One Institute Quarterly*, vol. 1, no. 3, fall 1958, 76–83.

Parker, Andrew, and Eve Kosofsky Sedgwick (eds.). *Performativity and Performance*. London: Routledge, 1995.

Pedersen, Lyn (pseud. James L. Kepner Jr.). "The Importance of Being Different." *One*, vol. 2, no. 3, March 1954, 4–6.

———. "Do Homosexuals Hide behind Great Men?" *One*, vol. 5, no. 5, May 1957, 4–6.

Perchuk, Andrew. "Pollock and Postwar Masculinity." In Andrew Perchuk and Helaine Posner (eds.), *The Masculine Masquerade: Masculinity and Representation*. Cambridge, Mass.: MIT Press, 1995, 42.

Perloff, Marjorie. *Frank O'Hara: Poet among Painters*. New York: George Braziller, 1977.

Phelan, Peggy. *Unmarked: The Politics of Performance*. London: Routledge, 1993.

———. *Mourning Sex: Performing Public Memories*. London: Routledge, 1997.

Phillips, Adam. *On Flirtation*. London: Faber and Faber, 1994.

Phillips, Lisa. *Beat Culture and the New America 1950–1965*. New York: Whitney Museum of American Art, 1995.

Podhoretz, Norman. "The Know-Nothing Bohemians." *Partisan Review*, no. 25, spring, 1958, 305–318.

Pollock, Griselda. "Killing Men and Dying Women: A Woman's Touch in the Cold Zone of American Painting in the 1950s." In Fred Orton and Griselda Pollock, *Avant-Gardes and Partisans Reviewed*. Manchester: Manchester University Press, 1996, 219–294.

Porter, Fairfield. "Rivers Paints a Picture: Portrait of Berdie." *Art News*, vol. 52, January 1954, 56–59.

———. "Larry Rivers." *Art News*, vol. 52, January 1954, 66.

———. "Jasper Johns." *Art News*, vol. 57, January 1958, 12.

———. "Larry Rivers." *Art News*, vol. 57, December 1958, 14.

Prentiss, Marlin. "Are Homosexuals Security Risks?" *One*, vol. 3, no. 12, December 1955, 4–6.

Raynor, Vivien. "Jasper Johns: 'I have attempted to develop my thinking in such a way that the work I've done is not me,'" *ArtNews*, vol. 72, no. 3, March 1973, 22.

Richardson, John Adkins. "Dada, Camp, and the Mode Called Pop." *Journal of Aesthetics and Art Criticism*, vol. 24, no. 4, summer 1966, 549–558.

Rifkin, Adrian. "Do Not Touch: Tom, with Sebastiano, Kant and Others." *Versus*, no. 6, 1995, 18–22.

———. "Theory as a Place." *Art Bulletin*, vol. 78, no. 2, June 1996, 209–212.

Rivers, Larry. "Young Draftsman on Master Draftsman." *Art News*, January 1955, 26–27, 58–60.

———. "A Discussion of the Work of Larry Rivers." *Art News*, March 1961, 44–46, 53–55.

———. "A Self-Portrait." *Listener*, 18 January 1962, 125–126.

Rivers, Larry, with Arnold Weinstein. *What Did I Do? The Unauthorized Biography*. New York: HarperCollins, 1992.

Rivers, Larry, with Carol Brightman. *Drawings and Digressions*. New York: Clarkson N. Potter, 1979.

Robertson, Pamela. *Guilty Pleasures: Feminist Camp From Mae West to Madonna*. Durham, N.C.: Duke University Press, 1996.

Rogoff, Irit. "Gossip as Testimony: A Postmodern Signature." In Griselda Pollock (ed.), *Generations and Geographies in the Visual Arts: Feminist Readings*. London: Routledge, 1996, 58–65.

Rorem, Ned. *The Paris and New York Diaries of Ned Rorem, 1951–1961.* San Francisco: North Point Press, 1983.

Rosenberg, Harold. "The American Action Painters." In *The Tradition of the New.* New York: Horizon Press, 1959 (originally published in *Art News*, 1952).

———. "The Art Establishment." *Esquire*, vol. 63, January 1965, 43, 46, 114.

———. "Rivers' Commedia dell'Arte." *Art News*, April 1965, 35–37, 62–63.

Rosenblum, Robert. "Jasper Johns." *Arts Magazine*, January 1958, 54–55.

Rosenzweig, Phyllis. *Larry Rivers: The Hirschhorn Museum and Sculpture Garden Collection.*Washington, D.C.: Smithsonian Institution Press, 1981, 41.

Rosnow, Ralph L., and Gary Alan Fine. *Rumor and Gossip: The Social Psychology of Hearsay.* New York: Elsevier, 1976.

Ross, Andrew. *No Respect: Intellectuals and Popular Culture.* London: Routledge, 1989.

Roth, Moira. "The Aesthetic of Indifference." *Artforum*, October 1977, 46–53.

Russell, David, and Dalvan McIntire. "In Paths Untrodden: A Study of Walt Whitman." *One*, vol. 2, no. 7, July 1954, 4–15.

"Saint Andrew." *Newsweek*, 7 December 1964, 72–74.

Salamensky, Shelley. "Gerede's Lebensraum: Heidegger, Language, Performance, Eugenics." *Signatures*, Web page visited 5 November 2004, printout on file with author.

Salamensky, Shelley (ed.). *Talk, Talk, Talk: The Cultural Life of Everyday Conversation.* London: Routledge, 2001.

Sandler, Irving. "Larry Rivers." *Art News*, vol. 60, December 1961, 11.

———. "The New Cool-Art." *Art in America*, vol. 53, February 1965, 96–101.

———. *The New York School: The Painters and Sculptors of the Fifties.* New York: Harper and Row, 1978.

Sawin, Martica. *Nell Blaine: Her Art and Life.* New York: Hudson Hills Press, 1998.

Schapiro, Meyer. "Larry Rivers." *Art Digest*, vol. 28, 1 January 1954, 17–18.

Schlesinger, Jr., Arthur M. *The Vital Center: The Politics of Freedom.* Boston: Houghton Mifflin, 1949.

Schneider, Rebecca. "Performance Remains," *Performance Research*, vol. 6, no. 2, 2001, 101.

Schuyler, James. "Larry Rivers." *Art News*, vol. 61, December 1962, 13–14.

Sedgwick, Eve Kosofsky. *Epistemology of the Closet.* London: Harvester Wheatsheaf, 1991.

Selz, Peter. "A Symposium on Pop Art." *Arts Magazine*, April 1963, 36–44.

———. "Pop Goes the Artist." *Partisan Review*, fall 1963, vol. 30, no. 3, 313–316.

Silver, Kenneth. "Modes of Disclosure: The Construction of Gay Identity and the Rise of Pop Art." In Russell Ferguson (ed.), *Hand Painted Pop: American Art in Transition, 1955–1962.* Los Angeles: Museum of Contemporary Art, 1993, 179–203.

Sinfield, Alan. *The Wilde Century: Effeminacy, Oscar Wilde and the Queer Moment.* London: Cassell, 1994.

Smith, A. E. "The Curious Controversy over Whitman's Sexuality." *One Institute Quarterly*, vol. 11, no. 1, winter 1959, 6–25.

Smith, Hazel. *Hyperscapes in the Poetry of Frank O'Hara: Difference/Homosexuality/Topography*. Liverpool: Liverpool University Press, 2000.

Smith, Patrick S. *Andy Warhol's Art and Films*. Ann Arbor, Mich.: UMI Research Press, 1986.

———. *Warhol: Conversations about the Artist*. Ann Arbor, Mich.: UMI Research Press, 1988.

Solomon, Alan. *Jasper Johns: Paintings, Drawings and Sculpture 1954–1964*. London: Whitechapel Gallery, 1964.

———. *Andy Warhol*. Boston: Institute of Contemporary Art, 1966.

Sontag, Susan. "Notes on Camp." *Partisan Review*, vol. 31, 1964, 515–530.

Spacks, Patricia Meyer. *Gossip*. New York: Alfred A. Knopf, 1985.

Stein, Jean, and George Plimpton. *Edie: The Life and Times of Andy Warhol's Superstar*. London: Jonathan Cape, 1982.

Steinberg, Leo. "Jasper Johns: The First Seven Years of His Art." In *Other Criteria: Confrontations with Twentieth Century Art*. London: Oxford University Press, 1972, 17–54.

Stimpson, Catherine R. "The Beat Generation and the Trials of Homosexual Liberation." *Salmagundi*, nos. 58–59, fall 1982–winter 1983, 373–392.

"The Strange World." *Time*, 9 November 1959, 52.

Suárez, Juan A. *Bike Boys, Drag Queens and Superstars: Avant-Garde, Mass Culture, and Gay Identities in the 1960s Underground Cinema*. Bloomington: Indiana University Press, 1996.

Swenson, G. R. "Andy Warhol." *Artnews*, vol. 61, November 1962, 15.

"The Talk of the Town: Notes and Comment." *The New Yorker*, 27 March 1948, 19–20.

Tebbutt, Melanie. *Women's Talk? A Social History of "Gossip" in Working Class Neighbourhoods, 1880–1960*. Aldershot, England: Scolar Press, 1995.

"The Third Sex." *Newsweek*, 1 June 1964, 46.

Tillim, Sidney. "Ten Years of Jasper Johns." *Arts Magazine*, April 1964, 22–26.

Timmons, Stuart. *The Trouble with Harry Hay: Founder of the Modern Gay Movement*. Boston: Alyson, 1990.

Tomkins, Calvin. *Off The Wall: Robert Rauschenberg and the Art World of Our Time*. New York: Doubleday and Company, 1980.

Tyler, Parker. "The Purple-Patch of Fetishism." *Art News*, vol. 56, March 1957, 40–43, 52–53.

Urbach, Henry. "Closets, Clothes, disClosure." In Duncan McCorquodale, Katerina Rüedi, and Sarah Wigglesworth (eds.), *Desiring Practices: Architecture, Gender and the Interdisciplinary*. London: Black Dog, 1996, 246–263.

Valentine Hooven, III, F. *Beefcake: The Muscle Magazines of America 1950–1970*. Cologne: Benedikt Taschen, 1995.

Varnedoe, Kirk. *Jasper Johns: A Retrospective*. New York: Museum of Modern Art, 1996.

Varnedoe, Kirk (ed.). *Jasper Johns: Writings, Sketchbook Notes, Interviews*. New York: Museum of Modern Art, 1996.

Vidal, Gore. *Palimpsest: A Memoir*. London: Andre Deutsch, 1995.

Warhol, Andy. *The Philosophy of Andy Warhol (From A to B and Back Again)*. New York: Harcourt Brace Jovanovich, 1975.

Warhol, Andy, and Pat Hackett. *POPism: The Warhol Sixties*. New York and London: Harcourt Brace Jovanovich, 1980.

Weinberg, Jonathan. "It's in the Can: Jasper Johns and the Anal Society." *Genders*, no. 1, spring 1988, 40–56.

Weinberg, Jonathan, and Falvia Rando (eds.). "We're Here: Gay and Lesbian Presence in Art and Art History." *Art Journal*, vol. 55, no. 4, winter 1996.

Weiss, Andrea, and Greta Schiller. *Before Stonewall: The Making of a Gay and Lesbian Community*. New York: Naiad Press, 1988.

"What Is a Homosexual?" *Time*, 16 June 1958.

Whitfield, Stephen J. *The Culture of the Cold War*. Baltimore: Johns Hopkins University Press, 1991.

Whiting, Cécile. "Andy Warhol: the Public Star and the Private Self." *The Oxford Art Journal*, vol. 10, no. 2, 1987, 58–75.

Wicker, Randolfe. "Effeminacy vs. Affectation." *Mattachine Review*, vol. 4, no. 10, October 1958, 4–6.

Wickware, Francis Sill. "Report on Kinsey." *Life*, vol. 25, 2 August 1948, 86–90, 92, 94, 97–98.

Wilson, Colin. *The Outsider*. London: Victor Gollancz, 1956.

Wolf, Reva. *Andy Warhol, Poetry, and Gossip in the 1960s*. Chicago and London: University of Chicago Press, 1997.

Wolfe, Bernard. "Angry at What?" *The Nation*, 1 November 1958, 316–322.

Woronov, Mary. *Swimming Underground: My Years in the Warhol Factory*. London: Serpents Tail, 1995.

{ INDEX }

Barr, Alfred H., Jr., 136–38, 144–47, 155, 157, 162, 186n.21

beat writers: Ginsberg obscenity trial and, 142; homosexuality among, 87–88, 179n.17

Beaver, Harold, 100

Beethoven, Ludwig, possible homosexuality of, 56, 59–60

behavioralist research, homosexuality in context of, 31

Beiber, Irving, 175n.2

Benton, Thomas Hart, 172nn.10–12, 173n.30; homophobia of, 23–29, 31–32, 39–40; images of masculinity and, 43, 47, 49–50, 72

biography/autobiography: as gossip source, 16, 170n.32; Rivers's *What Did I Do?*, 80–82

black culture, Rivers's involvement in, 86–87

Blaine, Nell, 13, 82–87, 93, 100, 103, 179n.12

Bockris, Victor, 115, 118, 121, 184n.37

"bodily ego" concept, 20

Bodley Gallery, 111

body images: camp depictions of, 101–5; gossip and role of, 20–21; in Johns's paintings, 69–70, 140–42, 146–51; in obscene literature, 142–45; queer discourse on art history and, 60–62, 177n.25; in Regionalist painting, 26–27; in Warhol's *Dance* canvases, 119–23

Boiffard, Jacques-André, 146

Boone, Bruce, 97, 100, 181n.38

"boy" drawings (Warhol), 111, 182n.11

"boys" stereotyping, in postwar cultural criticism, 17n.5, 24

Brainard, Joe, 12, 169n.20

Bruce, Stephen, 121–22

Burroughs, William, 179n.17

business liberalism, impact on art of, 171n.2

Butch magazine, 148

Butler, Judith, 20, 48, 118, 179n.14

Button, John, 2

Cadmus, Paul, 172n.12

Cage, John, 41–42

"Calamus" poems (Whitman), 68

camp: art history and role of, 3–4, 167n.4; irony and, 89–95; normative constructions critiqued by, 100–105; O'Hara's use of, 95–100, 181n.38; Rivers's discussion of, 82–88; Sontag's discussion of, 103, 132, 181n.47; Warhol's work and, 124–29, 184n.37

Campus Mistress, 142

Capote, Truman, 63, 111, 116–17

Carnegie Institute of Technology, 121

Carpenter, Edward, 56–58, 68

Cassady, Neal, 179n.17

Castelli, Leo, 136–38, 157

Chauncey, George, 59, 170n.29, 170n.31

City Activities, 30

City Lights bookstore, obscenity case against, 142

City Poet: The Life and Times of Frank O'Hara, 76

class issues, Warhol's exploration of, 124–29

Cleland, John, 142

"closet" metaphor: evolution of homosexual studies and, 14–15; Johns's work in context of, 157–62; Warhol's career and use of, 110–35

Cohn, Roy, 39

Colacello, Bob, 116

Collins, Bradford R., 117

Comintern (Communist International), 41

commercial art, distancing of artists from, 111–13

Communism, homosexuality linked to, 40–41, 174n.31

Confidential magazine, 10, 168n.17

conspiracy theories, of gay culture, 24–25, 29, 172nn.5–6

Cory, Donald Webster, 51–73, 121, 176n.8

Corydon, 55

Courbet, Gustave, 98

Coward, Noel, 10

Cowley, Malcolm, 68

Crane, Hart, 69

Crichton, Michael, 143

criminality of homosexuality, 51–52, 175n.2

Crowther, Bosley, 131

cultural signifiers: art history and role of, 61–63, 177nn.25–26; Rorem's discussion of, 67–68

cultural studies: evolution of homosexuality in, 14–15, 30–37; gossip in context of, 2–4, 167n.3. *See also* gay scholarship; queer studies; serious culture

Culture Hero magazine, 2

culture of homosexual suspicion: art criticism and, 26–29; art history in context of, 9–10; Kinsey's scientific studies and, 29–37

Cunningham, Merce, 41–42

"Curious Controversy over Whitman's Sexuality, The," 57

Curry, John Steuart, 23

Dance Diagram, 119–23

David, 61–63, 177n.26

David, Jacques-Louis, 100–101

da Vinci, Leonardo, 57, 59

De Antonio, Emile, 66, 112–14, 183n.17

Dearden, Basil, 177n.26

defamation laws, homosexual meaning and, 4, 167n.5

de Kooning, Elaine, 45–47, 50, 69

de Kooning, Willem, 45–48, 50, 69, 72

Delany, Samuel R., 171n.39

D'Emilio, John, 38, 175n.2

Demuth, Charles, 69

Derrida, Jacques, 17, 168nn.13–14

Dietrich, Marlene, 10, 85

Dine, Jim, 113

"disclosure": of gay identity in art, 5–9; in Johns's paintings, 157–62

Doonesbury cartoon strip, 128

Doss, Erika, 27, 172n.11

Double Portrait of Berdie, 93

Doyle, Peter, 68

drag, camp and, 85–86, 179n.14

Duberman, Martin, 40, 175n.3

Dutch Masters with Cigars, 104

Dyer, Richard, 64–65

Eberstadt, Frederick, 115

Edelman, Lee, 49, 130, 168n.16, 170n.28

Ehrenreich, Barbara, 37

Ehrenstein, David, 7, 10, 168n.17

Ellis, Albert, 58

Ellis, Havelock, 58, 68

employment discrimination, against homosexuals, 38–40, 173n.26

"Employment of Homosexuals and Other Sex Perverts In Government," 38

Epistemology of the Closet, The, 127–28

Esquire, 41

Eternally Obvious, The, 153–54

evidence, gossip and rumor as, 6–9

Factory (Warhol's arts venue), 126–27

Feldman, Alan, 96–97

feminization of American male, theories concerning, 174n.43

Ferlinghetti, Lawrence, 142–43

Figuring Jasper Johns, 138

Finch, Peter, 131

Fine, Gary Alan, 6, 8, 43

Fitzgerald, Sara, 185n.7

Fizeek Art Quarterly, 60–61

Flag, 71–72, 136–38, 185n.2, 186n.21

Flatley, Jonathan, 117

fragmented body casts, Johns's use of, 152–56, 187n.34

Francis, Richard, 140, 146

Frankenthaler, Helen, 81

Freilicher, Jane, 75, 77, 81

Freud, Sigmund, homosexual genius concept and work of, 56, 60

Fuss, Diana, 17, 170n.33

Gallop, Jane, 188n.4

Garbo, Greta, 10

Gardner, Paul, 133

gay identity, in art, 5–9

gay scholarship: art history in, 5–9; "closet" metaphor in, 15–16, 170n.30; definitions and terminology in, 8–9, 31–32, 173n.14, 179n.12; genius research and, 58–62; homophile journals' coverage of, 55–57; "outsider" homosexual in, 53–54; questions on academic status of, 4, 167n.6; on Warhol, 110. *See also* queer studies

Gay Sunshine magazine, 1, 63, 65–66

Geffen, David, 185n.5

Geldzahler, Henry, 2, 130

Gibson, Ann, 169n.22

Gibson, Marty, 161

Gide, Andre, 55

Ginsberg, Alan, 142–43, 159, 179n.17

Giorno, John, 1–4, 8, 115

Glueck, Grace, 74–75, 79

Gooch, Brad, 76, 79

gossip: as art history, 2–9, 12–16, 167n.3; about artists' sex lives, 1; cultural evolution of, 10–11, 168n.17; as evidence, 6–9; historical inquiry and, 19–20, 171n.39; Johns's work in context of, 157–62; mythologies of homosexuality and, 11–12, 169n.18; performative character of, 18–19, 171n.37; public documentation as source of, 16–21; queer world-making through, 65–72; in Rivers's

autobiography, 80–88; Rivers's paintings as, 77–81; Warhol's use of, 12–13, 106–10, 130–35, 169n.21, 182n.2

Greatest Homosexual, The, 100–105

Greenberg, Clement, 81

Greenberg, Noah (Mrs.), 81

Greene, Bert, 125–26, 134

Green Target, 136

Gros Orteil, Le, 146

Grossberg, Yitzroch (Irving). *See* Rivers, Larry

Growing up before Stonewall, 175n.2

"Growth of Overt Homosexuality in City Provokes Wide Concern," 14

Gruen, John, 49, 99

Guardian newspaper, 169n.18

Guest, Barbara, 96

Harper's magazine, 14

Harrison, Lou, 63

Hartley, Marsden, 68–69

Hefner, Hugh, 143

Heidegger, Martin, 6, 168n.8

hermeneutics of suspicion, homosexuality in context of, 9–10, 26–29, 49, 168n.16

Hess, Thomas, 100

heterosexuality: normative construct of, 36–37, 39, 45–50, 174n.45; Rivers's discussion of, 84–88; Warhol's camp identification with, 124–29

"hip" culture, Rivers's involvement in, 17, 86–88, 179

Hirschfeld, Magnus, 31, 56

history: gay men's identification with figures of, 51, 68; gossip in context of, 19–20, 171n.39

Hollywood: gossip about celebrities in, 10–11; Regionalist painting and influence of, 27–28; Warhol's embrace of, 109, 124, 182n.5

Home Gardener, The, 33

homintern concept: cultural evolution

Johns, Jasper (*continued*)
 works by, 19–20; commercial work
 by, 112, 183n.16; critical assessment of,
 151–56; O'Hara and, 115; queer dis-
 closure and work of, 65–66, 68–72,
 136–62; social network of, 41; sur-
 realism in work of, 145–51; Warhol
 and, 112–16
Johnson, Philip, 2
Johnson, Ray, 12, 169n.20
Johnston, Jill, 157, 187n.38
Jones, A., 174n.43
Jones, Caroline, 46, 123–25, 128
Jones, James H., 30, 170n.23
Joseph, 93
Josephson, Mary, 133

Kallman, Chester, 81
Kanovitz, Howard, 77, 79, 82
Katz, Jonathan, 5, 184n.43
Kaufman, Betty, 98, 181n.43
Kennedy, Jackie, 124
Kepner, James L., Jr., 52, 176n.7
Kerouac, Jack, 179n.17
Kikel, Rudy, 100
Kinsey, Alfred, 9, 13–14, 170n.23, 176n.8;
 culture of homosexual suspicion and
 work of, 29–39, 49–50; media images
 of, 36–37, 47–48
Kinsey, Clara McMillen (Mrs.), 36–37
"Kinsey Boogie, The," 30
Kinsey Institute, 144
Kleinberg, Seymour, 64, 71, 175n.3
Kligman, Ruth, 124
Koch, Kenneth, 96
Koch, Stephen, 133
Kozloff, Max, 133
Krasner, Lee, 45–47
Krauss, Rosalind, 119–20
Kupper, William H., 56, 60

Lady Chatterly's Lover, 142
Lancaster, Mark, 108–9, 187n.40

Larkin, Lawrence, 45–47
Lawrence, D. H., 142
Leja, Michael, 45, 47, 49
Leo Castelli Gallery, 136–38, 141, 144,
 185n.5, 186n.12
lesbian identity, gossip and, 13–14,
 169n.22
lesbian scholarship. *See* queer studies
Leutze, Emanuel, 89–90, 180n.22
Leyland, Winston, 65
libel suits, homosexual meaning and, 4,
 167n.5
Life magazine, 170n.28; artists discussed
 in, 47–48, 50, 69; Ginsberg obscenity
 trial covered in, 142; images of
 homosexuality in, 14; Kinsey article
 in, 33–36, 39; on Warhol, 111
literary history, genius and homosexu-
 ality in context of, 59–62

Magritte, René, 146, 153–54
Mailer, Norman, 58
Malanga, Gerard, 108, 115, 126, 183n.20
male gaze, homoeroticism of Johns's
 Target paintings and, 147–51, 186n.27
Mann, Catherine, 185n.7
Man Ray, 67
Mapplethorpe, Robert, 161
masculinity: cultural norms of, 10;
 discursive construction of, 13–14,
 45–49, 174n.43; of gay artists, 69–
 72; Kinsey's studies and ideas about,
 30–37
Mattachine Newsletter, 176n.5
Mattachine Review, 16, 176n.5; assimila-
 tionism discussed in, 119; queer
 discourse in, 55–57, 177nn.11–12, 25
Mattachine Society, 52, 175n.4
Mavor, Carol, 188n.2
McCarthyism: art world politics dur-
 ing, 88–89, 180n.21; cultural criticism
 and, 24; homosexual witch hunts
 and, 9–11, 38–40, 44–47, 173n.30;

Rivers, Joseph, 98
Rivers, Larry, 12, 19, 21, 169n.20; auto-
biography of, 80–82; camp in art of,
99–100, 181n.47; gay friendships of,
82–88, 179n.9; gossip concerning,
76–81; journalistic aspects in work
of, 98–99, 181n.43; life and career
of, 74–75, 178nn.2–3; nonnormative
heterosexuality of, 174n.45; O'Hara's
poetry and paintings of, 95–100;
O'Hara's relationship with, 76–79,
178n.5, 179n.7; photo-portrait of,
104; on queer identity and artistic
creativity, 64; social network of, 41;
subjectivity in work of, 100–105;
Warhol compared with, 108; *Wash-
ington Crossing the Delaware* painting
of, 88–95, 180nn.21, 28
Rivers, Steven, 98
Rogoff, Irit, 7
Rorem, Ned, 11, 65–67
Rosenberg, Harold, 41–42
Rosenblum, Robert, 140–42, 145–46
Rosenquist, James, 112
Rosenthal, Rachel, 187n.40
Rosnow, Ralph, 6, 8, 43
Ross, Andrew, 90
Rugged magazine, 148
rumor: as evidence, 6–9; psychological
aspects of, 43–44
Rumours (Fitzgerald), 185n.7
Rumours (Mann), 185n.7

Sagarin, Edward. *See* Cory, Donald
Webster
Salamensky, S. I., 7, 18–19, 171n.37
Saturday Review of Literature, 23–25, 27,
30, 39
Schapiro, Meyer, 155
Schine, David, 39
Schlesinger, Arthur M., 40, 174n.31
Schumacher, Michael, 142–43
Schuyler, Jimmie, 169n.20

Sedgwick, Edie, 124–26, 130
Sedgwick, Eve Kosofsky, 69, 124–25,
127–28, 183n.28
serious culture: art history and role of,
61–63, 177nn.25–26; gossip in context
of, 2–4, 167n.3; psychology of rumor
and, 43–44; queer world-making in
context of, 63–73; rumor as evidence
in, 6–9
sex lives of artists, gossip about, 1
sexology, homosexuality research and,
56–58
Sexual Behavior in the Human Male, 29
sexuality: art criticism and discus-
sion of, 3, 167n.4; cultural unease
concerning, 29–37; Kinsey's reports
on, 9; phantasmatic meanings of, 7,
168n.13; in Rivers's paintings, 76–81
Silver, Kenneth, 5, 68–69, 112–14
$64,000 Question, The, 75
Smith, A. E., 57, 68
Smith, Patrick S., 116
Soby, James Thrall, 25–26, 29, 43, 49
Solanas, Valerie, 124
Solomon, Alan, 126–27, 134
Sontag, Susan, 103, 132, 181n.47
Spacks, Patricia Meyer, 170n.32
speech acts: reproduction of, 19; by
Warhol, 125. *See also* "queer talk"
Stable Gallery, 109, 119–23, 184n.37
Stargazer, 133
Steel, 27
Steinberg, Leo, 140, 151, 156
Stern, Gerd, 142
Stimpson, Catharine R., 87
Stonewall riots, as historical turning
point, 15, 170n.31
striptease, body imagery and, 141
Studio, The, 98–99, 103
Studio 54 nightclub, 133
surrealism, Johns's *Target* paintings
and, 145–46, 186n.25
Symonds, John Addington, 58, 68

Tabachnick, Anne, 86
Target paintings, 69–70
Target with Four Faces, 136–37
Target with Plaster Casts, 19, 136–48,
 151–56, 159–60, 185n.4, 186nn.12, 21
Taylor, Elizabeth, 124
Ten Lizes, 107, 124–26
textuality, in Rivers's painting, 99–100
"Thank You, Mr. Kinsey," 30
theater, myth of homosexual domi-
 nance of, 40–42
Tiger magazine, 148
Time magazine, 14, 30, 42–43
Tip-Off magazine, 10, 40
Tolstoy, Leo, 90
Tomkins, Calvin, 41–43, 49
Trials of Oscar Wilde, The, 131
Tropic of Cancer, 142
Trudeau, Gary, 128
Tyler, Parker, 98–99, 181n.43

Ulrichs, Karl, 56
Urbach, Henry, 170n.29

Vasari, Giorgio, 3
Victim, 177n.26
Vidal, Gore, 41
Vietnam War, influence on art of,
 185n.2
visual arts, New York School of poetry
 and, 95–100
Vital Center, The, 174n.31
"Vitamin G" (gossip column), 2–4

War and Peace, 90
Ward, Eleanor, 119
Warhol, Andy: celebrity status of, 75;
 changes to physical appearance of,
 124–29; as commercial artist, 111–12,
 117, 183n.17; gossip about, 2; gos-
 sip's role in career of, 12–13, 106–10,
 169n.21, 182n.2; homosexual images

in work of, 14, 170n.27; "inning" of,
 123–29; queer identity embraced by,
 63, 111–23; transition of, to Pop artist,
 117–23
Washington at Dorchester Heights,
 93–94
Washington Crossing the Delaware
 (Leutze), 89–90, 180n.22
Washington Crossing the Delaware
 (Rivers), 88–95, 99, 103
Watney, Simon, 109
Weinberg, Jonathan, 5, 172n.12,
 187nn.42–43
Wesselman, Tom, 113
Western Christian theology, criminali-
 zation of homosexuality in, 51–52,
 175n.2
What Did I Do?, 80–88, 90, 105
"What's Holding Back American Art?",
 23
Wherry, Kenneth, 38
Whisper magazine, 10, 168n.17
White Flag, 137
White Numbers, 136
Whitfield, Stephen J., 39
Whitman, Walt, 57–59, 68–69, 71
"Why They Call Broadway the GAY
 White Way," 40
Wilde, Oscar, 52; camp culture influ-
 enced by, 132–35; Warhol's identifica-
 tion with, 125–27, 130–35
"Wilde Absolved," 131
Williams, Herb, 33–35
Williams, Linda, 141
Williams, Tennessee, 64
Winchell, Walter, 10
Wolf, Reva, 107, 182n.2
women artists: gossip concerning,
 13–14; stereotypes concerning, 13,
 169n.22, 170n.23
Wood, Grant, 23
World in the Evening, The, 85, 90

GAVIN BUTT IS LECTURER IN THE VISUAL

CULTURES DEPARTMENT AT GOLDSMITHS

COLLEGE, UNIVERSITY OF LONDON.

BUTT, GAVIN.

BETWEEN YOU AND ME : QUEER

DISCLOSURES IN THE NEW YORK ART

WORLD, 1948–1963 / GAVIN BUTT.

P. CM.

INCLUDES BIBLIOGRAPHICAL REFERENCES

AND INDEX.

ISBN 0-8223-3486-0 (CLOTH : ALK. PAPER)

ISBN 0-8223-3498-4 (PBK. : ALK PAPER)

1. HOMOSEXUALITY AND ART.

2. ARTISTS — SEXUAL BEHAVIOR. 3. GOSSIP.

4. ART, AMERICAN — NEW YORK (STATE) —

NEW YORK — 20TH CENTURY. I. TITLE:

QUEER DISCLOSURES IN THE NEW YORK ART

WORLD, 1948–1963. II. TITLE.

N72.H64B87 2004

701'.18'0722 — DC22

2004029837